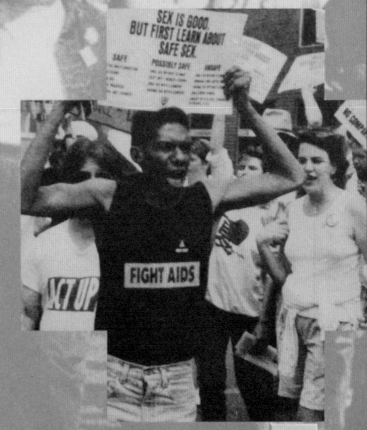

Edited by Staci Boris

WITH CONTRIBUTIONS BY

Christopher Audain

Tracy Baim

Lora Branch

Karen Finley

Tempestt Hazel

Anthony Hirschel

Jonathan David Katz

James D. McDonough

Danny Orendorff

Mary Patten

Kate Pollasch

Victor Salvo

Joseph R. Varisco

ART*AIDS*AMERICA**CHICAGO**

ALPHAWOOD FOUNDATION, CHICAGO

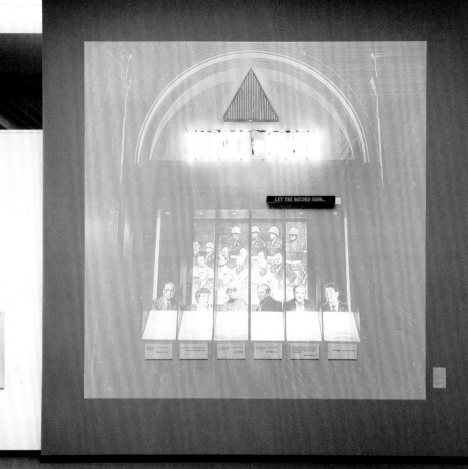

Foreword and Acknowledgments

In 2016, Jonathan David Katz told Alphawood Foundation's founder and chairman Fred Eychaner that the national tour of *Art AIDS America* could not find a venue in Chicago or anywhere else in the middle of the country. Fred is a true Chicagoan, and etched into every true Chicagoan's deep psyche is architect Daniel Burnham's motto: "Make no little plans; they have no magic to stir men's blood." If no Chicago museum would bring *Art AIDS America* to the city, then we would build one.

And so, in early 2016, we set about creating Alphawood Gallery in a vacant former bank headquarters adjacent to our offices. We built walls, laid carpet, and installed track lighting. And in record time we had created an elegant, museum-quality, 12,000-square-foot gallery to host this world-class exhibition. All of us are immensely proud of this effort and the quality of the result.

We were fortunate to be the last stop on the national tour, not only because this gave us time to create Alphawood Gallery, but also because it allowed us to address earlier criticism that the exhibition lacked sufficient representation of artists of color. It also gave us time to dig deep into local resources to supplement *Art AIDS America* by adding a unique Chicago perspective. As a consequence, the presentation of *Art AIDS America* at Alphawood was the largest and most comprehensive version to date.

We did all of this because *Art AIDS America* sits squarely at the intersection of the most central tenets of Alphawood Foundation's mission, which is to support and promote the arts, as well as the rights and interests of people living with HIV and AIDS. We never wanted to get into the museum business. Rather, this entire venture had *activism* at its core. Revisiting the darkest days of the epidemic by examining how AIDS changed American art and, indeed, America as a whole, allowed us to ask hard questions and relive difficult realities. The questions, reflections, and discussions engendered by *Art AIDS America* resonated throughout our community and our city. Younger people experienced the dread, panic, despair, and strength that

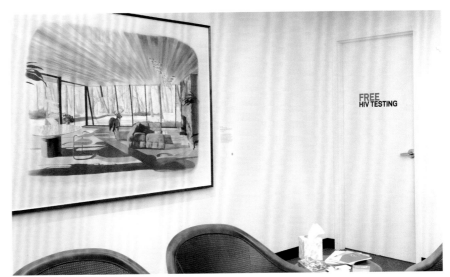

Opposite: Installation view of *Art AIDS America*, Alphawood Gallery, Chicago, 2017, with works by Shimon Attie, ACT UP/Gran Fury, and Deborah Kass

Installation view with work by Patte Loper and Free HIV Testing Area

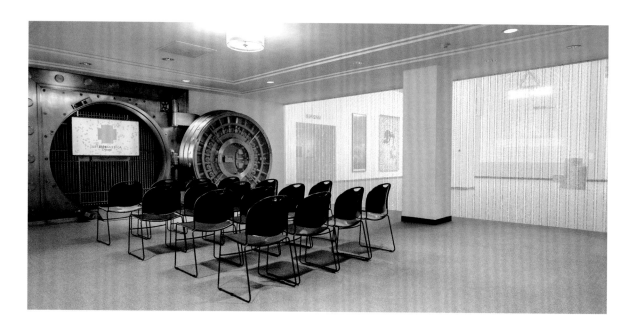

AIDS created. Veterans of the fight relived the bad and, importantly, the good. We hope everybody walked out the door with a renewed sense of how to use all the awful psychic scar tissue to keep fighting a fight that never seems to be quite won.

Our presentation of *Art AIDS America* went far beyond the gallery exhibition. During the four-month Chicago run, we partnered with scores of other institutions and organizations to present a stunning array of programs that expanded the exhibition in profound ways. From the opening-day press conference, during which the Chicago Department of Public Health released the latest HIV/STI data for the city, to the free daily HIV testing, to presentations and performances by Bill T. Jones, Karen Finley, and many, many talented and committed local artists, activists, and scholars, we tried to offer everyone a way to get to the deep meaning of the exhibition. These programs and events happened at Alphawood Gallery and other venues throughout the city. We are especially grateful that our neighbor DePaul Art Museum staged a companion exhibition entitled *One day this kid will get larger*, which examined the work of emerging artists who address the ongoing pandemic.

In this companion to the original catalogue, we offer the result of our work to bring *Art AIDS America* to Chicago. A great many people and institutions were part of the effort that made this ambitious undertaking a success. Our great thanks go, first and foremost, to Jonathan David Katz and Rock Hushka, the curators who spent ten years of their lives creating *Art AIDS America*. The Tacoma Art Museum and its former director, Stephanie Stebich, and the Bronx Museum of the Arts, the exhibition's organizers, also have our deep gratitude.

Thanks to all the lenders to the national tour (named in the checklist on pages 240–48), as well as those who generously lent their works to the Chicago presentation, especially Brooke Adams; Art Institute of Chicago; Dr. Daniel Berger; Lori F. Cannon; Chicago Department of Public Health; Frameline; Gerber/Hart Library and Archives; Garth Greenan Gallery; Kavi Gupta; High Museum of Art; Leslie-Lohman Museum of Gay and Lesbian Art; Magnolia Editions; Matthew Marks Gallery; Patric McCoy Collection; Esther McGowan; Museum of Contemporary Art Chicago; The NAMES Project Foundation; the New School; Rubell Family Collection; Victor Salvo and the Legacy Project; Sandler Hudson Gallery; Jordan D. Schnitzer; School of the

Art Institute of Chicago; Sperone Westwater; University of California, Berkeley Art Museum and Pacific Film Archive; Video Data Bank at the School of the Art Institute of Chicago; and the many wonderful artists who agreed to take part in this important exhibition.

We wish to pay particular tribute to Marcia Lipetz, Ph.D., the first full-time director of the AIDS Foundation of Chicago, who later was the first executive director of what became the Alphawood Foundation, and who also served valiantly on the Board of Directors of the Center on Halsted, Chicago's LGBTQ community center.

Special thanks to the Alphawood Exhibitions team: Director of Exhibitions Anthony Hirschel; Associate Director of Exhibitions Staci Boris; Alphawood Foundation Program Officer Christopher Audain, who was also head of programming for the exhibition; Program Coordinator Joseph Varisco; Exhibition Assistant Destiny Williams; Office Manager Melissa Terrell; and Facilities Manager Robert Dominguez.

Our colleagues at Newsweb Corporation, Joan Barry and Camille Dziewiontka, are owed a special debt of gratitude for going above and beyond their already hectic duties. We also are especially appreciative of our visitor services associates, who did the important work of creating a welcoming experience for our patrons and led a great many tours of the exhibition: thank you, Jennifer Castillo, Claire Fey, Sam Kirkwood, Louise Liu, Megan Moran, and Leo Williams. Finally, of the many consultants and advisors, we extend special thanks to Curatorial Consultant John Neff, Registrar Angela Steinmetz, Graphic Designer Michael Garzel, Video Producer Steven Rosofsky, and Publicist Beth Silverman.

This substantial publication and our dedicated website www.artaidsamericachicago.org document the exhibition and its programs in Chicago, ensuring that future generations and those who were unable to attend have access to the art, the scholarship, and the many important conversations that took place. Many thanks to Staci Boris for her vision, her persistence, and her sensitivity in pulling this catalogue together. We are grateful to the authors who have contributed to this volume for taking the time to explore additional artists and histories crucial to the understanding of HIV/AIDS in the United States as well as the challenging responsibility of exhibition making. We benefited from the production, editorial, and design expertise of all those associated with Lucia|Marquand and appreciate the support of University of Washington Press in distributing this book.

And finally, special thanks to Fred Eychaner, our leader and patron, who had the ambitious idea to do this in the first place. Without Fred's vision and drive, *Art AIDS America* would never have come to Chicago.

Installation view with detail of
Keith Haring's *Altar Piece*

James D. McDonough
Executive Director, Alphawood Foundation

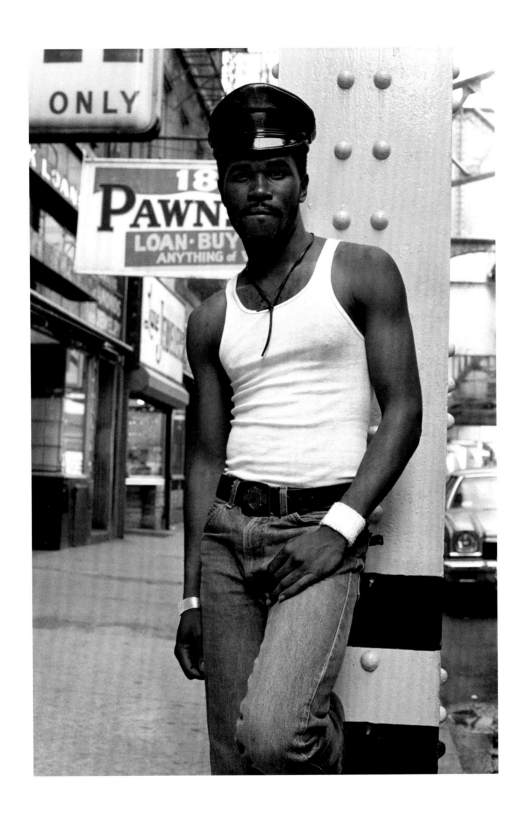

1
Patric McCoy

Only 18 Pawns, 1983–85/2016
Digital print from original
negative
12 × 9 in.
Courtesy of the artist

Special Acknowledgment

The Chicago iteration of *Art AIDS America* was to be the last and, we hoped, most complete exhibition of the entire multiyear run. In Chicago, as elsewhere, we sought to augment the touring exhibition with the addition of local artists particular to the specific issues, social experiences, and political realities endemic to this city. And there was no one we'd rather have head up this local effort than John Neff. John is a rare combination of artist, curator, social historian, and community activist. We are extremely grateful he was willing to expand the exhibition with the complex history of Chicago's response to The Plague. With his guidance, *Art AIDS America Chicago* took form.

John's long history in the Chicago art world, and his invaluable local contacts, allowed him to ferret out works of a range and quality that surpassed our already high expectations. After some considerable sleuthing, he helped us present an exhibition that was not only the most widely representative, but also the most nuanced and specific local account yet. John was responsible for some of the defining additions to the exhibition, including the great Howardena Pindell canvas *Separate but Equal Genocide: AIDS,* and a series of films and videos that was sorely lacking in previous exhibitions due to space and equipment considerations. John also brought into the exhibition the work of Patric McCoy, Michael Qualls, Israel Wright, Doug Ischar, and Daniel Sotomayor, each in their own way defining Chicago figures. Their presence not only strengthened the exhibition as a whole, but specifically raised its already high political temperature. Yet another Chicago artistic icon added to the exhibition was Roger Brown, as his AIDS-related work was, I am embarrassed to admit, unknown to the team responsible for the exhibition.

John also helped develop the elegant layout of the Chicago presentation and proved an invaluable cultural ambassador to other area arts groups. It's no exaggeration to note that without John, *Art AIDS America Chicago* would have had an altered, weaker form. John was at the heart of the Chicago exhibition, and it was our great, good luck that he remade it to speak in a Chicago accent.

Jonathan David Katz

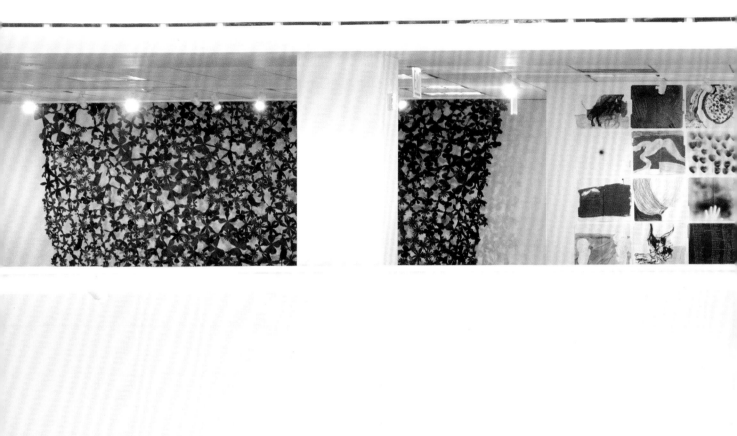

Art AIDS America in Chicago
New Venue, Final Venue

ANTHONY HIRSCHEL

I arrived at Alphawood Foundation in February 2016. There was much to do in order to present *Art AIDS America* in Chicago successfully. The Foundation had never presented exhibitions previously, nor did it have a suitable gallery space in which to do so. Addressing that issue was one of our most urgent obligations, and we settled within days on a renovation of the disused bank headquarters space in our own building. It proved no small matter to transform the bank into a gallery worthy of a major national traveling exhibition (and satisfactory to the dozens of lenders) in ten months, but that was only part of the challenge. We had no staff, no program, and no public familiarity with our venue as one where exhibitions might be presented, even if it was well located in Chicago's Lincoln Park neighborhood. The task of assembling all the facilities, staff, and policies of a museum in so short a time was daunting. Yet it was of paramount importance that we make the most of the opportunity. As Jim McDonough makes clear in his foreword, the themes and messages of *Art AIDS America* aligned so closely with the mission of the Foundation and the work of many of its grantees that success in its presentation was not simply desirable; it was essential.

Alphawood was fortunate to have the largest space of any of the venues, and it also had the greatest opportunity to respond to the controversy that had arisen around *Art AIDS America* in its early days. A preview version of the exhibition had appeared in West Hollywood in summer 2015. The full exhibition debuted at the Tacoma Art Museum in fall 2015, and it was there that, toward the end of the run, the Tacoma Action Collective mounted a protest in the galleries, questioning why an exhibition focusing on HIV/AIDS, an epidemic that has disproportionately affected communities of color, should include the work of so few artists of color. The exhibition then traveled to the Zuckerman Museum of Art at Kennesaw State University outside Atlanta and moved on to the Bronx Museum of the Arts before coming to Chicago, its final stop.

Installation view with, clockwise from top left, works by Jim Hodges, William Downs, Roger Brown, and Felix Gonzalez-Torres

The exhibition's original curators, Rock Hushka and Jonathan David Katz, and the organizing institutions—the Tacoma Art Museum in collaboration with the Bronx Museum of the Arts—had always intended to encourage subsequent venues to add to the exhibition, providing evidence in each city of the local artistic response to the AIDS crisis. In the wake of the protest in Tacoma, the organizers also urged subsequent venues to seek relevant works by additional artists of color. This freedom to amend the original curatorial concept demonstrated an uncommon level of professional trust and generosity, but also imposed significant additional responsibility on the Chicago team.

As visitors entered Alphawood Gallery's foyer, images of ACT UP protests held in Chicago in the 1980s surrounded them. The marchers, visibly angry yet joyous and triumphant all at once, helped provide a transition from the world outside to the calmer gallery spaces of an art exhibition, reminding visitors of the noisiness of the period and the fact that making genuine progress in society often requires the energy of many who are willing to speak up and speak out until the engines of government and corporate bureaucracies eventually respond. It also made clear that what visitors were entering was *not* a standard art gallery but rather an activist space intended to spur their own actions about matters important to them.

The exhibition consisted of more than 150 works arranged in various ways at the four venues, in part chronologically, to trace the arc of the artistic response to the epidemic, beginning in 1981 with real emphasis on the height of the crisis in the 1980s and 1990s, and then further works leading nearly to the present. But the works were also intended to be understood according to a system of four major themes: Body, Spirit, Politics, and Camouflage. In Chicago, we chose to follow a chronological path but acknowledged the curator-assigned themes of the works by color coding the labels and providing a printed guide with the wall texts.

It was the Camouflage theme that got to the heart of this exhibition's reason for being. Jonathan Katz argues that HIV/AIDS does not appear to be the subject of the majority of the works, which, in turn, has contributed to the significant underappreciation of the degree to which the epidemic affected and informed the course of American art starting in the 1980s. The societal pressures at the time were such that artists faced a stark choice: either address the disease and all the contested political and religious issues surrounding it directly, knowing that this would very substantially reduce the attention the works of art would receive, particularly within the museum and gallery world, or, instead, create work that veiled its meaning in order to enter the world of high art by stealth. Many artists chose this latter, subversive path, encoding their pain and anger in ways that appeared benign or invisible to the casual observer but could be deciphered by those in the know. Katz has many times recalled Felix Gonzalez-Torres's view that his art should penetrate the world of high art like a virus, its real meaning and anger undetected until it is too late to escape its effects.

The exhibition included all manner of work, from relatively traditional paintings, drawings, and sculpture to conceptual installations and video works, political cartoons, and photography. The largest works were arranged at Alphawood Gallery around the walls of a central atrium dominated by Gran Fury's *Let the Record Show*, projected close to its original scale at almost 16 feet square. Among the artists represented were nearly all of the most familiar names of the period—Nan Goldin, Felix Gonzalez-Torres, Keith Haring, Jenny Holzer, Barbara Kruger, Robert

Mapplethorpe, Marlon T. Riggs, David Wojnarowicz, and more—but there were also many others whose names were less familiar, in many cases not because their work was less powerful or accomplished, but rather because their lives had been cut short by HIV/AIDS before their reputations could blossom—Brian Buczak, Chloe Dzubilo, Ronald Lockett, Ray Navarro, Martin Wong, and many more. The scale of the loss was staggering, and it was palpable in seeing the galleries filled with work by artists whose lives and careers had been snuffed out far too soon.

Inevitably, some works included earlier in the exhibition's tour were no longer available, and replacements had to be found. Rock Hushka and Jessica Wilk in Tacoma worked with me, aided by Jonathan Katz, to secure works equal in quality and significance to substitute for those withdrawn. Many lenders stepped forward to fill these gaps, among them some in Chicago, for which we were deeply grateful. The Art Institute of Chicago generously lent three works, including Tony Feher's *Penny Piece* (pl. 5), a work about the artist's own mortality, made all the more moving by his passing several months earlier, as well as General Idea's *White AIDS #3* (pl. 7), a work of veiled tongue-in-cheek luminosity. Jim Hodges's exquisitely delicate curtain-like works would have been absent from the Chicago presentation of the exhibition had the Museum of Contemporary Art Chicago not generously agreed to lend *The end from where you are* (pl. 63), all the more ethereally mournful for being almost completely black. The Jordan D. Schnitzer Collection in Oregon kindly made Barbara Kruger's *"Untitled"* (*We will no longer be seen and not heard*) available to ensure that this key artist would be represented (pl. 6), as she had been by a different work in Tacoma. Jessica Tran at Matthew Marks Gallery ensured the loan of Nan Goldin's haunting photograph *Gilles' arm, Paris* (pl. 55), a sad, quiet, sympathetic detail excerpted from the saga of the artist's friend's inexorable decline. Yet this work really summed up much of the emotion of the exhibition as a whole, capturing the sense of loss inherent in careers and friendships disappearing, memories of those stalked by HIV/AIDS—this image excludes Gilles's face—fading as their lives ebbed. Esther McGowan of Visual AIDS in New York kindly lent Glenn Ligon's mysterious *My Fear is Your Fear* (pl. 8), a powerful work of elusive meaning, from her own collection. New York's Leslie-Lohman Museum of Gay and Lesbian Art agreed to lend Donald Moffett's *Homo Senses* (pl. 26), for which the artist had reused a New

Installation view of *Art AIDS America*, Alphawood Gallery, Chicago

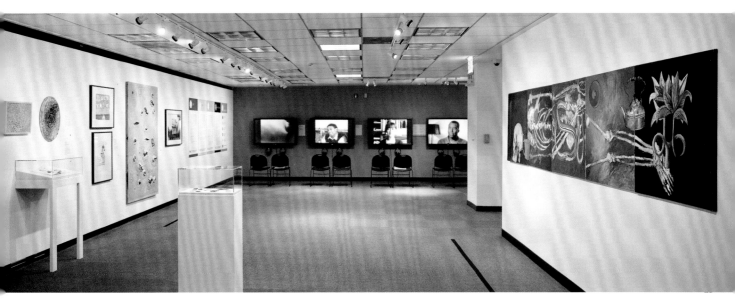

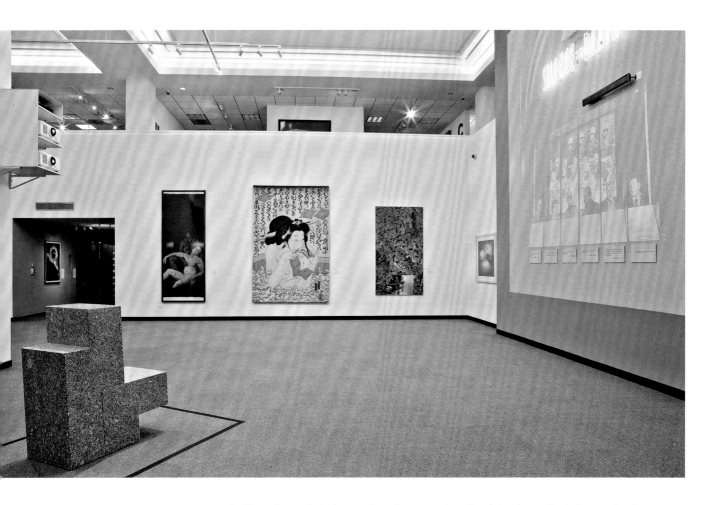

York City subway light box, only a few months after it had acquired the work. The New School's Art Collection contributed Luis Cruz Azaceta's *AIDS, Time, Death* (pl. 42) to replace a work too large to be accommodated in Alphawood's space. And Magnolia Editions, in Oregon, agreed to lend a vibrant, large-scale tapestry version of Masami Teraoka's *Geisha in Ofuro* (pl. 3), an image drawn from the artist's AIDS series, one of the works most photographed by visitors in Chicago. Frank Moore's elegant painting *Patient* (pl. 62) appeared thanks to a private collector and Sperone Westwater Gallery in New York.

David Cannon Dashiell had been represented earlier only by a single drawing; thanks to the generosity of the Berkeley Art Museum and Pacific Film Archive, we were able to add three more drawings from the artist's *Queer Mysteries* (pls. 23–25), a major monument too little known. A second work by Arch Connelly, *The More* (pl. 58), from the collection of Brooke Adams, was a diamond-shaped multimedia work that captured the fabulousness of costume jewelry in a work bursting with the vital energy of what appeared to be arterial flow. Dr. Daniel Berger, already a major lender to the exhibition, allowed us to borrow David Wojnarowicz's fragile untitled work created from a horse skull embellished with maps, a compass, and other materials that demonstrated the artist's power to express his profound anger about the response to HIV/AIDS in a work that exerts an irresistible fascination upon viewers (pl. 57).

The artist and doctor Eric Avery encouraged Alphawood to add his beautiful blood-cell-patterned wallpaper to the installation of his handmade-paper, HIV condom-filled piñatas above the stairs linking the Gallery's two floors (pl. 4), thus

more completely capturing his original concept for the work than had been possible elsewhere on the tour. Fred Eychaner kindly lent his example of Gran Fury's *Kissing Doesn't Kill* (pl. 12), part of the 1989 public transportation campaign that the Chicago Transit Authority quickly withdrew in response to the outrage it had provoked, a clear reminder of the tensions surrounding HIV/AIDS activism in the city at the time.

Karen Finley, whose installation *Written in Sand* (pl. 53) had traveled with the exhibition, agreed to have us add her *Ribbon Gate* (pl. 52). Both works invite participation in acts of memory by having the viewer write in sand or affix a ribbon to a cemetery-like gate in tribute to those lost to the crisis.

We were pleased to have succeeded in persuading Kia LaBeija, whose comments about the exhibition and its relative lack of inclusivity had become part of the story of the protests about *Art AIDS America*, not only to allow us to exhibit the three compelling works from her series *24* that had been included from the start, but also her newer work *Eleven* (pl. 46), which we installed as the final work in the exhibition. LaBeija had created *Eleven* in 2015 for *Art AIDS America*, reflecting on her life as a vibrant, young, gay woman of color, on the one hand, and as someone who has lived with HIV since birth as the result of maternal transmission, on the other. The irresistibly compelling image of the artist, seated in a spangled red prom dress while her blood is drawn by the doctor who has cared for her since she was four years old, and who cared for her beloved late mother in the same office, provided a profound and moving point of punctuation at the end of visitors' experiences of the exhibition.

Addressing the call to include works by Chicago artists in one sense proved relatively easy. Roger Brown, so important a figure in the Chicago art scene of the 1970s and 1980s, had lost his partner George Veronda in the very early days of the crisis. He later became ill himself and, although he never denied it, the HIV/AIDS content in his work has often been overlooked. Thanks to the generosity of the Kavi Gupta Gallery and the Roger Brown Study Collection, we were able to include two of his splendid paintings: *Peach Light* and *Illusion* (pls. 30–31). The former became the iconic image of the exhibition in Chicago. Brown and his HIV/AIDS work is the subject of Kate Pollasch's essay in this volume.

The Art Institute of Chicago also lent Doug Ischar's elegiac, untitled black-and-white photograph taken at the Belmont Rocks in 1985 (pl. 11), a time when it was a favorite gathering spot of the LGBTQ community. And younger artist Oli Rodriguez—the only artist whose work was included both in the Alphawood exhibition and in the companion project *One day this kid will get larger*, curated by Danny Orendorff for the nearby DePaul Art Museum—lent two of his works from *The Papi Project* (pls. 9–10), taken at the same spot nearly three decades later. The location had been transformed in the intervening years, and the site as Rodriguez depicts it in deliberately pale, hazy images is desolate and mournful, having lost the pulse of life it so obviously possessed in the 1980s, when his own late father frequented the area.

The most formidable challenge, the one that had inspired the Tacoma protest, was that of identifying and securing the loan of works by additional artists of color, both those dating from the height of the AIDS crisis as well as more recently, from Chicago and elsewhere. Addressing this proved more difficult than we had expected. Why? Was it simply that few artists of color had addressed HIV/AIDS in

their work despite its prevalence in their communities, perhaps arising from taboos that had even greater power for them than for other artists? (Those taboos still have power; the family of one well-known Chicago artist of color we had hoped to include was unwilling for his work to be exhibited in an exhibition devoted to HIV/AIDS.) Or was it because artists of color had for so long been shortchanged in the mainstream art world, often denied access to the first rank of galleries and museums, thus making their work less familiar and harder to find? Was it our own blindness to the works that did exist; our failure to acknowledge their importance or content? Probably it was a combination of all these factors. Nevertheless, explanations about the paucity of works by artists of color included in *Art AIDS America* were not enough; we had to do better to meet Alphawood Foundation's mission and satisfy the logic of the Foundation's decision to present the exhibition.

Initial research and networking in Chicago provided frustratingly few results. Why did even many of those who could be assumed most likely to do so have so little information on how artists of color in the city had responded to the AIDS crisis, what works they had made, and where these were now?

After weeks of nearly fruitless efforts, and thanks to a suggestion from Julie Rodrigues Widholm, director of the DePaul Art Museum, artist, curator, and educator John Neff joined the team. It is to John that we owe many of the most important discoveries.

As a start, we were fortunate to be able to include many of the works that had joined the exhibition in Kennesaw and the Bronx, among them Willie Cole's witty blackboard wordplay *How Do You Spell America? #2* (pl. 16). Whitfield Lovell's barbed wire-ringed memorial portrait *Wreath* also came to Chicago after appearing first in Kennesaw (pl. 27). William Downs's *I'll Say Goodbye Before We Meet* is an installation for which the artist employed used file folders arranged on the wall as the basis for drawings, poems, aphorisms, and imagery, often presented on the velvety black of chalkboard paint (pl. 28). It was a pleasure to have the artist come to Chicago to install the work himself.

The High Museum of Art in Atlanta permitted us to borrow Ronald Lockett's deeply personal *Facing Extinction* (pl. 15). Fabricated of recycled sheet metal used to clad buildings, the work employs the fate of the American bison as a metaphor, just as had David Wojnarowicz's *Untitled (Buffalo)* (depicted on the cover of Tacoma's exhibition catalogue), a theme made all the more poignant because the artist was a man of color in the South who felt he was not free to be open about his diagnosis. Lockett, who probably did not know Wojnarowicz's work, also perished.

Leslie Guy, then the curator of Chicago's DuSable Museum of African American History, suggested the work of New York–area photographer Gerard Gaskin. Gaskin had spent years documenting the underground House and Ball culture in which so many LGBTQ people of color had walked or danced. That culture had not previously been represented in the exhibition. The artist kindly lent us three of his works (pls. 43–45).

Jonathan Katz led us to Camilo Godoy, the youngest artist in the exhibition, whose HIV-positive and HIV-negative semen-infused soap work *Criminal (Illinois, 720 ILCS–5/125.01)* references the criminalization of sex for those who are HIV positive and, in the Chicago presentation, calls out the relevant Illinois statute (pl. 47).

Longtime Chicago AIDS activists Lori Cannon and Victor Salvo saw to it that one of the city's most potent and recognizable voices at the height of the crisis, Daniel

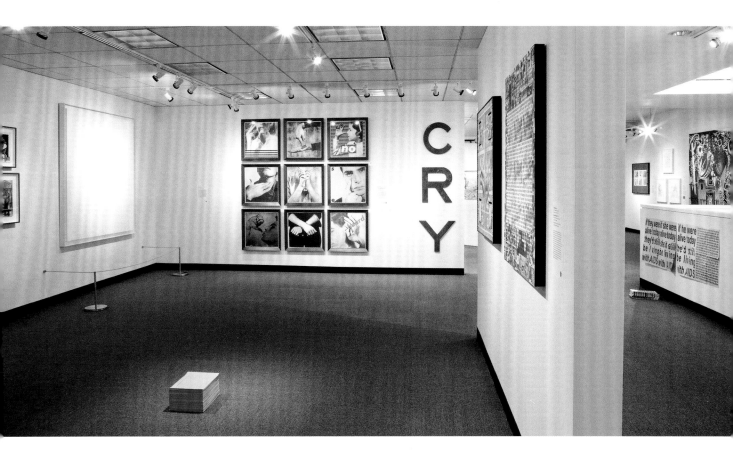

Sotomayor, was represented by three of the searing political cartoons for which he was so well known (pls. 32–34). His inclusion in the Chicago version of *Art AIDS America* came twenty-five years after he succumbed to the disease, yet his memory clearly lives on among his many friends and admirers. (Victor Salvo has contributed an essay on Daniel Sotomayor to this volume.)

Perhaps the most important single work Neff discovered had been hiding in plain sight. Howardena Pindell's *Separate but Equal Genocide: AIDS* (pl. 41), a work comprising two red-bordered, black and white American flag paintings hung side by side, offers a scorching indictment of federal and corporate racism in response to the AIDS crisis but also within a litany of historical episodes in the twentieth century, including the testing of biological warfare agents on people of color who were never informed of the nature of the experiments. No work could have spoken more directly to the circumstances surrounding HIV/AIDS in communities of color. We are very grateful to the Garth Greenan Gallery for its loan.

We were also able to present two of the works of Frederick Weston, who had been making mostly smaller works in New York City for decades. His *Blue Bathroom Series* employs materials from his daily life, including packaging from his medications, in serene, predominantly blue-toned collages that give evidence of the way managing a terrible disease can become routine, even beautiful (pls. 50–51).

Among Chicago artists, we were fortunate to encounter photographer and collector Patric McCoy. Through his generosity, we were able to include a selection of the black-and-white images he had taken in the mid-1980s (pls. 1, 19–22). In that period, he took photographs every day of scenes from a now-vanished life among gay men of color. McCoy also agreed to lend us two works by Michael Qualls, an artist too little recognized before his death from AIDS-related causes (pls. 48–49).

Qualls's works on small wood panels are composed of patterns that evoke blood cells and ultimately his own HIV-positive status. While Qualls did not discuss his situation publicly, one can discern his thinking in a title such as *Secrets, Blood, and Bones*.

Israel Wright, another photographer, also came to our attention, in part because of the work he had done in 1999–2000 for *The Faces of AIDS* campaign commissioned by the city's Department of Public Health. We included several of his portraits of individuals, notable, in part, because some of those who consented to be photographed still did not grant Wright permission to reveal their faces, a reminder of the very real fear of prejudice and threats to their families and careers that continued to exist even among those who were willing to take a stand (pls. 37–40). More of Wright's work and that of other photographers was available through the display of twelve of the original posters for *The Faces of AIDS*, generously lent by the City of Chicago (pl. 36).

Despite these additions, much more needed to be done to address the concerns that had arisen about the exhibition. Neff proposed adding videoworks, and here we were able to include more material by women and/or people of color. Ellen Spiro's well-known *(In) Visible Women* (pl. 13), T. Kim-Trang Tran's *kore* (pl. 14), and excerpts from the Chicago-produced *Kevin's Room*, created by Lora Branch—see her essay in this volume—and produced by Sharon Zurek (pl. 35), all provided powerful artistic experiences. We were also able to include New York– and Chicago–based activist, academic, and artist Gregg Bordowitz's widely known semi-autobiographical film *Fast Trip, Long Drop* (pl. 56); Tom Kalin's *They are lost to vision altogether* (pl. 54); as well as *Fierce Love Video Sequence 2: AIDS Activism and Art from Adversity* by Robert E. Penn, which had been shown in the Zuckerman Museum's presentation (pl. 61). And Katz led us to Lawrence Brose's early video work *An Individual Desires Solution* (pl. 18), a dream-like meditation on his separation from and the eventual death of his ill partner.

Installation view with works by Judy Chicago and Howardena Pindell

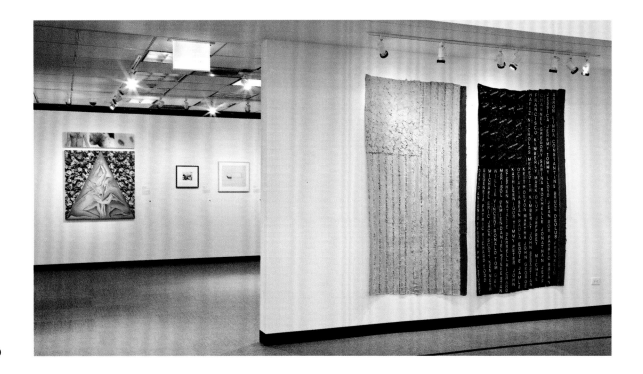

All these additions were profoundly welcome, as they helped round out the story of the role of HIV/AIDS in American art from its origins in 1981 nearly to the present. But Alphawood Foundation also wanted to be sure that this was not viewed merely as a polite aesthetic exercise. We were determined from the first to develop a substantive, wide-ranging, and provocative roster of public programs that would inform and challenge. (The complete list of programs appears in this volume and on the exhibition's archival website, www.artaidsamerica chicago.org.) Topics ranged from HIV/AIDS and race to HIV and aging, and included lectures; panel discussions; films; performances by artists; and readings of plays, music, dance, poetry, and more. Many programs took place at Alphawood Gallery, but others were developed and presented by an array of allied organizations throughout the city. Their participation was essential to ensuring that the project made the greatest impact.

The famed choreographer Bill T. Jones came to speak to a packed house at the DuSable Museum; Silk Road Rising and Victory Gardens Theater staged readings of plays; Karen Finley oversaw an elaborate workshop program, including performances by twenty artists throughout our gallery spaces; Kia LaBeija spoke; and partner organizations offered free daily HIV testing on site. And there were many more. The programming concluded on the exhibition's final night with the presentation of *Salonathon*, a revue of many artists, each making their own contribution. Taken altogether, the programming provided a rambunctious, stimulating, exhausting but exhilarating experience, the impact of which, we hope, long outlives the closing of the exhibition. (See the Programs section for extensive documentation.)

Finally, we were deeply grateful that the DePaul Art Museum undertook an exhibition designed as a companion to our own. *One day this kid will get larger* made an effort to reckon with the work that an inclusive pool of younger artists is producing today in response to HIV/AIDS. Organized by curator Danny Orendorff, DePaul Art Museum's project, presented just a few minutes' walk down the street from Alphawood Gallery, made clear that the scourge of HIV/AIDS is still with us, even if it now can be far better controlled, and that it continues to provoke moving work by a range of artists living with or confronting its effects. (The text of the exhibition guide for *One day this kid will get larger* is included in this volume.)

Our efforts to present the best possible version of *Art AIDS America*, extensive and heartfelt though they were, nevertheless were destined to fall short of presenting a comprehensive and thoroughly inclusive picture of the profound ways in which thirty-five years of the AIDS crisis affected the course of American art. No project can ever exhaust a subject or satisfy every viewer. We accepted that fact at the outset. Nevertheless, we hope that our efforts led to a rich, rewarding, and thought-provoking experience for visitors, and that this catalogue helps to capture some of that experience, both for those who did see the exhibition as well as for those who did not.

We wished also that our project led to greater awareness of the continuing HIV/AIDS crisis, and that our programs offered a call to arms to ensure that no pandemic or other crisis that so deeply calls upon our willingness to act out of a shared sense of our common humanity shall be neglected as HIV/AIDS was so shamefully for so long. That call to action is a challenge to us all.

2
Brian Buczak

Corpse, 1982
Acrylic on canvas in five parts
33 × 165 in.
Gift of Geoffrey Hendricks and
the Brian Buczak Estate to the
Leslie-Lohman Museum of Gay
and Lesbian Art

3
Masami Teraoka

Geisha in Ofuro, 2011
Jacquard tapestry
115 × 78 in.
Courtesy of the artist and
Magnolia Editions

4
Eric Avery

The Stuff of Life, 1993
Three-color linoleum block
print on Okawara paper and
wallpaper reproductions
Original sheet: 72 × 32 in.
Courtesy of the artist

HIV Condom Filled Piñatas, 1993
Molded-paper woodcuts
Each: 8½ in. dia.
Courtesy of the artist

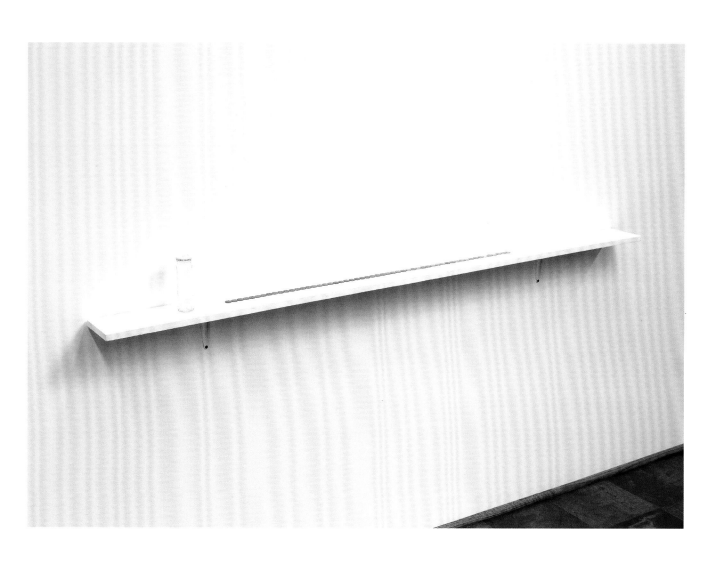

5
Tony Feher

Penny Piece, 1995/2016
Glass jar with lid, U.S. pennies,
and painted wood shelf
6⅜ × 77⅜ × 5⅜ in.
The Art Institute of Chicago,
Modern and Contemporary
Discretionary Fund

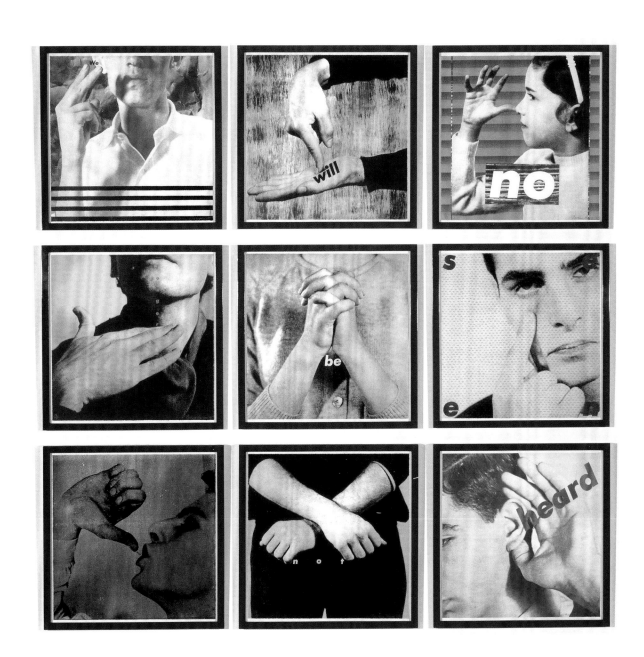

6
Barbara Kruger
*"Untitled" (We will no longer be
seen and not heard)*, 1985
Nine lithographs, eight in color
and one with silver leaf, in artist
frames
Each: 20⅓ × 20⅓ in.
Collection of Jordan D. Schnitzer

7
General Idea

White AIDS #3, 1992
Gesso on canvas
60 × 60 in.
The Art Institute of Chicago, Gift
of Society for Contemporary Art

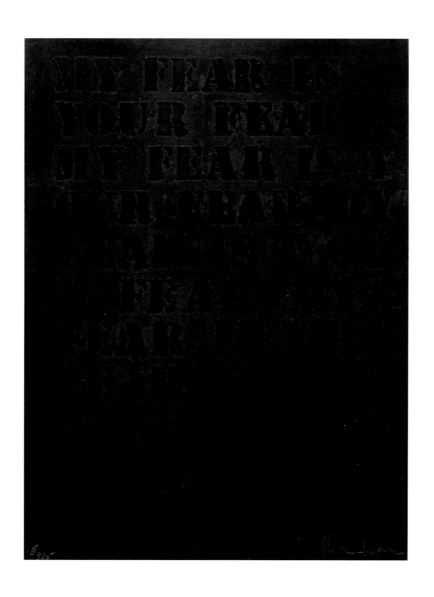

8
Glenn Ligon

My Fear is Your Fear, 1995
Screenprint on black wove
paper
12¼ × 9¼ in.
Collection of Esther McGowan

29

9
Oli Rodriguez
*The Papi Project: Public Cruising
Spot #22, Belmont Harbor,
Chicago, Illinois*, 2012
Digital archival print
18 × 24 in.
Courtesy of the artist

10
Oli Rodriguez
*The Papi Project: Public Cruising
Spot #24, Belmont Harbor,
Chicago, Illinois*, 2012
Digital archival print
18 × 24 in.
Courtesy of the artist

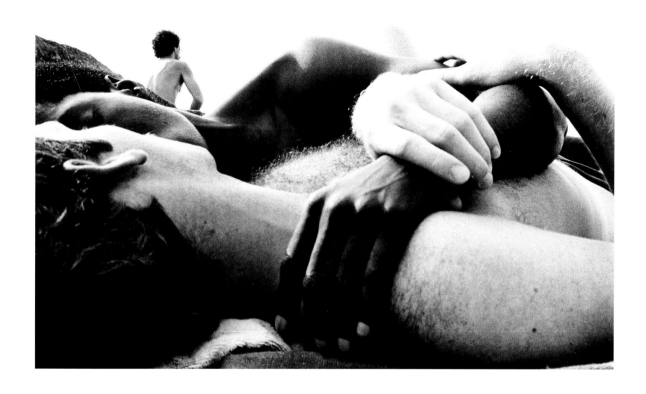

11
Doug Ischar

Untitled, 1985
Gelatin silver print
11½ × 16¾ in.
The Art Institute of Chicago, Gift
of Joyce Neimanas and Robert
Heinecken

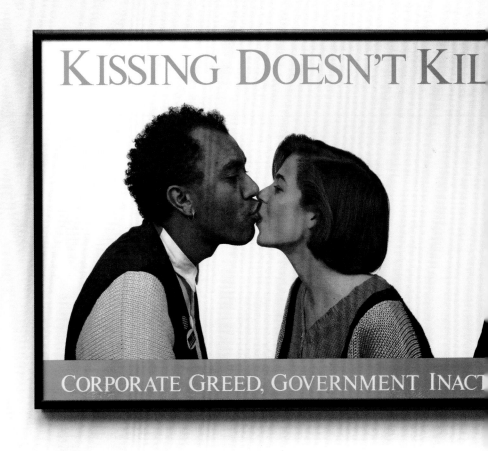

12

ACT UP NY/Gran Fury

Kissing Doesn't Kill, 1989
Four-color lithograph on card-
stock; this example originally
printed for the Chicago Transit
Authority
11½ × 37 in.
Collection of Fred Eychaner

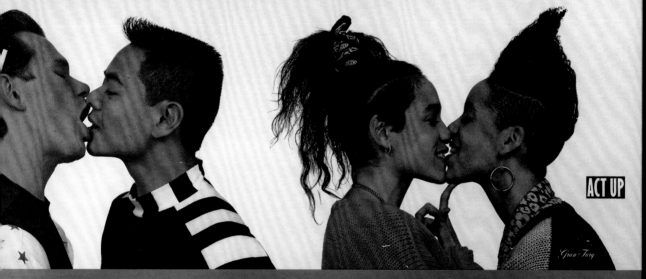

GREED AND INDIFFERENCE DO.

ACT UP

Gran Fury

...ND PUBLIC INDIFFERENCE MAKE AIDS A POLITICAL CRISIS.

13
Ellen Spiro

(In) Visible Women, 1991
Single-channel video
25:10 mins.
Courtesy of the Video Data
Bank at the School of the Art
Institute of Chicago

14
T. Kim-Trang Tran

kore, 1994
Single-channel video
17:00 mins.
Courtesy of the Video Data
Bank at the School of the Art
Institute of Chicago

15
Ronald Lockett

Facing Extinction, 1994
Welder's chalk on metal
mounted on wood
49¾ × 47⅛ × 3½ in.
High Museum of Art, Atlanta;
T. Marshall Hahn Collection,
1996.179

In/Different America and AIDS

JONATHAN DAVID KATZ

Ronald Lockett's masterful *Facing Extinction* (pl. 15), exhibited only in the Chicago iteration of *Art AIDS America*, is in many ways the absolute obverse of the vociferous, collective, highly politicized art that makes up the bulk of this exhibition. An image of a lone buffalo in striated sheet metal struggling to emerge out of the rust-red surface of the work, *Facing Extinction* now poignantly emblematizes a political moment that is so far removed from our contemporary consciousness that it is indeed facing its own extinction. Today, we firmly understand AIDS as a highly politicized disease whose etiology is utterly inseparable from discrimination—in fact, it has become the textbook case of the intersection of pathology and social prejudice. But before this moment, before AIDS was marked as communal, political, and made demographically articulate, it was not only solitary, but painfully isolating and debilitatingly secretive. So virulent was the social and political hostility that many people with AIDS never once disclosed their serostatus, and U.S. newspapers were filled with euphemisms about unmarried young men who died after a short respiratory illness. How many funerals did I go to in which the deceased partner was not only never mentioned, but not allowed to sit up front with the family and consigned to the rear with the public? People with AIDS didn't talk about their disease because it invited intolerance and bigotry, and, in turn, families, churches, and even hospitals refused the word AIDS out of fear, stigma, and/or shame. Throughout the 1980s, in the plague's initial epidemic phase, people with AIDS were thrown out of schools, small towns, even hospitals because of their disease. Dying of AIDS wasn't something to mourn; it was something to hide. Long before a largely queer activist community aggressively fought back against this refusal to name and specify, and in the process, forging a wildly successful collective politics around the disease, AIDS was in the closet as surely as homosexuality had been several generations before.

Lockett was a young, prodigiously talented African American artist in Bessemer, Alabama—a town named for the Bessemer furnace used in steel production. As a physically slight, artistically inclined man from a blue-collar, rust-belt community, Lockett kept his illness to himself and only said he had a cold or the flu until his first, and fatal, bout with pneumonia in 1998. Poor, not formally educated as an artist, albeit utterly convinced of his gifts, Lockett and his work are only now emerging into the public eye decades after his death. In fact, he was not in the earlier

iterations of *Art AIDS America* simply because Rock Hushka, my co-curator, and I, had never heard of him and only discovered the work—along with most of the art world—following his magisterial 2016–17 exhibition at several venues, including the American Folk Art Museum in New York and Atlanta's High Museum of Art. Now recognized as a major figure, Lockett, in life, wasn't shown or known except locally, toiling in obscurity, a fate familiar to many artists living outside the coasts, but one of special valence to poor, Black, rural talent with little access to the mechanisms of elevation in the art world.

Lockett's work is striking in part because it underscores the enormous gulf between an urban, professional, largely middle- and upper-class, majority-white AIDS activist culture and the very different trials of living with AIDS in the rural South. Though made at the height of ACT UP's public and political visibility in the 1990s, Lockett's art instead emblematizes the lonely, isolated AIDS politics of the early 1980s, before the rise of any activist movements. Clearly, for a marginal Black artist in rural Alabama, AIDS still entailed a haunting loneliness, of feeling disempowered, even hunted, despite the widespread social and political visibility of AIDS activism in urban population centers at the time. And, in the face of sky-high infection rates within the African American community, a largely urban AIDS activist movement not surprisingly framed and articulated AIDS according to the social and political context they knew. As a largely white movement comprising many individuals, a significant percentage of whom fled intolerant family, neighborhood, and/or religious contexts and moved to large cities to be free, leaving home and challenging the status quo was par for the course. But these same coordinates—family, neighborhood, and church—can possess a strikingly different quality for racial minorities, in that they also serve to mitigate the experience of subjugation within dominant white culture. However oppressive this home context can be—and it was often quite conservative in its social values—it remains a place apart from America's endemic racism. Minority populations with AIDS are thus faced with a painful choice: either leave home and cast your lot with an AIDS politics that can be exclusionary and alienating, if not actively racist, or stay home and experience exclusion and alienation because of the disease.

Lockett's solitary buffalo is an apt symbol of silent suffering, one that was likely developed separately from the use of the buffalo in, say, David Wojnarowicz's *Untitled (Buffalo)*, 1988–89 (see image, opposite). For both artists, the buffalo symbolized that widespread blood lust, actively slaughtering the innocent unto extinction simply because they were different from the mainstream. But while Wojnarowicz photographed a natural-history diorama to lend his image the clarity and focus required of a work of clear political intent, designed to be legible and evocative to a wide audience, Lockett's buffalo seems a much more personal and idiosyncratic thing, camouflaged, hard to spot, far less public and collective. In its hushed and unobtrusive tones, quietly resonant of autobiography, *Facing Extinction* speaks to the once habitual social isolation of AIDS, one in which the symptoms of the disease were often secondary to its everyday affect.

While there is an undeniable joy in the commanding activist voice of so many of the works in *Art AIDS America*, and power in the way they collectively refute the established culture of isolation and quarantine characteristic of the plague's initial spread, this subsequent collective, activist voice risks obscuring something eloquent about Lockett's work. At the height of AIDS activism, he constitutes a direct

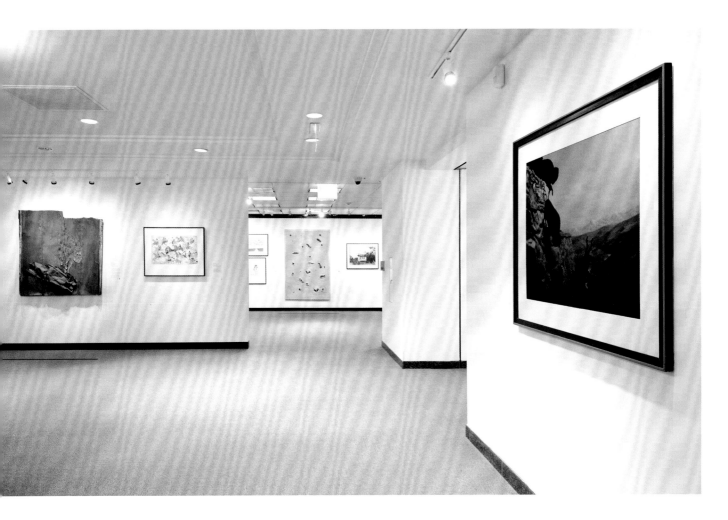

link to the enforced loneliness, segregation, and sequestration of people with AIDS early in the plague. And in our headlong, ultimately successful rush to take back power and win a seat at the table, we risk ignoring—or worse, forgetting—this other reality. To do so lets our foes triumph, for their great insight was to self-consciously isolate people with AIDS from the rest of American culture, to demarcate a "them" that was not "us," in large measure by appealing to the most reactionary fears about contagion. In so doing, they were able to accomplish two important things. First, this policed segregation of people with AIDS, or even those seen as at risk of developing it, mitigated against the development of a collective AIDS consciousness, of understanding that what felt like an individual, private, and even shameful agony was, in fact, both communal and deeply politicized—thus blocking the formation of the very activist collectivity that subsequently ended this paralyzing reign of silence. After all, if AIDS was solely understood as a product of one's individual pathology, not only would there be no grounds for collective action, there would also be a real incentive to stay silent and in the shadows. Second, it sought to make people with AIDS visible and knowable, to make them marked, responsible for, and complicit in their own demise. Psychologically, this allowed the majority to successfully segregate AIDS from the very idea of community, catalyzing the "essential" difference of people with AIDS so that the majority of Americans would feel less vulnerable, less threatened by what was, after all, still a communicable, lethal plague. Not surprisingly, these new forms of discrimination followed the old lines of prejudice already so well etched in the American psyche. America made

Installation view with works by Ronald Lockett, Thomas Haukaas, Izhar Patkin, and David Wojnarowicz

AIDS their disease, not ours, as a balm to its own fears, whatever the consequences to those who actually suffered its effects.

I happen to know what I'm talking about regarding this early phase of the epidemic at first hand. I was forged in the crucible of Chicago queer politics in the early 1980s, when the casual cruelty of the city's then unapologetically racist and homophobic political machine was bolstered by the election of Ronald Reagan, an ascendant Christian Right, and the emerging horror of this fatal plague. As an activist trying to win municipal protections for queers in employment, public accommodation, and housing (centrally involved in founding the Gay and Lesbian Town Meeting, which won this fight only well over a decade hence), it was a bleak, enervating time. Once, a group of us gathered in Chicago's City Council chambers in support of hearings on our bill as one alderman proclaimed, "Since homosexual sex involves copious amounts of excrement that fouls carpet and draperies," gay-rights protections were unfair to landlords. That was the general level of political discourse in the halls of power in Chicago at the time.

In 1983, my doctor noticed a little spot on my leg during a checkup and had it biopsied. It turned out to be Kaposi sarcoma (KS), and in this period before the advent of HIV tests, having a KS lesion by definition meant you had full-blown AIDS. The specialist he referred me to, visibly angry at his new-found impotence in treating his patients, explained to me on my visit how I was going to die ("3–5 gallons of diarrhea a day at the end" still sticks in my memory), how long I likely had, and then interrupted his cascade of horror by telling me he had to go back to another patient, an infant girl born with AIDS, who was dying in the next room. So when my ex, Irwin Keller, and I opened a guerrilla clinic for experimental HIV meds in our flat, mailing out untested drugs to desperate people at no cost, we were no more surprised that the police closed us down than we were that everyone we had tried to help died. Death was omnipresent, palpable, and I felt less like a young man at the beginning of life than a very old man at the end, my mood swinging wildly between a sense of being actively hunted and the even greater horror that they didn't even need to hunt us to ensure our extinction.

My hopelessness seemed mirrored in too much of the fabric of the city itself, as if what ailed me could also attack lots, even whole city blocks, at least in the poorer, largely nonwhite neighborhoods of the city. Violence was a fact of life in these neighborhoods, and as a newly arrived graduate student on my first night in Hyde Park—then a marginal community, albeit that rare integrated one—a fellow student passed me by conspicuously flipping open and shut a small switchblade to let me know he was armed. With AIDS felling my friends, legal protections still years in the future, street violence endemic, and the machine firmly in control of a hostile political establishment, it felt truly hopeless. And then the miracle happened: Harold Washington won election as mayor, vowing to break the machine and restore control to the city's diverse citizenry. Many of us campaigned for him, and I remember one meeting with him at his Hyde Park flat in which, to my utter amazement, he began to talk about how to secure queer civil rights.

His death in his second term felt like an assassination, and like a lot of activists in the city, I instinctively gravitated to City Hall when he died. Harold was a believer in nonviolence, but we all knew that the City Council would try to behead his insurgent anti-machine movement and appoint a stooge. The crowd was restive and, thinking we could head off any attempt to either destroy or co-opt his

legacy, I bent down and grabbed a brick from yet another building being taken down, and urged that we riot—that we let them know upstairs in the chambers that there would be no peace if they didn't honor his legacy. But after some argument, cooler heads prevailed, citing Harold's own peaceable views, and I put down my brick. Later that evening, a largely white City Council did, in fact, appoint a stooge, Eugene Sawyer, an African American alderman allied with the machine, as mayor, and when he was being interviewed about accepting the nomination, he said he decided to accept when he looked out the window and saw a crowd that had seemed on the verge of rioting put down their bricks and disperse. Then, he said, he knew it was safe to accept the nomination. And I learned not to be afraid of rioting.

Fast forward to 1989, and a few weeks after my arrival in San Francisco, while taking part in an ACT UP protest, I was arrested and hustled off to jail. It turned out I was one of the lucky ones, because this time it was the cops who rioted, forming a phalanx with their shields aloft and mowing everyone down on Castro Street, even elderly bystanders, then beating and arresting them. So many people were hospitalized that night that, paradoxically, it was safer to be in jail. It came to be known as the Castro Sweep, and the cops saw it as payback for their humiliation during the White Night Riots, when queers, incensed that Dan White, the admitted murderer of Harvey Milk and San Francisco Mayor George Moscone, got off scot-free. Police cars were burned during the White Night Riots and so the cops were itching to teach the queers a lesson about who was in charge. In jail that night, I joined in the planning of our response, a protest march around the Castro, reclaiming the neighborhood from the cops. Still really a Chicagoan, and as yet unused to the ways of San Francisco, I argued that we should schedule the protest in about a week or two, so we could advertise and organize it. The veteran San Franciscans laughed after I spoke, and said no advertising was necessary, that everyone would know what had happened. And sure enough, the following night, we marched around the Castro forty- to fifty-thousand strong while the cops, who showed up to bust heads, realized the scale of the protest and beat a hasty retreat. As if in coda to my newfound San Francisco liberation, by year's end the availability of a new, super-reliable HIV test that measured the virus's DNA determined that I didn't in fact have HIV, and that KS, though commonly associated with AIDS in young men, was, in fact, caused by a different virus. I had walked to the edge of the pit and was one of the very lucky few who was able to walk back.

It should come as no surprise, then, that I took all my emotions around AIDS, stuffed them in a shoebox in the back of the closet, and tried to get on with my life. But I had to acknowledge that I had been formed, and deformed, by HIV, and when Rock Hushka gave me the opportunity to work on *Art AIDS America*, I jumped at the chance. In the final analysis, I was lucky for a gay man of my generation, having lost only one former partner to the plague and having survived it myself. But, like so many queer and AIDS activists, I privileged, even in the essay that I wrote in the initial version of this catalogue, a strong, proud, united resistance forged in the fires of ACT UP, satisfying my desire to strike back at the evils we had so long endured. And in so doing, I forgot my early Chicago years, and their other narrative, the one where I debated for weeks before publicly announcing my HIV; the one where, afterward, other people conspiratorially called or came up to me and announced that they, too, had AIDS, but admitted that they had never said it aloud to someone

else before; the paralyzing fear that I had infected, had killed, those I loved; and the terrible shame when men with whom I had been intimate confronted me and accused me of killing them. It was such a painful period in my life that I've tried to forget it out of the accumulated trauma, my survivor's guilt, and the searing memory of such everyday events as being asked by the professor in one of my graduate classes not to attend the Christmas party at his house "because, you know, of my children."

It's awkward to talk about AIDS and shame, but that's clearly what I'm talking about. Since AIDS has been characterized, and even enabled by so many erasures and omissions, it is imperative not to lose sight of this profound sense of shame, isolation, and alienation that I felt before an activist movement took hold, and that others doubtless feel even unto the present day. AIDS not only pitted us against an uncaring world, it pitted us against each other, and deep wells of suspicion, fear, and dread animated our relationships to one another under its influence. No wonder we now hold fast to a narrative of communal activism, of a collective triumph over adversity, one that celebrates our many, very real political and procedural victories. But this triumphalism cannot be allowed to obscure the social shame and isolation that once and, sadly, in so many places, continues to amplify so much suffering and cause so many to avert their eyes from people with the disease.

+ + +

When the invitation finally came to close the national tour of *Art AIDS America* with an exhibition in Chicago, we were overjoyed. Chicago had long been one of the central cities we had hoped would host the show, along with a California venue. Little did I realize how toxic an AIDS show would prove to be even in today's museum world, and sadly, no institution in Chicago was willing or able to take it on until our rescue by Alphawood Foundation, which committed itself to the extraordinary step of essentially building a museum from scratch to the most exacting standards to host the exhibition. The development of what came to be known as Alphawood Gallery was an eventuality beyond my wildest dreams. Not least, the prospect of a final showing in Chicago also allowed us the opportunity to respond curatorially to some pointed criticisms of the exhibition's racial politics. On December 17, during *Art AIDS America*'s run at the Tacoma Art Museum, a group known as the Tacoma Action Collective staged a die-in to protest what they charged was the erasure of Black people from the exhibition.

As the protest and ensuing controversy spread, I experienced a maelstrom of conflicting emotions: surprise that what I thought of as an unusually diverse exhibition (more than one-third of the artists were not white men, despite the heavily male demographic of the disease); trepidation that in our years of careful research we had, in fact, somehow missed something of import by Black artists that we should have included; annoyance at the accusation that we were ignorant of, deliberately ignored, or worse, actively erased, works by Black artists; happiness that the issue of racial equity was finally front and center in the museum world; anger that we were being painted as racist when a show that was in fact already progressive and diverse was targeted for critique while hordes of mainstream museum exhibitions that had never included *any* African American or for that matter female artists passed by without a word of protest. But we had, of course, deliberately waded into these waters with an exhibition that explicitly and implicitly took the museum

world to task for its shameful inattention to the greatest art world cataclysm of our time. No surprise that then we ended up dealing with a left-wing blowback, now doing the condemnatory work previously expected of the right.

Of course, the issue of African American representation and, indeed, other forms of wide diversity in representation had long preoccupied us as curators. Inevitably, in doing an exhibition, you don't get all the works you hope to exhibit, and that was certainly the case with *Art AIDS America*. But at the same time, our research and the research of some of our partners in mounting the exhibition yielded relatively few additional artists we could have shown. This is not to deny that we missed some significant works, Howardena Pindell's early *Separate but Equal Genocide: AIDS* (pl. 41), William Downs's great *I'll Say Goodbye Before We Meet* (pl. 28), and Ronald Lockett's work chief among them. In other instances, we added work in other iterations of the exhibition, such as Willie Cole's powerful *How Do You Spell America? #2* (pl. 16), which we only discovered late in the curatorial process. For the Chicago installation, we also relaxed our initial determination that all works exhibited had to be directly about AIDS and in the interest of greater representation included work that dealt with HIV by implication or at one remove. Some of the critiques we faced were blatantly false, such as that we censored Jean-Michel Basquiat from the exhibition, when, in fact, the converse was true; we worked very hard, albeit unsuccessfully, to secure one of his AIDS-informed works.

But, at core, the critique of the exhibition turned on numbers. Depending on who was doing the counting and which exhibition was being referenced, there

Installation view with works by Nayland Blake, Felix Gonzalez-Torres, and Ronald Lockett

were only between five and eleven African American artists among more than one hundred works—a number quite substantially bolstered in the Chicago exhibition, which added fifty-seven works, about half by artists of color. As I sat with these discomfiting statistics, it occurred to me that more often than not, art by Black artists fell outside the activist-inflected, communal political narrative of the exhibition's mainstream. Like Lockett's *Facing Extinction*, much of the work by Black artists, even those working today, was instead deeply personal, articulating an inward, more privatized vision of AIDS than one that resonated with the collective politics of AIDS protest. Let me hasten to add that this is by no means universally true, and such masterworks as Marlon T. Riggs's *Tongues Untied* (pl. 17), on the checklist from the inception of the exhibition, or Pindell's *Separate but Equal Genocide: AIDS*, instead participated, like so many of the works in the show, in a forthright politics of activist engagement.

Yet I was struck by how often works by Black artists did turn on the privatized and personal—Kia LaBeija's self-portrait series *24*, say, or Derek Jackson's *Perfect Kiss*—in ways that were actually akin to the work of an earlier era of AIDS politics. They seemed closer in spirit to such works as Lawrence Brose's profoundly autobiographical 1986 film *An Individual Desires Solution* (pl. 18), which is the earliest AIDS film I've encountered, than to most of the art of their own time. In the face of a surging AIDS activism that has transformed people with AIDS into a newly cohesive community and constituency, the fact was that much Black art seemed to fall to one side of this new ethic of collectivity. It seemed more attuned to articulating a self-presence than a communal one. And that reminded me of a dressing down I got as a young activist decades earlier, while trying to mobilize the membership of an African American private gay men's social club on the South Side in favor of the Chicago anti-discrimination ordinance we were then proposing. After I explained my purpose in contacting the club's president, he paused and then asked me why I was only now contacting him, and where were the white gays on issues of poverty, unemployment, substance abuse, racial discrimination, and other core problems

Installation view with works by Dean Sameshima, Adam Rolston, Gerard Gaskin, Kalup Linzy, and Michael Ehle

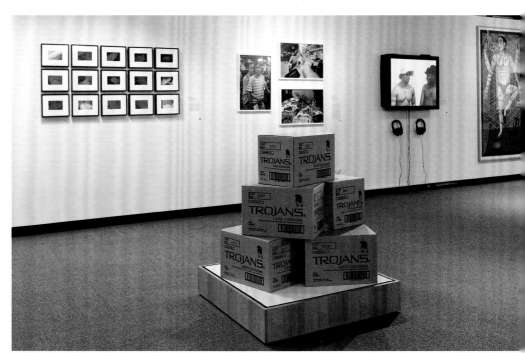

facing his community? And now, he continued, you want me to help you on a gay issue? Gay issues, he said, were way down on his list, and he didn't have the luxury of worrying about gay issues.

I was appropriately chastened. As a young, privileged, and relatively ignorant white gay man in graduate school, this was the first time I came to understand how gayness could function to exclude as well as include. Against the comfortable politics of intersectional identity that we were only then discovering, his challenge was profoundly unsettling in seeming to reinscribe racial difference, and racial discrimination, within a queer community that understood itself as open and inclusive. My point is that in trying to frame the debate around numerical representation, we risk missing its defining emotional tenor—that demographics, even intersectional demographics, can't capture the nuances of presence and absence, of membership and omission, that I think drive much of the debate and its corollary anger. As the national discourse around AIDS has shifted to questions of treatment and pre-exposure prophylactic drug regimens, this sense of exclusion has only been exacerbated, such that blackness is made relevant more as a marketing demographic than as a complex overarching social category. This means that talking about AIDS doesn't necessarily entail talking about AIDS in the Black community, as Black AIDS can (but need not) operate in and through a very specific raced context.

Inattention to how a generalized AIDS activist discourse whitewashes extremely different racial experiences of the plague, even in the context of what we think of as progressive activism, may thus account for why so much Black art still so often refuses the language of the collective in favor of testifying to self-presence. The desire to insert oneself into AIDS representation can be at core a desire to see AIDS discourse turned away from its homogenizing whiteness, a whiteness that whites often do not see. To refuse the language of commonality is thus a politically informed critique of the limits of that ideal of community, exclusions it is perhaps not even aware it is making. This, then, is the larger exclusion that perhaps animated the protests, one that objected to the number of Black artists we included in *Art AIDS America* to be sure, but that beneath that, recognized that my AIDS discourse was not yours, that even activism can itself telegraph forms of inclusion and exclusion, highlighting, say, the very real needs of a coastal, educated, and relatively affluent, largely white population emerging out of shame and into anger, to the exclusion of a poor Black community in a very different social context in Bessemer, Alabama.

As AIDS activism ever more directly usurped a language of authoritative presence, of universal representation and inclusion, perhaps it came to sound ever more false to some ears. How then to balance the language of activism, of asserting voice and power, with its necessary, inevitable twin, a language of loss, of fear, and of hopelessness? Once, not so long ago, we only knew the language of loss. Have we repressed that knowledge in a perfectly understandable act of overcompensation? The work of Black artist Willie Cole suggests a way to combine activism and loss, power, and fear. In his *How Do You Spell America? #2*, Cole deploys a familiar, old-school blackboard support with the word "America" at the top. Below each letter in America are a series of words that start with the letter in question, such that under the "A" we get AGING, AIDS, ADMIT, ALLOW, ALLIED, then the word AMERICAN crossed out and AFRICAN sketched in, followed by another crossed out AMERICAN, then the word ANXIOUS, and so on. These vertical poems can also be read

horizontally, however, from left to right like a typical English sentence. And those first horizontal sentences read, "AGING MOM EATS RIBS IN CITY APARTMENT" and AIDS MAN (with MOM crossed out) EXPRESSES RAGE (the word RELUC-TANCE crossed out) IN(VOLVING) COITUS ACTIVITIES. A little further down, we can read "ANOTHER MUTATED EPIDEMIC REPORTED(LY) INVADED CEN-TRAL AFRICA," while the crossed-out words in the sentence produce "ANOTHER MEASLES EPIDEMIC REPORTEDLY INFECTED CONTINENTAL AMERICA."

Cole thus conducts a fugue of competing voices and perspectives born of our differences, a work of art that stages our very contemporary divide between Black and white, between those for whom AIDS is central and that other America that barely knows it exists, between those who emphasize Africa and those for whom America is all that matters. Like Cole's art, America is polyphonic, signifiers crossing and recrossing until coherence is obliterated and all we can hear are the competing voices—one as concerned with mutated viruses in Africa, as the other is obsessed with measles in America. In short, there is no one single way to spell America, no authoritative version on offer. There are only competing accounts, each presuming that their version is the correct one. Their differences may be ultimately traceable to differences in race, class, sexuality, and/or gender, and so on, but that doesn't lend any particular account greater universal validity or authority. On the contrary, it is only in their clash, in the fugue, that America is finally realized. As a one-time professional protester, this is what I learned from this protest: that to define *my* America as *the* America was the least American thing I could possibly do.

Postscript

In her eloquent essay in this volume, Tempestt Hazel writes that *Art AIDS America* "was a monumental memorial to AIDS in America and was celebrated as such but felt a bit like an alternate universe where Black people, Brown people, and women either didn't exist or weren't substantially impacted and didn't respond or react through visual language." Her observations have been a repeated critique of the exhibition across all its venues, and as one of the co-curators, I would like to respond.

When we began *Art AIDS America,* it was never intended to be "a monumental memorial to AIDS in America." On the contrary, its brief was far more specific: to address why so much art about AIDS didn't seem to look like or suggest AIDS in any but the most encoded and indirect ways. This led us to consider how the art world responded to AIDS in the period before effective treatments emerged (the so-called beleaguered period of AIDS art), and the show was initially conceived to specifically address AIDS representations within the art world—ranging from direct political statement to the most indirect, well-camouflaged suggestion. Since direct political activism tended to marginalize an artist within the AIDS/homopho-bic confines of the art world, most artists not surprisingly chose to camouflage their AIDS references, and it was towards surfacing this buried content that this exhibition came to life.

But as we worked on the exhibition, the relative paucity of works by African American artists in the period in question became a mounting concern, and we

eventually made the decision to open the exhibition beyond the beleaguered years of the 1980s and 1990s. To our relief, we found vastly more works by a diverse population of artists in expanding the exhibition's temporal parameters, but at the same time we also changed fundamentally the exhibition's thematic focus, enabling the now widespread misperception that the exhibition was intended as a memorial to those who struggled, fought, and died on the front lines of the battle against AIDS. As an exhibition with more than one-third nonwhite, nonmale representation, *Art AIDS America* is one of the most diverse touring exhibitions in recent memory. But that recognition was lost.

In mounting the Chicago exhibition, we worked alongside John Neff and Director of Exhibitions Anthony Hirschel to uncover every possible work by African American artists we may have missed. We circulated requests for suggestions quite widely, polled experts in AIDS and African American art, and the results, in the beleaguered period, were few. John's careful sleuthing led us to Howardena Pindell's *Separate but Equal Genocide: AIDS*, and I was lucky to discover the work of Ronald Lockett, work that had only recently emerged from obscurity following a masterful exhibition that traveled to several museums. The earlier incarnation of the exhibition at the Bronx Museum of the Arts led to the inclusion of such works as Willie Cole's masterful *How Do You Spell America? #2*, and the curatorial team at the Zuckerman Museum, part of Atlanta's Kennesaw State University, added such works as William Downs's superb *I'll Say Goodbye Before We Meet*. In short, a communal effort was needed, operating out of different parts of the country, to rectify the historical erasures of African American artists from the art-historical record.

To argue, as some voices do even in this catalogue, that we as curators were unaware of the need to diversify artistic responses to AIDS when mounting this exhibition is simply not the case. As I hope this account underscores, the question of who spoke of AIDS and from what subject position was a central concern from the get-go. Even after a national campaign to find examples of artists we admittedly didn't find, the results were still so painfully few that in the case of the Chicago exhibition, we bent the original rule of inclusion that all works of art had to be, to one extent or another, directly about AIDS. Instead, we elected to include works redolent of Black queer life before The Plague hit.

An exhibition such as *Art AIDS America* in 2017 confronted wholly different social and cultural realities than it would have decades before. The current critique over the exhibition's diversity would have been hard to imagine in an era in which the mere prospect of an AIDS exhibition would have been met with unrelenting hostility from every branch of government. In that sense, and in many others, this critique is all to the good. But historical exhibitions necessarily take on the very exclusions they seek to explode. In seeking to analyze the most beleaguered period for art about AIDS, we replicated that era's paucity of diverse voices. Percentage counts of racial diversity in the exhibition thus cannot get hold of this historical absence, an absence that is as eloquent about the period as anything we placed on the walls. We could have made more of this historical absence, and in retrospect we should have. But in the face of all the critiques launched against *Art AIDS America*, I do not want this historical absence and erasure to get lost. The art world is still so far from representative, and while I wish more anger was directed at other exhibitions' continuing exclusions, that this critique was voiced is a move in the right direction.

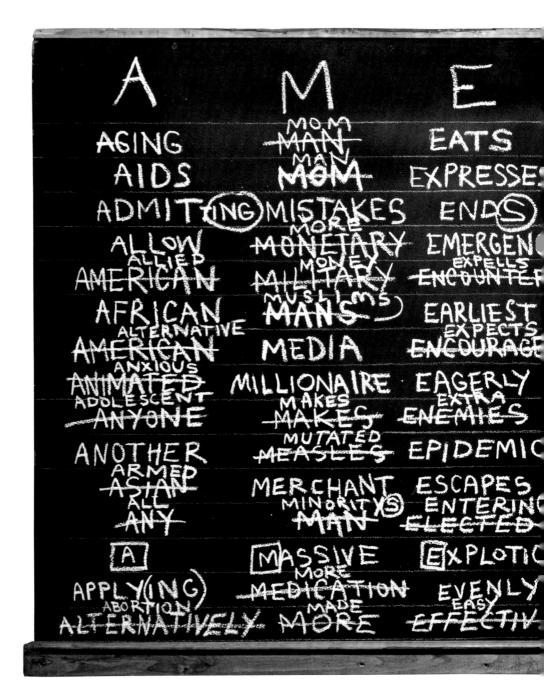

16
Willie Cole

How Do You Spell America? #2,
1993
Oil stick, chalk, and latex on
Masonite and wood
49¼ × 96½ × 4½ in.
The Bronx Museum of the Arts,
Gift of Jennifer McSweeney

R I C A

R	I	C	A
RIBS			APARTMENT
~~RAT~~	IN	CITY	~~AGAIN~~
RAGE			
~~LUCTANCE~~	IN(VOLVING)	COITUS	ACTIVITIES
REGRET	INSTILL(S)	CONFIDENCE	AGAIN
RATIONS		CONTAMINATED	
~~RELIEF~~	INSIDE	~~CITY~~	AREAS
ESISTANCE	IN(SIDE)	CENTRAL	ASIA AMERICA
RECALL		~~CLAN~~	
~~COLLECTIONS~~	INCLUDE	CANINE	ASSAULTS ATTACKS
EPUBLICANS	IN(FLICT)	~~CHARGE~~	AFTERWARDS
REVEALS		~~CONTROL~~	~~AGAIN~~
~~REVEALES~~ REVENUE	INDEPENDENT	CAMPAIGN	AGENDA
NNING	INSIDE	COCAINE	ARMY
	~~ILLEGAL~~	~~CONTRABAND~~	~~ABROAD~~
	INVADED	CENTRAL	AFRICA
EPORTED(LY)	~~INFECTED~~	~~CONTINENTAL~~	~~AMERICA~~
ROBBERY		CRYING	AMERICA
~~IOT~~	INCIDENT	~~CURSING~~	~~ALOUD~~
	IMMEDIATE	CREDIT	ACCOUNT
ECIEVE(S)	~~INSTANT~~	~~CASH~~	~~ADVANCE~~
[R]IPPED	[I]NVESTMENT	[C]OMPLEX	[A]PART
REMOVES	INGROWN	CORNS	AWAY
~~OTATING~~	~~IN~~	~~CIRCULAR~~	~~ACTION~~
RU486	IS	CHANGING	AMERICA

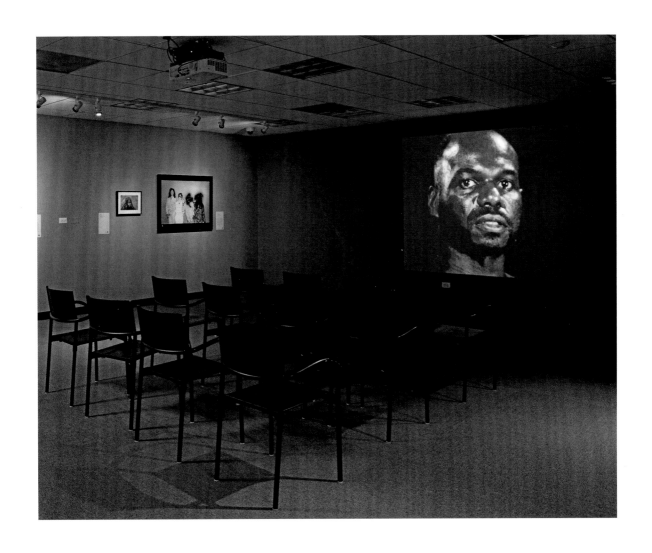

17
Marlon T. Riggs

Tongues Untied, 1989
Video
55:00 mins.
Courtesy of Frameline

I'm gonna, well I'm calling my mum
early this morning to see–ah–to
see–um–have her call this place called
the Bristol Cancer Clinic in–ah–the
west coast of England (cough) and see
how much the treatment over there
would cost. If the treatment doesn't
work out in Mexico, or over there,
I'll probably have to go back to
England in the end.

18
Lawrence Brose

An Individual Desires Solution,
1986
Super-8mm transferred to
digital video
16:00 mins.
Courtesy of the artist

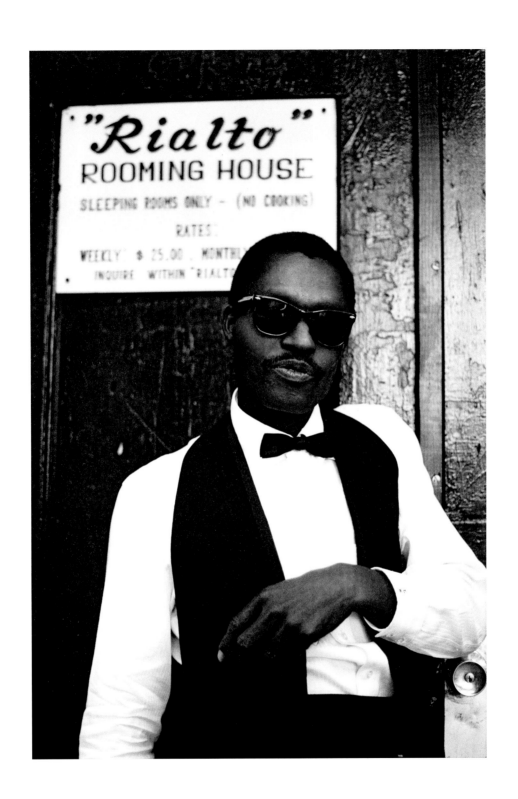

19
Patric McCoy

Loyal Concierge, 1983–85/2016
Digital print from original
negative
12 × 9 in.
Courtesy of the artist

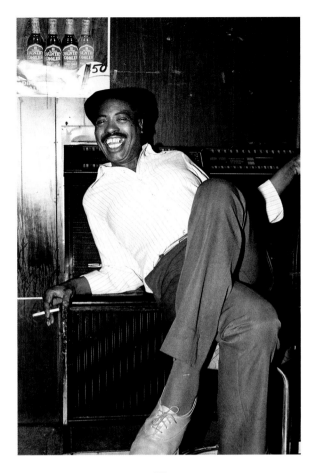

20
Patric McCoy

Youngblood, 1983–85/2016
Digital print from original
negative
12 × 9 in.
Courtesy of the artist

21
Patric McCoy

Sunglass 1, 1983–85/2016
Digital print from original
negative
12 × 9 in.
Courtesy of the artist

22
Patric McCoy

Afghan Zo, 1983–85/2016
Digital print from original
negative
9 × 12 in.
Courtesy of the artist

EYES FRONT

23
David Cannon Dashiell

Study for Queer Mysteries, 1992
Graphite on vellum
17 × 14 in.
University of California, Berkeley
Art Museum and Pacific Film
Archive. Museum purchase:
Bequest of Phoebe Apperson
Hearst, by exchange, 2013.73.1

24
David Cannon Dashiell
Study for Queer Mysteries, 1992
Graphite on vellum
17 × 14 in.
University of California, Berkeley
Art Museum and Pacific Film
Archive. Museum purchase:
Bequest of Phoebe Apperson
Hearst, by exchange, 2013.73.2

25
David Cannon Dashiell
Study for Queer Mysteries, 1992
Graphite on vellum
17 × 14 in.
University of California, Berkeley
Art Museum and Pacific Film
Archive. Museum purchase:
Bequest of Phoebe Apperson
Hearst, by exchange, 2013.73.3

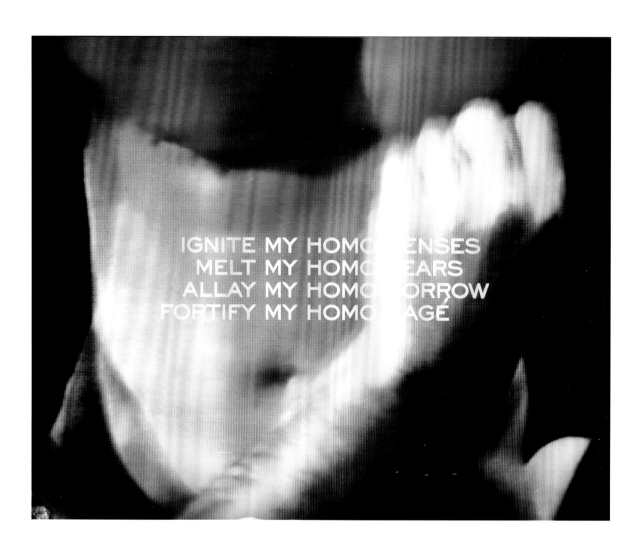

26
Donald Moffett

Homo Senses, 1989
Cibachrome transparency
mounted in lightbox
46 × 57 × 7 in.
Collection of the Leslie-Lohman
Museum of Gay and Lesbian Art,
Founder's Gift

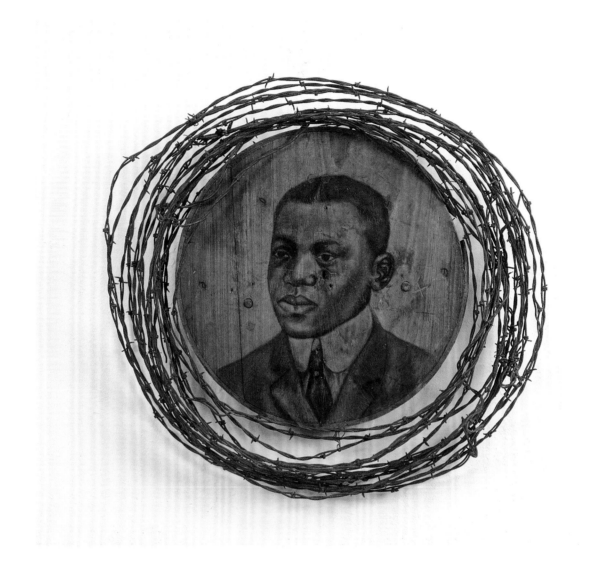

27
Whitfield Lovell

Wreath, 2000
Charcoal, wood, and barbed
wire
23 × 23 × 6½ in.
The Bronx Museum of the Arts,
Museum purchase

28
William Downs
I'll Say Goodbye Before We Meet,
2013–16
Mixed media and ink wash on
found folders
Dimensions variable
Courtesy of the artist and
Sandler Hudson Gallery

59

Black Alder
Black a moor
Black and blue
Black and tan
Black and tan coon hound
Black and white
Black Angus
Black Art
Black ball
Black bass
Black bear
Black belt
Black berry
Black bile
Black bird
Black board
Black body
Black book
Black box
Black bread
Black buck
Black burn
Black Canyon
Black cap
Black caribs
Black cherry
Black cock

Black crappie
Black Currant
Black damp
Black Death
Black Diamond
Blacken
Black Eyed
Blackett
Black eye
Black Eyed pea
Black Eyed Susan
Black Face
Black Fish
Black Fly
Black foot
Black Footed Ferret
Black Forest
Black gold
Black grouse
Black guard
Black gum
Black hand
Black haw
Black hawk
Black head
Black heart

Black hearted
Black Hills
Black hole
Black hole of Cal...
Blacking
Black jack
Black leg
Black Letter
Black light
Black light trap
Black list
Black Locus
Black Lung
Black ly
Black magic
Black mail
Black Maria
Black mark
Black Market
Black Mass
Black Mold
Black money
Black Mountains
Black Munn
Black Muslim
Black Nationalism
Black ness
Black Night shade
Black oak
Black out

Black P...
Black Panther
Black pepper
Black ...wabler
Black Pool
Black power
Black Prince
Black pudding
Black racer
Black raspberry
Black Rod
Black rot
Black sea
Black sheep
Black shirt
Black skimmer
Black smith
Black snake
Black spot
Black spruce
Black stone
Black strap
Black Studies
Black Tail
Black tea
Black thorn
Black tie

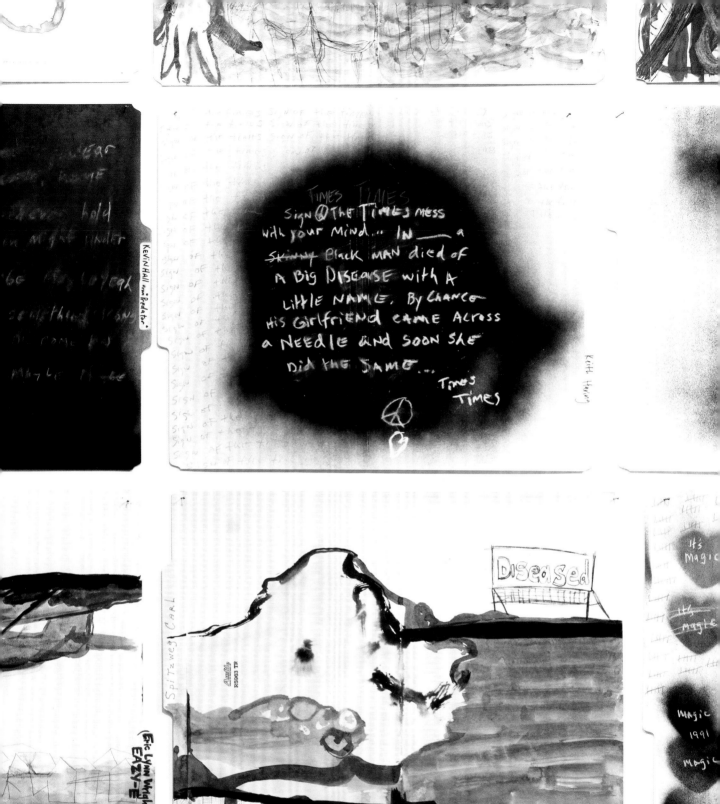

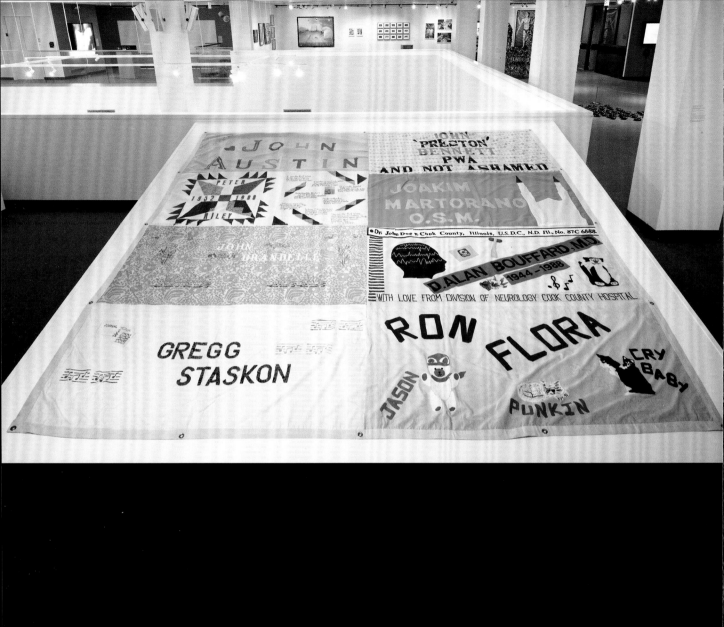

AIDS
The Plague Years

TRACY BAIM

If you are of an older generation, and especially a gay man, you probably remember reading or hearing about a July 3, 1981, *New York Times* article reporting on a strange series of illnesses striking gay men in East Coast and West Coast urban areas. Just twelve years after the Stonewall riots in New York, the decade of love and liberation had come to a crashing end.

It was the summer of 1981 when the U.S. Centers for Disease Control's (CDC) *Morbidity and Mortality Weekly Report* (MMWR, June 5 and July 3) first stated that a new disease might be in our midst. It could have been around for years, but it was just at that time starting to exhibit itself. The individual illnesses striking these young gay men were otherwise rare—*pneumocystis carinii* pneumonia and Kaposi sarcoma, the latter manifested as purple lesions. These and other obscure illnesses had started to be diagnosed some thirty months prior to the 1981 MMWR reports. In January 1982, the syndromes together began to be called GRID, Gay-Related Immune Deficiency, and the acronym stood until July of that year, when it was renamed AIDS, or Acquired Immune Deficiency Syndrome. The *New York Times* first used AIDS, as A.I.D.S., on August 8, 1982. The rumors and media reports, including those in the gay press, trickled out for many months. But by 1983–84, it was clear a major epidemic was at hand, one that struck more than gay men.

In Chicago, organizations such as Howard Brown Memorial Clinic (HBMC; now Howard Brown Health) and Gay Horizons (now Center on Halsted) tried to cope with new legal, psychosocial, and health issues facing the community, but more support would be needed. Within three years, other major institutions were founded, many of them still in existence. These included AIDS Foundation of Chicago, Chicago House, Open Hand (now Vital Bridges), Test Positive Aware Network, Stop AIDS, Kupona Network, AIDS Legal Council of Chicago (now Legal Council for Health Justice), Project Vida, Chicago Women's AIDS Project, and dozens more. Eventually, more than one hundred agencies dealt with some aspect of AIDS, from fundraising events—including AIDS Walk, Strike Against AIDS, Dance for Life, and AIDS Ride—to service groups, research, and prevention organizations.

In many ways, the quick rise of activism and empowerment, the goals to "help our own," came out of the 1970s gay and women's liberation movements. Women had been taking control of their own health and well-being, and gay, lesbian, bisexual, and transgender people were already creating community centers and support

29

The NAMES Project Foundation

Panel from *The AIDS Memorial Quilt*, 1987
Mixed media

This essay is adapted from *Out and Proud in Chicago: An Overview of the City's Gay Community*, ed. Tracy Baim (Evanston, IL: Agate, 2008)

63

structures outside the mainstream. Doctors were coming out, and those same doctors would be on the front lines of medical research and care during the AIDS crisis. LGBT people took leadership roles in the new AIDS infrastructure, heading small organizations that would become multimillion-dollar agencies. Part of the response was due to the fact that mainstream doctors and agencies were quick to spout anti-gay feelings and even push for AIDS-phobic acts, such as quarantining and contact tracing. Families ostracized their own sons and daughters, and schools tried to keep out HIV-positive children, including an Indiana boy named Ryan White. There was a huge backlash in the United States, and LGBT people were the first to recognize that we had to find solutions from within. We could not rely on a homophobic culture to save our lives. Soon, allies would come to our side. But even in 2018, abstinence-only funding takes precious resources away from AIDS work, despite studies that show those programs do not work.

Government Response

While the disease in Chicago and other U.S. cities was initially reported as mostly affecting white gay men, it was immediately clear that its path was wider and would have an impact on the entire world.[1] It was never a white male disease, and in recent years the U.S. racial breakdowns, and impact on transgender people, has been even more profound.

When speaking with LGBT people who were out in the 1980s, almost all report having felt the impact of AIDS, through their friendship circles, their families, the deaths of partners, or their own HIV diagnoses. But what is striking is the vastly different experiences. In some cases, individuals may have lost hundreds of people from their circle of friends. Yet another person of the same age, in the same city, was relatively untouched, attending few funerals and giving few memorials.

Mayor Harold Washington served Chicago from April 1983 until his death in office, in November 1987. This was an era when the city's response to AIDS was in a critical uphill swing. The LGBT community worked alongside city officials to respond to the many facets of the disease. AIDS Action Project of HBMC held forums starting in 1981, and shortly after HBMC and the Chicago Department of Health (CDH) jointly proposed formation of a Chicago AIDS Task Force. It comprised organizations working in the AIDS area, plus hospitals, the Chicago Medical Society, and the CDH. CDH also convened an AIDS Roundtable attended by commissioners of local health departments from across the United States.

Peggy Baker, who was the mayor's coordinator of gay and lesbian issues, remembers those years as intense. Baker had started her role in June, just a few months before Washington died. She was pushing what the gay community most sought: support from Washington for the gay-rights ordinance. She worked with the mayor's Committee on Gay and Lesbian Issues on strategy. Shortly before Washington died, Baker introduced him at the Commission on Human Relations luncheon, a sign that he was supporting the gay community. After Washington died, many of his appointees were iced out by the new administration of Eugene Sawyer. Baker said a lot of the AIDS-related discussions were on the city's own personnel policies. She said police officers and fire department paramedics were refusing service to gay people based on their fears of HIV/AIDS.

Washington addressed gay and AIDS issues in an interview I conducted with him for the September 4, 1986, issue of *Windy City Times* (fig. 1). Washington said

he was familiar with AIDS, and pushed for "education, research, direct services provided, it depends and varies with the neighborhood. . . . In certain parts of the Hispanic and Black communities it's a tragic, tragic sight. And because of the institutions therein, the economics therein, it's more difficult to provide services for such people no matter what the cause. . . . I'm not satisfied . . . that anybody really knows how to go about this problem. I don't have the slightest idea . . . what is the real role of the city . . . in terms of dollars, in terms of commitment. We want to be involved in part of the solution to the problem."

That next July, after two years of meetings, including with people from the health department's AIDS Activity Office (formed in 1982), community members on the city's AIDS Advisory Panel, and other experts, a report was released by Dr. Lonnie Edwards, the city's health commissioner, and his department: *AIDS: A Working Plan for Chicago*. The report's recommendations were short-run actions on education, patient care (institution and community-based), legal, and financing of medical services. Policy development would also be part of the actions. Washington died four months after this report came out, and it is unclear what aspects were ever implemented—but what is clear is that professionals and community advocates continued to work together to respond to the crisis.

The 1980s: Acting Up

LGBT people interviewed for the Chicago Gay History Project saw the rise of AIDS in the mid-1980s as both a curse and a potential blessing. AIDS caused the voluntary and involuntary outing of thousands of gay people, from Rock Hudson to colleagues and family members. With death on the line, many gay men were emboldened to come out and live a quality life, not a closeted one. The American public had never seen so many gay men and lesbians "coming out." It would take a few more years for a critical mass of bisexual, transgender, gender nonconforming, nonbinary, and intersex people to make waves in the mainstream media.

In 1984, Jerry Soucy and Katie Sprutta were part of the AIDS Action Project of HBMC, one of the first places where people with AIDS could go in Chicago. An article for *GayLife* on November 8, 1984, reported that there were fifty surviving people with AIDS in Chicago at that point. The duo bemoaned a general apathy within

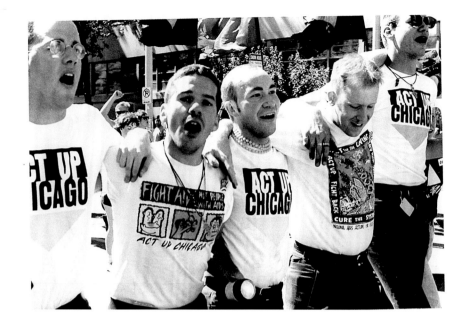

Figure 2.
ACT UP members at Pride
Parade, c. 1990

the gay community about AIDS. "They think there will be a cure soon. . . . The crisis is not over and it is not going to be over soon," Soucy said at the time.

Chicago for Our Rights (C-FOR) morphed into a Chicago chapter of the national ACT UP (AIDS Coalition to Unleash Power) movement in 1988 (fig. 2). C-FOR was a name chosen by a group of Chicagoans arrested at U.S. Supreme Court demonstrations after the October 1987 March on Washington. There had actually been a radical group prior to C-FOR, called Dykes and Gay Men Against Repression (DAGMAR) (alternate uses of the "R" were Right Wing, Reagan, etc.). DAGMAR had marched in Pride parades and responded to the KKK presence there. DAGMAR and C-FOR merged and became Chicago for AIDS Rights (C-FAR), which later became the Chicago ACT UP chapter.

Some early AIDS demonstrations, like a June 30, 1987, protest at Federal Plaza, were sparsely attended. Chants included "Reagan, Reagan, you can't hide! We all know it's genocide!" In August 1987, activists David Bell, Maryon Grey, Carol Jonas, Don Maffetore, Darral Pugh, and Ferd Eggan tied themselves to the fence outside the Chicago home of Illinois Governor James R. Thompson to pressure him into not signing homophobic AIDS legislation (fig. 3). An estimated four hundred people participated in the DAGMAR–sponsored march and protest. A twenty-four-hour vigil was held, with no arrests. (Bell died soon after from AIDS complications, and Eggan died in 2007.)

Figure 3.
Dr. Ron Sable (left) speaks with
activist David Bell (right), who
had chained himself to the
fence of Governor James R.
Thompson's home to protest
draconian state AIDS legislation
in 1987

On June 16, 1988, C-FAR occupied the Chicago office of the regional director of the Food and Drug Administration (FDA) to push for more AIDS research and drugs in the pipeline. C-FAR members Eggan and Paul Adams (who also died of AIDS) commandeered two phones and began dialing the national FDA office to issue their demands. The demonstrators demanded that drug companies be banned from "extorting huge profits from people with AIDS." Eight protesters were handcuffed by security officers, some of whom wore rubber gloves.

Not all AIDS activists were on the streets risking arrest. There was a deliberate move to have both an "inside" and an "outside" approach (fig. 4). Existing groups such as the Illinois Gay and Lesbian Task Force and the Chicago Area Republican Gay Organization met with government officials. City and state health departments were feeling the political heat, and Governor Thompson, after pressure from activists, needed to meet with the gays in "suits and ties." Each of these battles was being fought on many fronts: the work to stem the tide of bad AIDS legislation, increase AIDS funding, allow safer-sex messages on buses and trains (fig. 5), push for access to low-cost AIDS drugs, and fight for more AIDS beds for women. Chicago hosted national AIDS demonstrations, stopping traffic in the streets along march routes and laying down beds in front of the Cook County Building. Chicago activists also traveled around the country to protest at the 1988 Democratic National Convention in Atlanta and at events in Washington, DC; New York; and San Francisco.

Mayor Washington's liaison to the gay and lesbian community, Katherine "Kit" Duffy, had done a solid job of outreach and attended many AIDS events, as did her successor, Peggy Baker. Mayor Eugene Sawyer, who took office in 1987, signed the city's gay-rights bill into law. But when Richard M. Daley took over as Chicago mayor in 1989, he inherited a community already on edge about failed health

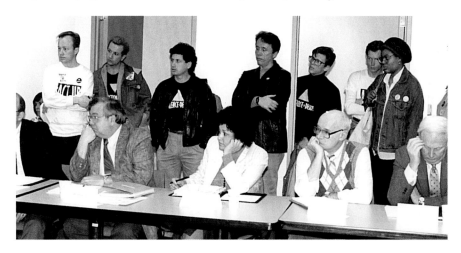

Figure 4.
ACT UP members (back row, middle three, left to right: Daniel Sotomayor, Ferd Eggan, Paul Adams) attend the second meeting of Chicago AIDS Council, late 1980s

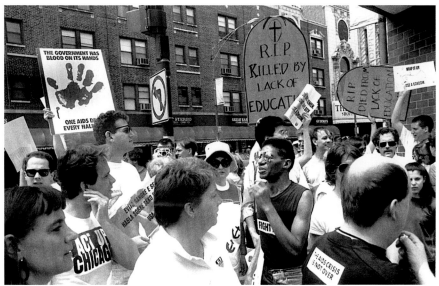

Figure 5.
ACT UP versus CTA protest (middle: Ortez Alderson), May 20, 1989

department policies and people. Daley was seen as not acting fast enough to increase AIDS spending, and protests occurred at City Hall and at a dramatic 1989 community meeting at the de facto community center, the Ann Sather restaurant on West Belmont Avenue.

Daniel Sotomayor, Lori Cannon, and other AIDS activists confronted Daley wherever they could, and 46th Ward Alderman Helen Shiller and others were able to fight for more city AIDS funding. Daley eventually repaired his reputation among most gays; however, many AIDS activists, including Sotomayor, did not live long enough to see that happen.

But no matter how media-savvy and creative ACT UP became, the divisions in the community and within organizations were similar to those in society. ACT UP meetings were often long and heated. There were people living with AIDS and people fighting for them. Diverse voices all came to the movement with their own agendas, and many could not separate out AIDS as their only cause. ACT UP was a very loose coalition, and members could choose what events they wanted to stage. Prominent members, including Sotomayor, became telegenic media stars, able to use their charisma to help the cause. But despite, or maybe because of, the amazing dedication of these activists, there was bound to be burnout. The energy could not be sustained. Some activists died, and others could not maintain the fever pitch. By the end of the 1980s, ACT UP was about to give way to Queer Nation, which itself was short-lived.[2]

Rapid Response

Among other responses to AIDS was the important work of two doctors at Cook County Hospital, which saw a large proportion of the early cases in Chicago. Dr. Ron Sable, an openly gay physician, and his straight colleague, Dr. Renslow Sherer, founded the Sable/Sherer Clinic in 1983 to focus on treatment for people with AIDS and AIDS-related complex (fig. 6). Sable, who twice ran unsuccessfully for 44th Ward alderman, later died of AIDS complications. Sherer, meanwhile, has continued to work for many years on issues related to AIDS. He was also a key ally in the years when the state legislature was considering measures to stem the epidemic. As a straight, married man with children, he was happy to play that role. "It's an obvious fact to me that while the rest of the world did almost nothing and ignored AIDS—in fact, consciously looked the other way—best symbolized by the fact that our president [Ronald Reagan] didn't utter the word until September 1986 . . . people did nothing, with the exception of the gay community," Sherer told *Outlines* reporter William Burks in July 1987.

People with AIDS, or even those thought to have AIDS, were losing their jobs, and organizations such as the American Civil Liberties Union, Lambda Legal (which opened a Chicago office in the 1990s), and individual attorneys and firms fought for their return to work. In 1987, a Cook County Hospital doctor was removed from treating patients because he had AIDS. After protests and a review, he was allowed only limited practice. Airlines discriminated against ill passengers—or even those thought to be gay and "carriers." People were afraid of gay waiters. Even gay bar customers were afraid of sharing drinking glasses with those who "looked" sick. Dentist Larry Spang lost his job at a federal prison, which led him to found a Chicago clinic for low-income HIV-positive people.

Figure 6.
Article about Sable/Sherer Clinic, *GayLife*, August 30, 1984

In Chicago, the bathhouse controversy never reached the same crescendo—or outcome—as the closing of the baths in San Francisco. Chicagoans connected with the political establishment made it clear that unsafe sex was going on in many places, and that the goal was to educate men wherever they were—and that bathhouses were safer than parks and other cruising areas, because condoms could be distributed and safer-sex information posted.

People with AIDS also needed personal and individual support in many aspects of their lives. These included legal issues (losing apartments, writing wills), basic needs (housing, food, dog walking), psychosocial needs (support groups, counseling), and even in death (funeral homes often turned away people who died

of AIDS complications, and families often fought surviving partners for assets). Prevention was also important, and free condoms, safer-sex literature, and safer-sex demonstrations were the rage. Gays protested the Roman Catholic Church's attempts to stifle condom use. Lesbians held a blood drive.

The need to raise money for all these endeavors also opened up a new era of more sophisticated fundraising than the gay community had ever seen. In combination with support from straight allies, gay and AIDS groups began hosting black-tie galas. AIDS Foundation of Chicago (AFC) hosted a huge gala on September 27, 1987, at the Chicago Theatre, raising more than $1 million. The event featured Angela Lansbury, Peter Allen, Jerry Herman, Colleen Dewhurst, Chita Rivera, Lily Tomlin (via film), Leslie Uggams, Oprah Winfrey, Mayor Washington, U.S. Senator Paul Simon, and all of Chicago's gay and lesbian choral groups. This "Show of Concern" was a co-benefit for AFC and the American Foundation for AIDS Research. Chicago socialite Beverly Blettner chaired the event, sponsored by Marshall Field's, *Outlines* newspaper, and others.

Other fundraisers that provided support included the annual Strike Against AIDS bowling events, walks and runs, tag nights at bars, golf benefits, pie tosses, croquet tournaments, drag shows, dances, bike rides, and more. WPWR-TV Channel 50 Foundation (now Alphawood), Crossroads, and other foundations provided key early funding.

Impact on Culture

There was also a cultural response to AIDS. In 1982, the Lionheart gay theater company presented the world's first AIDS play, *One*, by Jeff Hagedorn (who died of AIDS in 1995). The School Street Movement's Sex Police dancers educated people about AIDS. Many worked on an annual Dance for Life benefit for AIDS groups, an event still staged. The ranks of Chicago Gay Men's Chorus and Windy City Gay Chorus were devastated by AIDS, and they performed at many funeral services for their own singers and at AIDS benefits.

Members of every creative profession, from photographers to filmmakers, dancers to choreographers, musicians to actors, writers to playwrights, were affected. Visual artists were also taken in their prime. Sotomayor was an editorial cartoonist who used his anger and wit to create cartoons that cut to the heart of AIDS issues in the late 1980s. He died in 1992, shortly before his partner, nationally renowned playwright Scott McPherson (*Marvin's Room*), died of AIDS, as well.

Among dancers lost to AIDS was Joseph Holmes, whose Chicago dance company continued after his death in 1986. At first his family did not want it to be known he had AIDS, so no mention of it was made at his huge South Side funeral service. Keith McDaniel, who had gone from Chicago to stardom in the Alvin Ailey American Dance Theater, died in 1995 at age thirty-eight.

Thing magazine publisher Robert Ford was also a pioneer in publishing, heading a zine that played a vital role for the African American gay community in town. Ford died in 1994.

In the design world, the Design Industry Foundation Fighting AIDS had a strong fundraising community, bringing straights and gays together to raise money for a variety of groups. Season of Concern did the same among theaters and theater patrons.

Showing Their Names

Another major event for the city was the first display in town of The NAMES Project *AIDS Memorial Quilt* panels, July 9–11, 1988, at Navy Pier, well before the pier was renovated to be a tourist attraction (figs. 7–8). While the quilt returned in later years, the 1988 display was seen as a pivotal coming together of people from all communities and stood as a symbolic and somber reminder of those lost. Organizers of the NAMES display stood in solidarity with C-FAR in refusing to take a $2,000 contribution from the drug company Lyphomed, the embattled maker of pentamidine, at the time the most common treatment for the pneumonia striking persons with AIDS. The company had a monopoly on the drug and had raised the price 400 percent, sparking protests at its Chicago-area facility in suburban Rosemont. More than one thousand volunteers helped with the *AIDS Memorial Quilt* exhibition, which included nearly three thousand panels. An estimated twenty thousand people attended. The Chicago display was part of a national tour that ended in Washington, DC, in October 1988, on the anniversary of the quilt's first full display during the 1987 March on Washington. The quilt, founded by San Francisco–based Cleve Jones, has returned to Chicago in small sections and in one more large showing in 1998, the quilt's largest-ever indoor presentation.

The volunteer infrastructure that supported all these activities numbered in the tens of thousands. Whether it was sitting by someone's bedside in the Illinois Masonic Medical Center's Unit 371, delivering a meal for Open Hand, picketing the Chicago Transit Authority for refusing to display AIDS educational ads, getting

Figure 7.
The NAMES Project *AIDS Memorial Quilt* exhibition at Navy Pier, Chicago, 1988

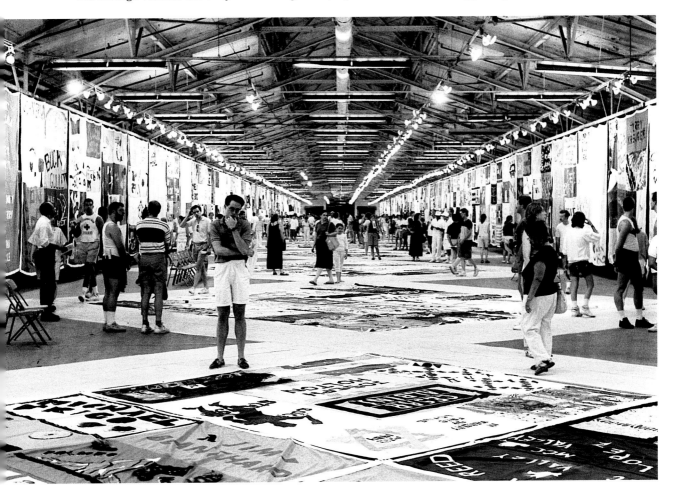

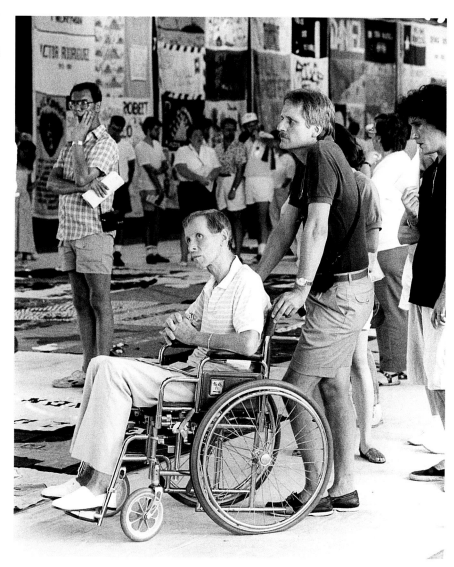

arrested at the Cook County Building or the American Medical Association, lob-
bying in City Hall or Springfield, coming out among *The Faces of AIDS* for a photo
exhibit or book, or simply donating money, the effort to cope with AIDS in Chicago
has been a herculean task. Not every Chicagoan could rise to the occasion, and
many thousands did not live to see the new century.

1 Since the start of the epidemic and through
2016, the CDC reports that 1,232,346 people have
received an AIDS diagnosis. The Chicago Depart-
ment of Public Health (CDPH) began tracking
what would later become known as AIDS in
1980. It should be emphasized that these were
cases reported to CDPH, since not all doctors
may have known what signs to look for (espe-
cially in the early 1980s). The statistics have also
been adjusted over the years, and categories have
slightly changed. As of June 30, 1987, Chicago had
more than 760 people diagnosed with AIDS and
among those, 443 had died—a 58 percent fatality
rate. Of those 1987 cases, 160 were among gay/
bisexual men, and 9 among gay/bisexual IV drug
users. Of the total, 106 were white, 77 Black, 15

Hispanic. In 2015, Chicago documented 921 new
HIV infections, part of 37,600 new HIV infections
reported nationally to the CDC. (CDPH has a slight
lag in reporting statistics of HIV/AIDS and other
diseases, so in early 2018 their most recent sta-
tistics are for 2015.) CDPH reports that in 2014,
the number of people living with HIV was at the
highest it has ever been at 23,355 individuals. This
is more than a four-fold increase compared to the
5,449 individuals living with HIV in 1990. For the
past five years, the number of HIV infection diag-
noses has been relatively stable.

2 See Chicago ACT UP member Deborah B. Gould's
book, *Moving Politics: Emotion and ACT UP's Fight
Against AIDS* (Chicago: University of Chicago Press,
2009).

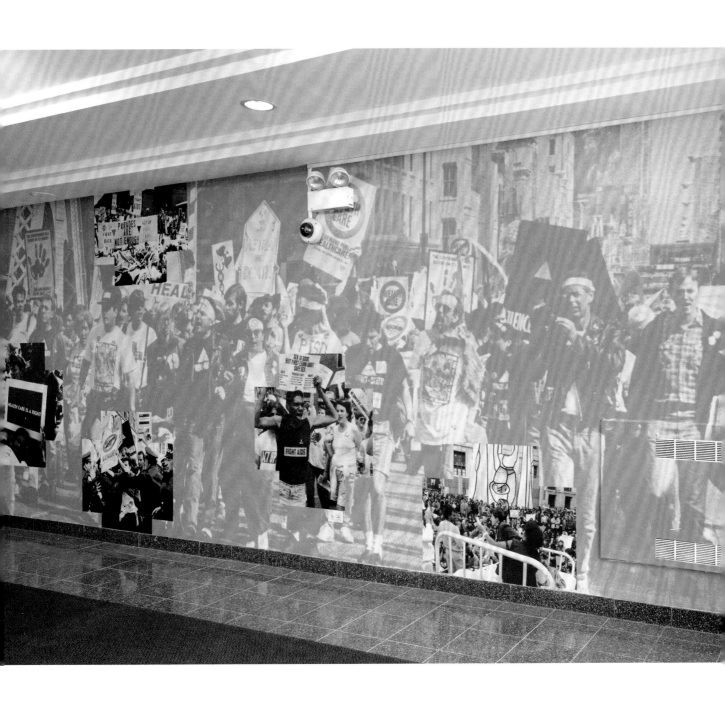

Pictures from an Epidemic

MARY PATTEN

Figure 1.
Photo mural designed for *Art AIDS America* at Alphawood Gallery, Chicago, by Alex Kostiw from archival materials researched collaboratively with John Neff. Images incorporated in the mural are from Mary Patten's ACT UP/Chicago archive and Bruce Johnson's archive

This essay is adapted from "The Thrill is Gone (Confessions of a former AIDS activist)," in *The Passionate Camera*, ed. Deborah Bright (London: Routledge, 1998).

The hallway leading into the *Art AIDS America* exhibition at Alphawood Gallery was covered with a double-sided photo mural designed by John Neff and Alex Kostiw, creating a living wallpaper with images primarily sourced from my ACT UP/Chicago archives (fig. 1). Some were life size, like the picture of a crowd marching on LaSalle St. Bridge during the AIDS Actions for Healthcare demonstration in April 1990. These images were screened back to about 50 percent density, printed in blue violet, and inset with vivid, detailed moments of people in protest, framed within the exhibition's logo.

Neff's and Kostiw's intent was to preface the exhibition by situating it in relation to Chicago AIDS activism from the mid-1980s to the mid-1990s. Stunning as the imagery was, it created a kind of epic, honorific scale for chapters and events that were also ragged, rough, and fragmentary—things that are true for all social movements. The collected anecdotes here address some of the "pockets" and gaps in a familiar historicized narrative, the smoothness of which is too easily captioned and contained. AIDS activism is an unfinished, although quieter, project; the demands and legacies persist, even in a reconfigured present.

Four chants and nine stories from ACT UP/Chicago

1.

Antibody, Positive, Negative, risk group, taboo, tattoo, William Buckley, syndrome, conspiracy theory, stigma, shame, opportunistic infection, IV drug user, shared needles, vectors, magic bullet . . . plague, barbed wire, silence, concentration camps, crisis, bodies, lesions, wasting

2.

Rage, Criminal, Buddy, Victim, Liar, Murderers, Scumbags, needle exchange, protest, pharmaceuticals, transmission, megaphone, sex, cures, pills, profits, propaganda, patents, die-ins, quilt, PWA, AIDS warrior, Haitian refugee, Guantánamo Bay (earlier), behaviors, healthcare . . .

bandages, bodies, bureaucracy, condoms, crime, civil disobedience manuals, direct action training, deathbed, drug trials, freedom bed, ghost, gloves, head-bands, irradiated, lab coats, parade, red tape, research, speak out, stretchers, teach in, testimony, theatre, vigil, witness, x-ray

3.

Coffin, Memorial, Obituary, Ashes,
Desperation, Mourning, Loss, Failure,
Histories, Memories, Solidarities, Funerals
Drugs into bodies
Cocktail, Sexism, Racism, Privilege,
Africa, Global AIDS, Women . . .

4.

guilt, fear, loss, joy,
exuberance, rage, listlessness, hope,
fury, righteousness, shame, Shame!
abandonment, out-of-time, exhaustion,
emptiness, flatness, tiredness,
silliness, cattiness, numbness,
over-the-top, in-your-face, cynicism, dreams,
grief, passion, despair . . .
is solidarity a feeling?

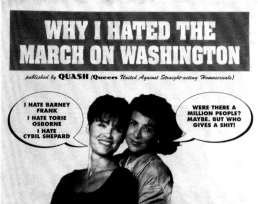

1. Propaganda, part 1

ACT UP named the epidemic, the actors, the causes. We did the research, educated the experts, challenged the culture. We changed the language, and changed the frame: "AIDS victim" became "person with AIDS" (PWA); "risk behaviors" became "risk groups." We used funny acronyms: DAGMAR (Dykes and Gay Men Against Reagan, Repression, Racism, the Right Wing . . .), RAGU (Romanian Art Guerrilla Unit), QUASH (Queers United Against Straight-Acting Homosexuals), and QUISP (Queers United in Support of Political Prisoners) (figs. 2, 3).

Prior to 1988, the City of Chicago relied on U.S. government–produced posters with overwhelmingly fear-based images to "address" the AIDS epidemic. In response to criticism from the gay community, the City's Health Department commissioned and produced its first HIV/AIDS educational campaign. The basic message—that individuals could "choose" not to become infected—was useless. There was no information, rendering the campaign misleading and dangerous (fig. 4).

Daniel Sotomayor, one of the most visible activists in ACT UP/Chicago, pushed us to collectively create "Target CTA," a counter-ad campaign to confront the city's criminally negligent mis-education. We created posters for CTA buses and trains all over the city (fig. 5). In Spring of 1989, we gathered at the bus depot on Diversey and Broadway. We mounted buses, put up a bunch of our own "ads" in the overhead advertising spaces, and distributed real information about real resources at a time when services for people with HIV and AIDS were scarce or did not yet exist. It was a direct action. People got arrested, went to jail, and some got hurt. But this

Figure 2.
DAGMAR participating in March on Washington, 1987

Figure 3.
QUASH broadside, 1993

Figure 4.
Poster published by the Chicago Department of Public Health, 1988

Figure 5.
ACT UP/Chicago poster, 1989

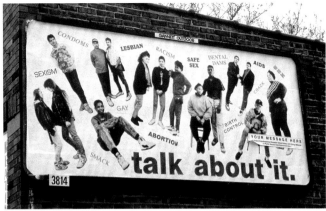

counter-information campaign was pivotal for ACT UP/Chicago. We also made billboards and other agit-prop.

In 1989 and 1990, Randolph Street Gallery (an important alternative art space in Chicago at the time), and Group Material, a NYC–based artists' collaborative, organized a public art project, "Your Message Here." Forty design concepts by artists, educators, and community groups were selected for billboards in working-class urban neighborhoods throughout the city. (The billboard company Gannett Outdoor donated advertising space.) The ACT UP Women's Caucus collectively brainstormed and designed three proposals that were chosen for the project. In "AIDS DOESN'T DISCRIMINATE," we appropriated the city's "I Will Not Get AIDS" campaign (fig. 6). HIV/AIDS activists, their children, and lovers were our models, a diverse group of "faces of AIDS," determined to fight for "treatment, education, and support.… No matter what it takes." "Talk about it" featured floating portraits of teenagers from West Town, a primarily Puerto Rican community, and Uptown, one of the poorest but most integrated neighborhoods in the city, surrounded by words like "safe sex," "AIDS," and "racism"—encouraging open and frank discussion about sex, drug use, risk, and prevention—a broader framework for coming to terms with the epidemic (fig. 7).

Shelley Schneider-Bello grabbed a video frame from a TV news clip of Mayor Richard M. Daley at a kids' Christmas giveaway in 1989, inspiring a poster by an anonymous group (fig. 8), while Robert Blanchon's hilariously sardonic sticker brought the counter-campaign full circle (fig. 9).

The "power breakfast" t-shirt was controversial within ACT UP/Chicago because there was "no dental dam visible" (seriously). But although the design had nothing to do with AIDS, it was our best-selling T-shirt, a reminder that one of ACT UP's greatest strengths lay in our mix of joy, rage, critique, and sexy goofiness (fig. 10).

2. Propaganda, part 2—second city shame

In 1990, Creative Time's "Art Against AIDS, On the Road" sponsored a series of billboards in Chicago and elsewhere for display on buses and train platforms. The "controversy" sparked by Gran Fury's "Kissing Doesn't Kill"—a homo-hating backlash led by members of the City Council—created a media frenzy and the systematic defacing of the billboards. These were Franz Kline–like swaths of black paint, not the work of everyday taggers. It was embarrassing that Chicago had once again distinguished itself as a reactionary backwater, as if these things weren't happening all over the country, as if AIDS activists did not routinely endure repression, punishment, and sex phobia. Queers responded by carrying Gran Fury's work in that year's Gay Pride Parade (fig. 11).

Figure 10.
ACT UP/Chicago Women's Caucus T-shirt, 1990

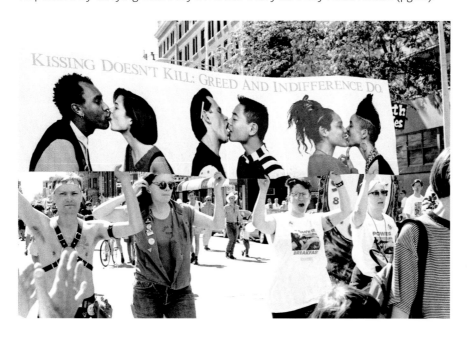

Figure 11.
Gran Fury's *Kissing Doesn't Kill* banner in Gay Pride Parade, 1990

3. Solidarities, part 1

It became a truism that had it been lesbians instead of gay men who were struck down in such numbers by AIDS, equivalent solidarities would not have emerged. In the larger queer community, some argued that there were two plagues: AIDS and breast cancer, and half-imagined scenarios where gay men did not support lesbians. In 1989, the ACT UP/Chicago Women's Caucus created a "consciousness-raising" questionnaire that we circulated at a membership meeting in 1989. Men who responded overwhelmingly wrote that "gay men are too selfish" to show up for women as we had done for them. But the "male supremacy quiz" was a bit of a set-up (fig. 12). One question asked which words are used to describe the smell of

Figure 12.
ACT UP/Chicago Women's Caucus, "Male Supremacy Quiz"

Figure 13.
ACT UP/Chicago Women's Caucus banner

1

ACT UP MALE SUPREMACY QUIZ 9-5-89

1. How many women in the US are raped each year? *10 million*

2. How many women in the US are victims of incest each year? *5 million*

3. Now that women in the US have entered the labor force in great numbers, about how many men are doing half the household cooking, cleaning, and childcare? *500,000*

4. Before abortion was legal in the US, about how many women died each year from back alley abortions? *100,000*

5. What adjectives are you familiar with that describe the smell of female genitals? *tuna, fish*

6. About how many women in the US are battered each year? *1 million*

7. Which epidemic is killing women in much greater numbers than AIDS is killing people? What percent of women?

8. What percent of women in Africa have AIDS? *35%*

9. How do straight women get AIDS? *male partners who are HIV carriers*

10. What percent of new cases of AIDS in Chicago are among women? *1 in 2*

11. What is a near-epidemic immune suppressive illness affecting women in great numbers now? (clue: it is hypothesized that it may be related to AIDS/ARC). *Chronic fatigue*

12. What groups are systematically excluded from drug trials? *women*

ESSAY QUESTIONS

If the AIDS crisis had hit primarily women, do you think that gay men would be responding to us in the numbers that we are responding now? Why or why not.

I would hope so but I'm not sure. We're pretty oblivious to alot of stuff in the world, but that's alot of people in this country, isn't it?

13. About what % of rapers are acquainted w their victims?

CHICAGO DYKES RULE

PUSSY BY THE LAKE

female genitalia. Respondents could cite a stereotype, profess ignorance (itself a kind of political weakness or flaw), or lie. Telling the truth meant repeating a common insult, which appeared to endorse it—a kind of trap.

At the same time, the Women's Caucus happily appropriated "fish" in our banners and stickers, where we combined a sophomoric chant ("Chicago Dykes Rule") while reclaiming "dykes" and "pussy"—pussy is pussy but also catfish; a fish is what pussy smells like; and Lake Michigan is full of smelts (fig. 13).

4. Debts

ACT UP did not always acknowledge our social movement predecessors. Direct action, street theater, and media genius were not "invented" by us. ACT UP inherited much from the women's liberation, civil rights, Black Power, and anti-apartheid movements—all of which succeeded, for a brief moment, in subverting business-as-usual, deploying the rhetoric of personal transformation and social revolution, visualizing a literal "turning inside out" through demonstrations, media spectacles, and struggles for power.

In our appropriations as well as inventions, ACT UP created a theater of our bodies in the public sphere, shifting the spectacle of AIDS. Our contribution was to smear the dichotomies between "private" and "public" life, between our bodies, our sexualities, our desires, and our social/political selves.

5. freedom beds, death beds

The image of the "freedom bed" alternated with those of ACT UP's die-ins, where, on cue, activists would drop to the ground in sprawled silence, our supine bodies outlined in chalk by others. In these tableaux, the street became a metaphoric death bed, and the tracings left behind marked the site as a scene of murder, a visual testament to the bodies that were, in fact, disappearing (figs. 14, 15). These tactics mirrored earlier protests marking the U.S. bombings of Hiroshima and Nagasaki, where chalk outlines called up the ghostly irradiated traces of thousands of dead human beings.

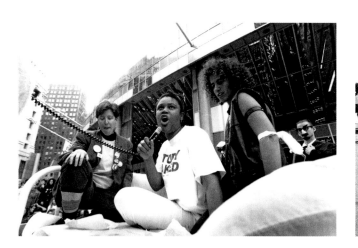
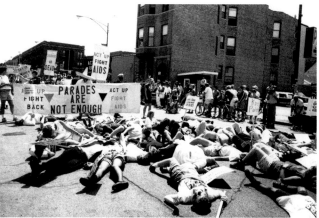

6. Solidarities, part 2

I thought about reminding us that we can win sometimes.

In April 1990, ACT UP/Chicago hosted the National AIDS Actions for Healthcare, organized nationally under the auspices of ACT–NOW (AIDS Coalition to Network, Organize, and Win). A twenty-four-hour teach-in and vigil at Cook County Hospital, followed by rallies and a day-long march threading through downtown Chicago, targeted insurance and pharmaceutical companies, the American Medical Association (AMA), and city and county public health administrators.

The city and the county had claimed for months that an empty ward in Cook County Hospital couldn't be opened to women because there wasn't enough money to build a separate bathroom. The culmination of the day-long protests was the National Women's Caucus action, where we used beds as a literal direct-action tool. We semi-secretly dragged fifteen old, heavy mattresses, representing the fifteen empty beds of Cook County Hospital's AIDS ward, through the streets and alleys of downtown Chicago. Chanting "AIDS is a disaster, women die faster" and "Women are dying to get in," lovers, friends, comrades and fuck-buddies, butches and femmes, older women and teenagers, sat down on these old mattresses, using them and our bodies to block midday traffic at a major downtown intersection in front of City Hall.

In 1990, only a handful of HIV-positive women in Chicago were willing and able to identify themselves publicly. Two of them, Betty Jean Pejko (featured in Ellen Spiro's *(In) Visible Women*, pl. 13) and Novella Dudley were keynote speakers at the teach-in and vigil held just prior to the demonstrations. Members of the Women's Caucus put on hospital gowns and seized mattresses in solidarity with women with AIDS. In assuming these identities and representations, our intention was

Figure 14.
ACT UP/Chicago Women's Caucus members Mary Patten, Saundra Johnson, and Debbie Gould at a "Freedom Bed" protest, Chicago, 1990

Figure 15.
ACT UP and Queer Nation die-in during Gay Pride Parade, June 28, 1992

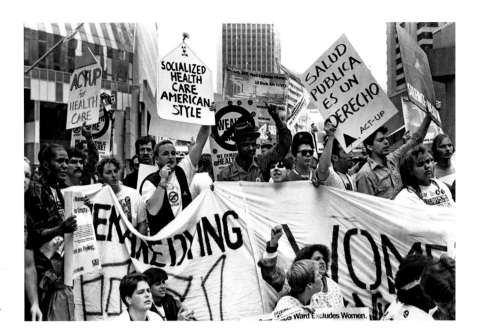

not to speak *for* women rendered "invisible and voiceless," but to create a visual homology of our identification with women with AIDS, not unlike Argentinian protestors who "became" *desaparecidos* (the disappeared) by wearing white death masks at demonstrations in the 1970s and 1980s.

Two national caucuses—of people of color and people with immune system disorders (P.I.S.D.)—joined the action, creating crucial diversions that allowed the women to prolong the blockade. This was a pivotal moment of mutual solidarity in the AIDS movement among women, people of color, and people diagnosed with HIV/AIDS and chronic fatigue syndrome, at a demonstration that powerfully focused our demands in the context of a national healthcare agenda (fig. 16). And, in a particularly swift demonstration of the effectiveness of civil disobedience and direct action, Cook County's AIDS ward was opened to women two days later.

7. normalization

By the March of Washington in 1993, some of us in ACT UP and Queer Nation longed for the vibrancy and the heterogeneity of queer cultures that seemed to have all but disappeared with the one-two notes of assimilation—from gays in the military to gay marriage (fig. 17). For many in the AIDS movement, the battle against the epidemic was inseparable from the production of lesbian, gay, and genderqueer identities. The shifting of the epidemic to more and more poor people, communities of color, intravenous drug users, and women necessitated that the fight against AIDS become a fight against racism, homelessness, the drug plague, the prison system, and the collapsing social safety net in this country. None of these potential battlegrounds is particularly mediagenic; all are almost hopelessly, routinely endemic to the structures of capitalist society.

8. residues, traces . . . things that are left

I have in front of me an image of a police officer with gloved hands smashing my friend Tim's head down on a barricade, while another grabs his exposed neck. The site was ACT UP's demonstration against the AMA in 1991. This was a turning point for ACT UP/Chicago, a marked escalation of police brutality, where demonstrators were beaten, hospitalized, and traumatized. More injuries were sustained here than ever before in our protests. Perhaps more significantly, we suffered collective psychic damage; many people were effectively freaked out. We were up against the limits of our own power and effectiveness.

The AMA demonstration, like all such experiences, was a potentially educational one. There were many in the AIDS movement who had been buffered all their lives from the overt aggression of the state by protective layers of class, skin color, male supremacy, or gender conformity, for whom this brutality was new and unprecedented. These experiences linked to a new kind of consciousness about the systematic police brutality endured and fought by African Americans, Mexicans, other people of color, poor people, and "street" folk for centuries.

And while some people moved from this experience with greater awareness, seriousness, and sense of solidarity, others were hurt, frightened, and afraid. Despite our press conferences, counter-information, and lawsuits, the calculated brutality by the police—much of it soft-tissue injuries which, though less visible than head crackings and blood wounds, took longer to heal—the violence had a chilling effect on our ranks. This was the same time period of increased police infiltration, "dirty tricks," and spying on AIDS activist groups across the country, and an escalation of anti-gay violence and bigotry nationally (fig. 18).

Figure 18.
ACT UP/Chicago member Tim Miller showing injuries inflicted by Chicago police at the American Medical Association demonstration, Chicago, June 1991

After a period of only six or seven years, a condensed lifetime for many of us, the literal disappearance of so many friends, lovers, and community people—who had joined the horribly escalating numbers of the dead—began to collapse into the erasure of our images in the media. We dropped out of sight. This produced another hole in our midst, another empty space: we were literally being chalked out (fig. 19).

Figure 19.
Mary Patten, *Untitled (names and addresses)*, 1994, 10-year-old address book, correction fluid

Figure 20.
Letter from Angie Caceres, 1983

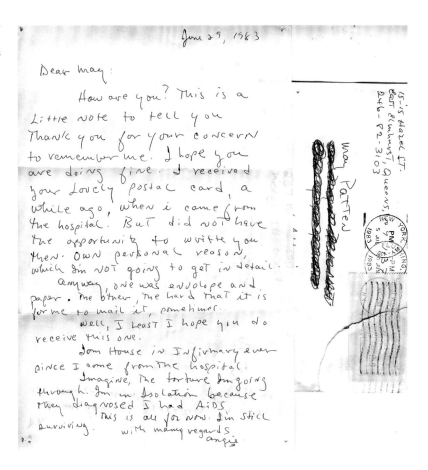

9. *Post Script*

Any act of remembrance involves a common thread: inscribe, encode, engrave names and lives that have been arrested—stopped, stalled, detained, sometimes extinguished. Names under erasure, that must be repeated because they have been forgotten or have faded/receded with time. Names that need to be spoken, phrased, in a different way. Turned inside out and sideways.

I find myself circling around several figures. One is spectral—Angie Caceres, the first person I ever met to be diagnosed with AIDS. This was in 1982, before the tag of "G.R.I.D." (Gay-Related Immune Deficiency) was supplanted by "H.I.V." and "A.I.D.S." I met Angie in 1982 at Rikers Island, the New York City jail. She was a beautiful, tall Borinqueña, a dropout from NYU, and a junkie.

This is the last letter I received from her: torn envelope, blue writing on cheap paper (fig. 20). I imagined her, lesions all over her body, trapped and quarantined in the jail's AIDS ward. Alone in a cold clean room, a prison within a prison. No one there to say goodbye. She asked for stamps. I sent her some. By the time they arrived, she was already dead.

I think of Robert Blanchon, who died in 1999 when some people thought that people with HIV disease were not dying anymore. His art endures although he is gone. He made this piece, titled *Untitled (eye frame)*, when he began to lose his vision, particularly in one eye (fig. 21).

I think of the women in prison who taught us so much—people like Rosalind Simpson-Bey, Katrina Haslip, Susan Rosenberg, Linda Evans, and Judy Clark, who honored our practice as they struggled against the worst possible odds to build

Figure 21.
Robert Blanchon, *Untitled (eye frame)*, 1998; prescription eyeglasses, custom frame, and glass shelf

peer education and counseling programs inside prisons, like A.C.E. (AIDS Counseling and Education) at Bedford Hills prison in New York State. "We saw the empowerment that was fought for by the gay community . . . and rather than saying, "this is terrible, you've got to do something for us," we learned from PWAs in the streets that if we didn't do it for ourselves, no one was going to do it for us."

And finally, Ferd Eggan (fig. 22): Some people know Ferd from his years in ACT UP/Chicago, ACT UP/LA, or in his role as AIDS coordinator for the City of Los Angeles in the early 1990s. Experimental film buffs might have seen *The Continuing Story of Carel and Ferd*; others may have read his book, *Your LIFE Story by someone else*, or visited his apocryphal website, The Cranky PWA ("If you had AIDS, you'd be cranky too!"). Diagnosed with HIV in the mid- 1980s, Ferd was a long-term survivor, finally succumbing to liver cancer on July 7, 2007.

Each of these people occupy a position, coordinates on a map. Together their names form an arc that ascends, levels out, and finally crashes. . . . or disappears into the normalcy of the present.

Heroism is as collective as it is individual, probably more so—and much of it is never visible, never recognized. It is my hope that this archive of photos and ephemera invokes a little bit of "the imagined community" of ACT UP/Chicago—our energy, our desires ("we want the world and we want it now"), our struggles binding our lives together, as we worked together, held each other, and made many necessary and life-saving changes possible.

Queer Hero Dead

**FERD EGGAN
R.I.P.
1946-2007**

Figure 22.
"Queer Hero Dead," 2007

30
Roger Brown

Peach Light, 1983
Oil on canvas
72 × 48½ in.
School of the Art Institute of
Chicago and the Brown Family,
Courtesy of Kavi Gupta

Roger Brown
On Leather and Longing

KATE POLLASCH

I suppose on learning of HIV one could just stop everything—stop living and get ready to die. But why prepare to die . . . when you're dead all the past preparation in the world doesn't help your present condition.

I chose to prepare to live.[1]

Having lived privately with HIV for six years, artist Roger Brown, in 1993, wrote a letter of disclosure to select family and friends. In this letter, Brown's words come together in a careful orchestration of personal and political reflection, as seen in the excerpt above. "Choice" is a keyword when considering Brown's art practice and legacy. Beginning his career in the early 1970s, Brown "chose" to both reveal and conceal his sexuality, relationships, and fantasies in his paintings throughout the early decades of his practice.

Brown was a leader in the Chicago Imagist community, a loosely formed group of artists working against the grain of Abstract Expressionism that overshadowed New York City, and he experienced thriving commercial reception matched by art critic recognition in his early career.[2] Throughout the 1970s, aware of the professional danger of being too sexually explicit in his work, he coded signals in his paintings of cruising in Chicago public parks, seen in the subtle silhouetted figures nestled between bushes or trees; cultural references to gay literary figures and queer movie cult classics; and references to his partner, architect George Veronda, evident in Mies van der Rohe–style architecture and grammatical plays in his titles. By 1980, Brown experienced substantial international artistic recognition and had his first retrospective at the Montgomery Museum of Modern Art, and his second retrospective in 1987 at the Hirshhorn Museum and Sculpture Garden in Washington, DC.[3] Concurrent with his professional rise, by the 1980s, the ramifications of HIV/AIDS on his life quaked with deep reverberations, the impact of which resulted in a marked shift in his painting practice. Brown predominantly left behind his subliminal references for a bold overt approach to visualizing the political injustice, personal loss, and shifts in sexual culture that HIV/AIDS unearthed. Diagnosed as HIV positive in 1988, and dying in 1997, Brown also spent the final five years of his life "preparing" his most powerful public statement: converting his private domestic space into a public house museum and archive.[4] The Roger Brown Study Collection and Archive is a historic site rich with traces and tales of his life,

his health, and his sexual experiences that were formerly inaccessible to the general public but continue to speak as a contemporary queer hub of history that rings louder than the cruelty of the epidemic ever will.

Throughout Brown's career, and in the first decades after his death, little art-historical research was completed on the effects of HIV/AIDS or the evolving account of Chicago's gay leather community, focused around the Gold Coast Bar, that was embedded throughout his work. For nearly a decade, I have traced the threads of the artist's experiences, found scribbled on the edges of his sketchbooks or in palpably poetic handwritten letters to friends and colleagues, as a means to recontextualize him within art history and bring voice to the shifts in his work and life. This research was possible because of Brown's archive, the profound gay history that he institutionalized in the wake of the national trauma of HIV/AIDS, and his own lived experience of public and private negotiation. The inclusion of Brown's artwork in the *Art AIDS America* exhibition is a deeply impactful moment of recognition for this hometown hero, as his legacy and art speak volumes about the ramification of HIV/AIDS on Chicago and the nation.

Slick leather hugging bulging muscles, chaps and shirtless oiled chests, and police batons used in the right way cascaded across the walls and corners of Chicago's Gold Coast Bar, a decades-long leather bar and lower-level sex club founded by Chuck Renslow in operation from 1958 to 1988.[5] A staple of Chicago's leather community, the bar was adorned with larger-than-life erotic murals painted by artist Dom "Etienne" Orejudos, who found influence from artist Tom of Finland.[6] Brown was a known patron of the bar, often described by community members as a quiet observer who could be found in the corners or back walls of the space.[7] For Brown, the bar began his artistic response to HIV/AIDS and was also the site of his professional transition between operating as a guarded artist employing codes for visual communication and an overt artist speaking with unwavering directness.

In 1978, Brown created his first work visualizing the sexual wonderland of the Gold Coast. *City Nights: All-You-Wanted-To-Know-or-Don't-Want-To-Know-And-Were-Afraid-To-Ask-A-Closet-Painting (subtitle supplied by Barbara Bowman)* (1978; fig. 1), was never publicly exhibited during Brown's lifetime, but it offers a foundation for understanding the sensual community and pleasure exchange untouched by the epidemic to come.[8] Pulling the roof off the Gold Coast Bar, Brown exposed a glimpse into the smorgasbord of sexual stimulation available to knowing visitors. Outside of the central building filled with glory holes and penetration, voyeurism and sex acts occur in bushes and among the silhouetted pedestrians walking along the shadowy streets. Brown inverted the normative infrastructure of the city by making sexual activity central and open across the scene and isolating individuals not engaged in sexual activity in distant buildings along the horizon line. As a prominent mainstream artist at the time, he could have placed this work outside the subcultural context of the Gold Coast community and into a new public sector; however, it remained tucked away at Phyllis Kind Gallery and later in his archive, out of public view throughout his life.

The next time Brown referenced the Gold Coast Bar in a mainstream gallery was his 1983 *Peach Light* (pl. 30). This painting was exhibited widely during Brown's lifetime, and I consider it a dense visual web of mortality, erotic desire, community, and healing at the very early stages of HIV/AIDS that has been primarily misread.

Figure 1.
Roger Brown, *City Nights: All-You-Wanted-To-Know-or-Don't-Want-To-Know-And-Were-Afraid-To-Ask-A-Closet-Painting* (subtitle supplied by Barbara Bowman), 1978; oil on canvas, 72 × 48 in. © School of the Art Institute of Chicago and the Brown family, courtesy of Kavi Gupta

Exhibited at the Chicago branch of Phyllis Kind Gallery the year it was painted, *Peach Light* received mixed reviews, and Brown did not speak about the artwork's context. In the first year of public exhibition, art critics and writers from New York and Chicago identified the work with varying contexts, deeming it a tribute to the U.S. military, a general commentary on death, and even a visual skeleton joke.[9] The work was framed in the context of HIV/AIDS in the 1984 Encyclopedia Britannica's *Medical and Health Annual*, but simplistically captioned as a representation of death.[10] But *Peach Light* was far from a patriotic salute to military life, a warning sign of death, or a one-punch skeleton visual play.

In this work, the leather hat is a coded reference to Dom "Etienne" Orejudos and the military or leather dress code needed to descend into the bar's lower-level sex club. Placing the work in a Gold Coast context, *Peach Light* referenced the time the bar changed their lighting to a softer peach to help offset the visibility of

Figure 2.
Roger Brown, page from 1983 sketchbook with sketches for *Peach Light* and *Giant Gray Stripe*; ink on paper, 10 × 8 in. © School of the Art Institute of Chicago and the Brown family, courtesy of Kavi Gupta

Kaposi sarcoma (KS) and weight loss in patrons with AIDS-related symptoms who were coming to the bar to be with their community, seek social connection, and continue to be a part of the erotically attractive space.[11] Reflecting on the saturated erotic terrain that Brown portrayed in *City Nights*, he chose, by 1983, to retreat from a more overt style and employ coded references to visualize his participation in this community. However, looking at his preparatory sketches, Brown also considered including a second shirtless figure, invigorating the work with a strong sense of cruising or a pick-up encounter (fig. 2).[12] By visualizing both the compassionate effort of the bar staff to find normalcy for guests already ravaged by KS alongside capturing the erotic happenings and sexual potentiality of the space, Brown gave voice to both sexual eroticism and HIV awareness, something that would be continuously stripped apart and divided by politicians and conservative public personalities for years to come.[13] In the final painting, however, he permitted the work to lead multiple, parallel public lives. In one way, it was absorbed into the mainstream with complete unawareness, while being identified as a work concerning HIV/AIDS but only in the context of death. At the same time, the painting also spoke subliminally to knowing Gold Coast community members and patrons. Therefore, the history of *Peach Light* is fraught; it is a key fragment that spoke of the onset of HIV/AIDS in Brown's life and Chicago's leather community, but also remained too coded for most to interpret in 1983.

Over the next two years, Brown completed *The Plague* (1984) and *Illusion* (1985; pl. 31). Both works are charged with the urgency and overwhelming impact of HIV/AIDS on the nation and in Brown's life. In *The Plague*, the city's depths are flattened into a smooth surface of dark streets and semi-shadowed male figures, rendered with such a vertical, totemic perspective that they appear at risk of falling off the canvas. Standing figures look on at the fallen men, some in shock, while others seem not to notice what lies in plain sight. With *The Plague*, Brown thrusts the epidemic to the forefront of his canvas, making it impossible for an audience to ignore. This 1984 painting is a pointed visual metaphor for the unforgivable ignorance and blindness that so many politicians and citizens took while others tirelessly fought for change. Although *Illusion* contains no overt reference to HIV/AIDS, the harsh reality of death, the youthful portrait, and metaphoric weight of the title speak

Figure 3.
Roger Brown, *Aha! Heterosexuals Fuck Too*, 1991; oil on canvas, 72 × 72 in. © School of the Art Institute of Chicago and the Brown family. Kavi Gupta/Roger Brown Estate

to the tidal wave of mortality among a generation withstanding the weight of government oppression and cultural expulsion in the early years of the epidemic.

In 1988, Brown was diagnosed as HIV positive, and in the years after, his paintings concerning sexuality, politics, and HIV/AIDS reach the height of their outspoken directness. In 1991, Brown created *Aha! Heterosexuals Fuck Too* (1991; fig. 3),

addressing Magic Johnson's public declaration of his HIV-positive status. The surrounding media spectacle was partially focused on his social behavior and sexual history, with Johnson insisting that he was not gay but a Casanova attempting to "accommodate" the outpouring of women seeking sex with him while also upholding his marriage.[14] In an exhibition at Phyllis Kind Gallery in 1992, Brown included *Aha! Heterosexuals Fuck Too* in a new body of artwork influenced by self-taught "circus sideshow/freak show" banner painters from the early 1900s.[15] Appropriating the bright border, circular text, and portrait design of the banner paintings, Brown presents a smiling, bright-eyed Johnson in his Lakers uniform as framed in the sideshow context.[16] *Aha! Heterosexuals Fuck Too* points to the moral spectacle of the media and the public's realization that the basketball superstar, a heterosexual, not only had a diverse sex life but "fucks," as Brown put it. The portrait criticized mainstream America's "othering" and abandonment of people with HIV by placing a heterosexual star athlete—the antithesis of the stereotype of a person with AIDs—in the frame of "freak."[17] Setting the stage for Brown's overt artistic approach in the later decade of his life, *Aha! Heterosexuals Fuck Too* antagonistically spoke to the way HIV was more about social views concerning lifestyle choices, bodies, and difference than a medical problem that was desperate for scientific and government attention.

In 1993 Brown created *This Boy's Own Story: The True and Perfect Love That Dares to Speak Its Name* (1993; fig. 4), a painting about the sexual development of an underage child. Here, a work concerning sex is woven into the discussion of HIV/AIDS as Brown noted in a personal letter to a collector: "So I would say my willingness to

Figure 4.
Roger Brown, *This Boy's Own Story: The True and Perfect Love That Dares to Speak Its Name*, 1993; oil on canvas, 36 × 48 in. Private collection. Courtesy of the Roger Brown Estate/ Kavi Gupta

do a painting which discloses so much of my private sexual history was brought on by the experience of being HIV positive for about 6 years. . . . In a way the 'Boy's Story' kind of begins my road to disclosure of my own HIV status before my obituary starkly discloses it for me."[18]

On a broader cultural level, at the time, the media and select government officials used the fear and uncertainty of HIV as a tactic to claim that gay and HIV-positive men were "recruiting" children to become gay.[19] In 1989 Gran Fury created the *Kissing Doesn't Kill* public art project, commissioned by "Art against AIDS, On the Road." In Chicago, the poster was exhibited on public transit. Chicago city alderman Robert Shaw ignored the HIV and AIDS activist content, deeming it an advertisement that "seems to be directed at children for the purpose of recruitment." Subsequently, on June 22, 1990, the Illinois State Senate approved the "No Physical Embrace" bill, preventing the Chicago Transit Authority "from displaying posters showing or simulating physical contact or embrace within a homosexual or lesbian context where persons under 21 can view it." The bill was later defeated due to protests and local gay and lesbian community outcry, but it reflects a larger, national homophobic fear of gay adults recruiting children.[20] Completed just three years later, *This Boy's Own Story* was shown at Phyllis Kind Gallery in Chicago in 1994. In the face of artistic censorship across the nation, extreme homophobic political policy, and local fear-mongering linking HIV/AIDS and homosexuality to pedophilia, Brown used his mainstream art gallery to speak directly and unabashedly about these topics.

Brown's work was harshly reviewed by Chicago art critic Alan Artner, a long-time professional rival of the artist, and the work was minimally discussed in the years to come, leaving its content and cultural commentary unexamined.[21] In *This Boy's Own Story*, Brown visualized a comic book–style narrative progression of childhood sexual development of a young boy into a man. When the artwork was initially exhibited, Brown completed an interview in which he stated that his own adolescence lacked sexual guidance and that he longed to be in a relationship with an older man at the time.[22] In *This Boy's Own Story*, Brown mapped his world of "what could be" positive child and adult sexual experiences, unbound by legal issues, and then boldly displayed that mapping in a mainstream Chicago art context. In Brown's narrative, the child actively seeks out his experiences and relationships, rather than passively being coerced or tricked into an unwanted one. The painting also operates as Brown's evocation of 1970s urban sexual practices, as the artist stated, "The last panel which shows a progression to such promiscuity that many of us enjoyed in the 60s and 70s is probably my biggest hint of my HIV status."[23] But, the last panel contains no suggestion of the specter of HIV or the extreme loss that would perforate a generation. By not signifying HIV in his depiction of nonmonogamous embrace, it evokes a queer sexual memory of 1960s and 1970s, more familiar to the unending pleasure experiences found in *City Nights* (1978). In 1994, Brown's work of unencumbered, safe, childhood sexual maturation and nonmonogamous union offered the possibility of imagining sexual practices beyond the then-current atmosphere. He powerfully visualized an experience otherwise demonized by politicians to distract from the prolific pain, medical industry abandonment, and cultural oppression surrounding HIV, activism, and arts censorship.

31
Roger Brown

Illusion, 1985
Oil on canvas
72 × 60 in.
School of the Art Institute of
Chicago and the Brown Family,
Courtesy of Kavi Gupta

Brown died of complications from HIV/AIDS in 1997. As the disease entered the national consciousness and impacted his community, Brown shifted from employing coded references to harnessing an unquestionably direct visual language. Aware of his mortality, Brown, in the final years of his life, transferred his private home and its content to the School of the Art Institute of Chicago with the intent for it to be a public house museum. The Roger Brown Study Collection is a rich haven of erotic fantasies, love letters, sketchbooks, anger and political rants, medical records, and unending artistic inspiration. The museum demonstrates his willingness to choose generosity and vulnerability in the final years of his life by gifting his home filled with the mundane and magnificent life experiences of a Chicago artist who refused to be silenced by HIV/AIDS and refused to be made invisible or shamed by government neglect and homophobic hatred. Brown is a distinct artist within HIV/AIDS and American art history. His coded visual language and connection to Chicago's leather community gave voice to the early onset of HIV in Chicago through the lens of a mainstream artist grappling with the dangers of being overtly explicit in his work, while his more personal gesture of the Roger Brown Study Collection and final artworks later in life operate as impactful, unwavering visibility that reaches far beyond the limits of his death.

1 Roger Brown, *Personal Correspondence*, Roger Brown Study Collection Archive, March 20, 1993.

2 Dennis Adrian, "Critical Reflections on the Development of Chicago Imagism," in *Chicago Imagism: A 25 Year Survey; Exhibition Davenport Museum of Art, December 3, 1994–February 12, 1995* (Davenport, IA: Davenport Museum of Art, 1994), 3.

3 Mitchell Douglas Kahan, *Roger Brown* (Montgomery, AL: Montgomery Museum of Fine Arts, 1980); Sidney Lawrence, ed., *Roger Brown* (New York: George Braziller, Inc. in association with the Hirshhorn Museum and Sculpture Garden, Smithsonian Institution, 1987).

4 "An Overview of Brown's Gifts to The School of the Art Institute of Chicago," Roger Brown Resource at SAIC, http://www.saic.edu/webspaces/rogerbrown/brown/overview.html [accessed August 2010].

5 Robert Bienvenull, "The Development of Sadomasochism as a Cultural Style in the Twentieth-Century United States," PhD diss., Indiana University, 1998, 244; Tracy Baim, *Out and Proud in Chicago: An Overview of the City's Gay Community* (Evanston, IL: Agate Surrey, 2008).

6 Domingo Orejudos and Tom of Finland, *The Art of Etienne* (New York: Target Studios, 1980).

7 This information was gleaned from oral interviews with Lisa Stone, Dennis Adrian, and William Bengston, July–November 2012.

8 Stone, Adrian, Bengston interviews, 2012.

9 Bill Utterback, "Up's Column," *Chicago Magazine* (1983): 13; Kim Levin, "Power to the Painter," *The Village Voice*, February 28, 1984, 78–79; Eleanor Heartney, "Arts Reviews," *Arts Magazine* 58 (May 1984): 97.

10 David T. Durack, "An Epidemiologic Maze," in *1984 Medical and Health Annual*, ed. Ellen Bernstein (Chicago: Encyclopedia Britannica, Inc., 1984), 25–37.

11 Stone, Adrian, Bengston interviews, 2012.

12 Roger Brown, Sketchbook, Roger Brown Study Collection Archive, 1993–97.

13 Jonathan Weinberg, *Male Desire: The Homoerotic in American Art* (New York: Harry N. Abrams, Inc., 2004), 161–77; Sander L. Gilman, "AIDS and Syphilis: The Iconography of Disease," *October* 43 (winter 1987): 87–107; Paula A. Treichler, "AIDS, Homophobia, and Biomedical Discourse: An Epidemic of Signification," in *AIDS Cultural Analysis Cultural Activism*, ed. Douglas Crimp (Cambridge, MA: The MIT Press, 1988), 31–71; Dennis Altman, "AIDS and the Reconceptualization of Homosexuality," in *A Leap in the Dark: AIDS, Art, and Contemporary Cultures*, ed. Allan Klusacek and Ken Morrison (Montreal: Véhicule Press, 1992), 32–43; Douglas Crimp, "How to Have Promiscuity in an Epidemic," in *AIDS: Cultural Analysis Cultural Activism*, ed. Douglas Crimp (Cambridge, MA: The MIT Press, 1988), 237–72.

14 Douglas Crimp, "Accommodating Magic," in *Melancholia and Moralism: Essays on AIDS and Queer*

Politics, ed. Douglas Crimp (Cambridge, MA: MIT Press, 2002), 203–21. For examples of how Johnson addressed the public or was discussed by the media following his public announcement, see "Magic Johnson's Full Court Press Against AIDS," *Ebony Magazine* (April 1992): 108–10; Laura B. Randolph, "Magic and Cookie Johnson Speak Out for First Time on Love, AIDS, and Marriage," *Ebony Magazine* (April 1992): 100–107; Randy Shilts, "Speak For All, Magic," *Sports Illustrated Magazine*, November 18, 1991, http://sportsillustrated.cnn.com/vault/article/magazine/MAG1140284/1/index.htm [accessed December 20, 2012]; Dave Anderson, "Sorry, But Magic Isn't a Hero," *New York Times*, November 14, 1991, http://www.nytimes.com/1991/11/14/sports/sports-of-the-times-sorry-but-magic-isn-t-a-hero.html [accessed December 23, 2012].

15 Calvin Reid, "Roger Brown at Phyllis Kind Gallery," *Art in America* (December 1, 1992): 112–13.

16 Johnny Meah, Jimmy Secreto, and Teddy Varndell, *Freaks, Geeks, and Strange Girls: Sideshow Banners of the Great American Midway* (San Francisco: Last Gasp, 2005).

17 Magic Johnson, "I'll Deal With It: HIV has Forced me to Retire, but I'll Still Enjoy Life as I Speak Out about Safe Sex," *Sports Illustrated Magazine*, November 18, 1991, http://sportsillustrated.cnn.com/vault/article/magazine/MAG1140267/2/index.htm [accessed December 20, 2012]. In this article, Johnson stated, "until last week I was just like so many other people in this country: I was ignorant of the reality of AIDS. . . . To me, AIDS was someone else's disease. It was a disease for gays and drug users. Not for someone like me." See also Samantha King, "The Politics of the Body and the Body Politics: Magic Johnson and the Ideology of AIDS," *Sociology of Sports Journal* 10 (1993): 270–85; Simon Watney, "The Spectacle of AIDS," *October* 43 (Winter 1987): 73; Jennifer Brier, *Infectious Ideas: U.S. Political Responses to the AIDS Crisis* (Chapel Hill: The University of North Carolina Press, 2009), 22–174.

Later, Johnson used his positive status and new awareness of the issues of AIDS to advocate for safe-sex education versus abstinence, more government action, and public social services. These are political positions that he continues to advocate to this day. Studies have shown that Johnson's later public discussion of HIV and AIDS and safe sex had an effect on larger public awareness, specifically for urban African American youth. For studies on Johnson's impact on safe-sex advocacy, see Philip H. Pollock III, "Issues, Values, and Critical Moments: Did 'Magic' Johnson Transform Public Opinion on AIDS," *American Journal of Political Science* 38, no. 2 (May 1994): 426–46, and Judith Tedlie Moskowitz, Diane Binson, and Joseph A. Catania, "The Association between Magic Johnson's HIV Serostatus Disclosure and Condom Use in At-Risk Respondents," *The Journal of Sex Research* 34 (1997): 154–60.

18 Roger Brown, letter to private collector, date unknown, from private collector's collection.

19 In March 1986, in the *New York Times*, William F. Buckley called for the mandatory tattooing of people with AIDS. William F. Buckley, "Crucial Steps in Combating the AIDS Epidemic: Identify All The Carriers," *New York Times*, March 18, 1986, A27. For a critical overview on the activist response to Buckley, see Richard Meyer, *Outlaw Representation: Censorship and Homosexuality in Twentieth-Century American Art* (Boston: Beacon Press, 2002), 225–27. In June 1987, Jesse Helms spoke on national television about the federal quarantine of people with AIDS. For an overview on that public declaration, see Meyer, *Outlaw Representation*, 218–23. See also Richard Meyer, "The Jesse Helms Theory of Art," *October* 104 (spring 2003): 131–48; Jennifer Brier, "Save our Kids, Keep AIDS Out: Anti-AIDS Activism and the Legacy of Community Control in Queens, New York," *Journal of Social History* (summer 2006): 965–87; Robert Atkins, "A Censorship Timeline," *Art Journal* 50, no. 2 (autumn 1991): 33–37. See also Judith Tannenbaum, "Robert Mapplethorpe: The Philadelphia Story," *Art Journal* 50, no. 4 (winter 1991): 71–76; Lawrence A Stanley, "Art and 'Perversion': Censoring Images of Nude Children," *Art Journal* 50, no. 4 (winter 1991): 20–27; Allen Ginsberg and Joseph Richey, "The Right To Depict Children in the Nude," *Aperture* 121 (fall 1990): 42–45; Steven C. Dubin, "The Trials of Robert Mapplethorpe," in *Suspended License: Censorship and the Visual Arts*, ed. Elizabeth C. Childs (Seattle and London: University of Washington Press, 1997), 366–91.

20 Meyer, *Outlaw Representation*, 238–44.

21 Alan G. Artner, "Brown Show A Questionable Achievement," *Chicago Tribune*, April 29, 1994, 74.

22 Mark Jannot, "Artist Provocateur," *Chicago Magazine* (October 1994): 86–89 and 118–21. 23.

23 Brown, letter to private collector, 3.

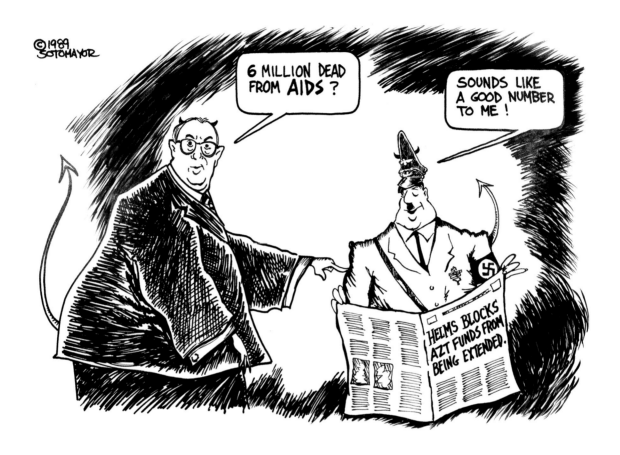

32
Daniel Sotomayor
6,000,000, 1989
Ink on vellum
11 × 14 in.
Sotomayor Collection, Courtesy
of Lori F. Cannon

Daniel Sotomayor
Chicago, Illinois
August 30, 1958–February 5, 1992

VICTOR SALVO

Daniel Sotomayor, a graduate of the American Academy of Art, was the first openly gay and nationally syndicated political cartoonist in the United States and co-founder of the Chicago Chapter of the AIDS Coalition to Unleash Power (ACT UP). The product of a difficult and complicated childhood spent in Chicago's Humboldt Park neighborhood, Daniel was of Mexican and Puerto Rican descent. He was also a gifted artist.

At odds with "The Angriest Queer" reputation he would eventually develop, Daniel was actually good natured, wickedly funny, and could be very mischievous. The direction of his life changed in 1987 when he discovered that he had been infected. Soon he was surrounded by others who had also tested positive for the HIV virus and, more significantly, were willing to talk about it. His circle rapidly grew to include emerging activists like Paul Adams—a talented graphic artist who would blaze his own trail into AIDS activism and become Daniel's mentor.

Daniel's story, like so many heroes of that era, unfolded rapidly, because the one thing nobody had was *time*. The fierce urgency of NOW accelerated everyone's plans and actions once the full extent of what AIDS was about to do became apparent. In 1987 it was not uncommon for a vital young man to come down with minor flu-like symptoms and be dead in six weeks. No one knew who would be next or how long it would take for death to find them.

Daniel became involved with C-FAR (Chicagoans for AIDS Rights) in 1988 and was one of those who championed that organization's metamorphosis into "ACT UP/Chicago," a transition that would begin fully in 1989. ACT UP, which was originally established in New York in 1987 by activists/historians Vito Russo and Larry Kramer, had exploded on the scene to challenge and shame recalcitrant politicians; to confront the medical, insurance, and pharmaceutical industries; and to give a creative outlet for the rage that had to be released alongside parallel efforts to establish caregiving agencies struggling to survive and take hold with no assistance from the federal government.

ACT UP became a lifeline for activists like Daniel who needed to focus their anger into leverage that could bring about real, lasting change in policy. He was impatient, very combative, and intolerant of stupidity or vacillation. Prone to reject any assertion of authority or privilege, Daniel would not take "no" for an answer. It was the perfect combination to fuel his activism. He quickly rose to prominence as

the central spokesperson for ACT UP/Chicago—to the everlasting relief of many and the eternal chagrin of others who found his particular style too off-putting even for an organization run by anarchists.

It was Paul Adams, Daniel's mentor, who convinced him to turn his frustration and anger with both the federal government—and ACT UP—into commercial art. Adams, who had been the reigning "Mr. Windy City" (a local gay-male beauty pageant) before emerging as an AIDS activist through ACT UP/Chicago, had also evolved into a journalist writing for *Gay Chicago Magazine*. Paul talked both Daniel, and the editors of *Gay Chicago*, into taking a stab at political cartooning. It was a challenge that would come to define the remainder of Daniel's life.

Daniel began producing his cartoons in 1988. Soon he was nationally syndicated, with his work appearing in papers across the country, making him the first (and only) openly gay and openly HIV-positive political cartoonist in the United States, quite possibly the world. By 1991 he had produced 147 political cartoons about AIDS that explored politics, religion, public policy, popular culture, and the internal dynamics of the gay community itself. In the process, he captured the nuances of the explosive battle around AIDS in real time—an accomplishment which, in retrospect, has come to offer a glimpse into not only Daniel's mind and heart, but also into the machinations of AIDS activism during a finite, but intensely critical, crucible of time in the history of AIDS: 1988 to 1991.

One of his earliest submissions captured a recurring theme in his work: the specter of Nazi Germany and genocide. In the late 1980s, the government was controlled entirely by the Republican Party, which was in the back pocket of the Christian Right. It had become obvious to anyone paying attention that the political and religious leaders who ran the United States at the height of the AIDS crisis had placed gay men in their crosshairs. His 1989 political cartoon *6,000,000* featured Congressman Jesse Helms of North Carolina, probably the most universally hated politician of the era next to President Ronald Reagan (pl. 32). Their failure to act in the earliest days of the crisis, when honest information about safe-sex practices could have saved thousands of lives, proved that Christian politicians like Helms and Reagan believed gay men were expendable. The comparisons to Hitler were easy to make.

Though Daniel's cartoon submissions struck a chord and were a hit, he was also almost immediately plunged into controversy. The pharmaceutical industry. The insurance industry. Law enforcement. Religionists. Politicians. Even gay "icons." No one was safe from his poison pen. He had also become a central figure in virtually every street protest "zap" staged by ACT UP/Chicago. He was known to use his press credentials (from whatever paper he was working for) to infiltrate press conferences—a practice that earned him as many enemies as admirers. One of *Gay Chicago*'s owners had deep connections to Chicago's established political bosses, none of whom were amused by the antics of Daniel Sotomayor. This led, not surprisingly, to him being fired in 1989, barely a year after he started. His cartoons were eventually picked up by another prominent weekly Chicago gay newspaper, *Windy City Times*.

The themes of his cartoons were always changing, influenced as much by contemporary events as by what was happening in his own life. The more central his activism became in his life, the more those lines blurred. In *Shame* (pl. 33), Daniel vented his rage at families who had rejected their gay sons by focusing on the

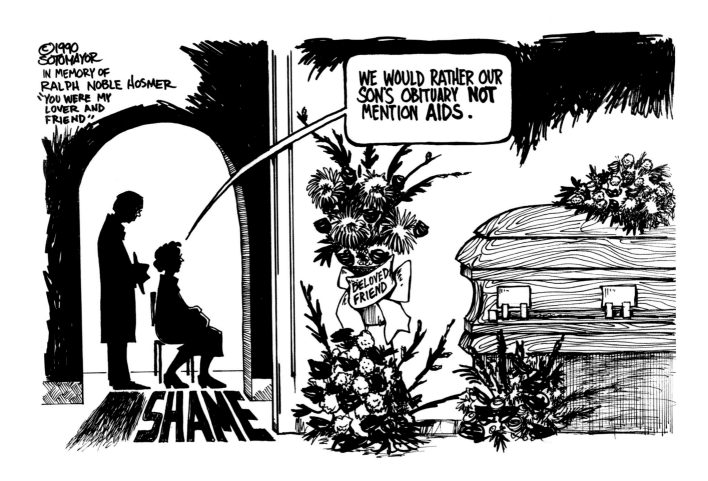

33
Daniel Sotomayor

Shame, 1990
Ink on vellum
11 × 14 in.
Sotomayor Collection, Courtesy
of Lori F. Cannon

Figure 1.
Photographer unknown, *Daniel Sotomayor Coordinates Street Protest Against Chicago Transit Authority*, 1989

parents of Ralph Hosmer. Daniel and Ralph had been lovers from 1975 to 1985. They remained devoted friends, providing care for each other until Ralph's death from AIDS in 1989. It was not unusual for gay men to provide care for former partners, especially because it was common for those with AIDS to be abandoned by their families. Daniel never forgave Ralph's parents for their unwillingness to face his illness honestly.

In the spring of 1989, Daniel took center stage in a huge public zap against the Chicago Transit Authority (CTA) to protest that agency's refusal to allow effective "Safe Sex Ads" to be posted on its buses and rail transit cars (fig. 1). Hundreds were arrested, Daniel among them. His cartoon that week was about the zap, which meant Daniel was effectively using his job at *Windy City Times* to reinforce his own activism. Similarly, in 1990, Chicago's participation in the National AIDS Actions for Healthcare brought thousands of activists out to shut down "The Loop" (downtown Chicago's central business district) and take over both the Cook County Building and the adjacent plaza. Now-infamous photos and video show Daniel, Paul Adams, Tim Miller, and other activists being dragged off a huge window ledge

Figure 2.
Photographer unknown, *Daniel Sotomayor Arrested at Cook County Building While Protesting the AIDS Actions for Healthcare*, 1990

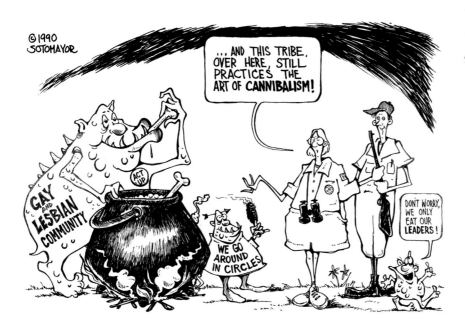

Figure 3.
Daniel Sotomayor, *Cannibalism*,
1990; ink on vellum, 11 × 14 in.
Sotomayor Collection, Courtesy
of Lori F. Cannon

after unfurling an enormous banner "WE DEMAND EQUAL HEALTHCARE NOW" (fig. 2). Once again, the most gripping visual of that day's news cycle was of Daniel Sotomayor. Additional zaps would follow a similar pattern. Daniel was fired by *Windy City Times* late in 1990.

Unemployed for the second time in a year, Daniel was uncertain about his future. The AIDS zaps were beginning to intensify but so was the rancor within ACT UP, where he was feeling increasingly marginalized. In *Cannibalism* (fig. 3), Daniel captured the internal dynamics of organizations that used smear tactics to destroy the leaders they had once followed. Daniel's star power was at the crux of the growing move to oust him. He had become the most recognizable face of AIDS activism in Chicago and that gave him much too much power within an organization that was supposed to have no leaders. But Daniel could not be contained. His activism, which had been keeping him alive, was now emblematic of the increasing stress and isolation in his life. Something had to change. Daniel quit ACT UP.

Daniel's syndicated cartoons had been picked up by the newest weekly newspaper called *Outlines*. Run by Tracy Baim—who had split off from *Windy City Times* shortly after co-founding that paper a few years earlier—*Outlines* was decidedly more politically savvy. It keyed into the activist zeitgeist that was rapidly overtaking the entire news cycle of gay papers across the country because of the death march AIDS was leading. In Baim, Daniel found a sympathetic and supportive friend who would continue to publish his cartoons—and tacitly endorse his activism editorially—until his advancing illness forced him to stop drawing in the fall of 1991.

As his own health slowly began to fail, Daniel grew increasingly philosophical about matters of aging and the folly of youth. A recurring theme was the dangerously blissful ignorance that gripped most young gay men who had no shortage of rationales for why they were not at risk for infection. Daniel had been one of them. His cartoon *Same Old Excuses* captured his sadness and frustration (pl. 34); it was also a portent for the community. It did not help that the mainstream media was fixated on the East and West Coasts, making it all the more difficult to get people to understand what was happening in Chicago. The problem was exacerbated

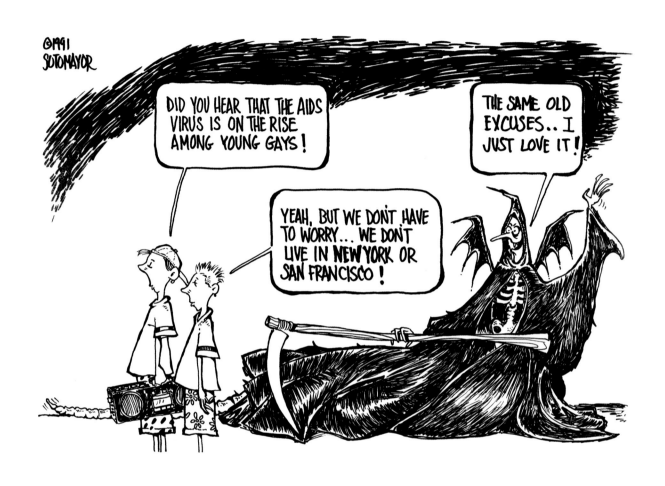

34
Daniel Sotomayor

Same Old Excuses, 1991
Ink on vellum
11 × 14 in.
Sotomayor Collection, Courtesy
of Lori F. Cannon

because many young people, especially in communities of color, did not pay strict attention to the LGBT press, which was seen as relating only to older white gay men. Combined with having to battle the government and the church, it was easy to believe gay men were doomed if young people of every stripe could not be persuaded to change their behavior.

Though world weary, like a championship boxer nearing the end of his time, Daniel had at least one major activist blow left to strike. Throughout his meteoric career, there was one man whose every inaction about AIDS inspired a seething rage: Richard M. Daley, the all-powerful mayor of Chicago. Without fail, Daniel managed to show up wherever the mayor was going to be. Daley was also a perennial favorite in his cartoons. If Daley said or did anything around the city's woefully inadequate response to AIDS, it was assured that Daniel would either be there to call him out on it or capture it in ink.

It was February of 1991, the night of the Impact Gala at the Chicago Hilton. (Impact was the dominant LGBT political action committee of that era.) The growing political clout of the LGBT community came with an expedient stop-over visit by the mayor of Chicago. Knowing in advance that the mayor was scheduled to attend, Daniel used his connections to breach the security cordon that was erected by LGBT political leaders to keep people (like him) out. As Daley and his entourage toddled down a side gallery to the main ballroom, Daniel emerged from the shadows without warning and, in a brilliantly timed flash, unfurled a hand-painted banner that said simply "Daley Tell The Truth About AIDS" (fig. 4).

It was a stunningly adept piece of political theater, complete with a photographer strategically positioned to snap a picture that crystalized what AIDS activists were up against: a community whose leaders were obsessed with sucking up to politicians while bodies were piling up like cordwood. That picture—taken mere seconds before Daniel was bodily thrown out of the building—is now one of the most famous in all the history of Chicago AIDS activism. And the banner he had made with his own hands is preserved to this day like it was the Shroud of Turin.

Figure 4.
Photographer unknown, *Daniel Sotomayor Confronts Chicago Mayor Richard M. Daley at Political Gala*, 1991

Figure 5.
Daniel Sotomayor, *Get Your AZT*,
1989; ink on vellum, 11 × 14 in.
Sotomayor Collection, Courtesy
of Lori F. Cannon

But the endless fighting—with politicians, the church, his employers, his friends, fellow activists—had taken its toll. He did not have it in him to fight them all *and* fight AIDS at the same time. Unknown to most people, Daniel had for years refused to take the only approved treatment for AIDS—azidothymidine triphosphate (known as AZT)—because of its notorious toxicity after building up for several months in the bloodstream. In *Get Your AZT* (fig. 5), he skewered the company most closely associated with the drug for profiteering at the expense of AIDS patients who could not escape the reality that the only available treatment for their illness was, itself, slowly killing them. Under these circumstances, the substance took on bleakly mythic proportions. In *Genocide* (fig. 6), he succinctly summarized how activists had come to view the faceless factories who pumped out AZT to a patient constituency with no other options.

Though he perhaps added two years to his life by *not* taking AZT, by the fall of 1991 Daniel was experiencing a rapid succession of increasingly serious medical crises. Then the bottom fell out. When he was rushed to the hospital in January 1992, we knew the end was near. Thus began the daily vigil. His lover—playwright Scott McPherson (*Marvin's Room*)—was also in the grip of failing health. All of us were caregivers for both boys, so we split our time between Scott at the house and Daniel at Illinois Masonic Hospital. When Scott was stricken with pneumocystis pneumonia a few weeks later, he, too, was brought to Masonic and assigned, not surprisingly, to Daniel's room. We watched in silence as the hospital staff moved the two small cabinets from the center of the room and slowly pushed their beds together so that Daniel and Scott could hold hands.

By February 2, 1992, Daniel was no longer responsive, but there was one last role we needed for him to play. If he could not do it, we would do it for him. We snuck Scott out of their hospital room—IVs and all—and brought him by limousine to the Chicago Hilton. It was the night of the Impact Gala, exactly one year from the night Daniel was bodily thrown out of that same function for having confronted Mayor

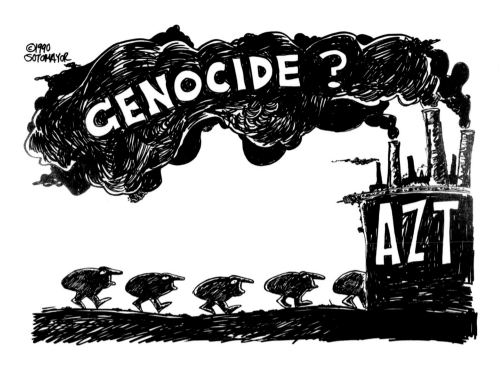

Figure 6.
Daniel Sotomayor, *Genocide*,
1990; ink on vellum, 11 × 14 in.
Sotomayor Collection, Courtesy
of Lori F. Cannon

Daley. But on this night, with Scott looking on, we accepted the Alongi Award—the LGBT community's highest political honor—which was bestowed on Daniel in recognition of his unrelenting, unapologetic AIDS activism.

Obviously, a lot had changed between 1991 and 1992. It was a turning point for Chicago's LGBT community, largely because Daniel had refused to be quieted—especially by his own people. The sycophantic accommodations our leaders had exchanged for tepid political favors had been replaced by a seething rage at the death toll of AIDS among Chicago's gay men. That was Daniel's legacy. In his death throes he had succeeded in punching through the bubble that had been created to forcibly separate street activists like him from the hallowed halls of political power. That night, when one thousand people leapt to their feet to applaud the sacrifices of the one man in Chicago who could not be there, we were all, finally, on the same side.

Daniel Sotomayor died three days later—on February 5, 1992—in the ICU at Illinois Masonic Hospital. It was the conclusion of four gut-wrenching years that were, at turns, horrific, haunting, healing, humbling, and heroic. We each remember it in our own way—as the worst of times . . . and the BEST. Those who were there the night Daniel's star went supernova knew we had a responsibility. *We were spared for a reason.* And, indeed, his closest surviving friends continue to work on behalf of the LGBT community in memory of the man who inspired us all.

✚ Why Art?

LORA BRANCH

There is a critical role for art in HIV/AIDS awareness, prevention, and care. In Chicago's African American communities, art and AIDS activism have taken many creative forms. Billboard campaigns, television programs, music, dance, and touring photography exhibitions are successful interventions where traditional public health strategies have faltered.

Navigating the intersection of art and activism is not always easy or comfortable. Efforts are often met with caution and censorship. To use artistic expression as an educational tool without weighing down its creative intent is a challenging calibration. When it works well, art used for public health allows for dignity instead of shame. Importantly, these efforts may provide the consumer with emotional space to independently interpret its meaning, apply its lessons, and participate in its story.

Public health activism and its intersection with the arts serve an important role in my life. It wasn't until the death of my own friends in the early 1990s that I realized that it played such a powerful role in my own healing. In my search for inspiration to keep going, I recognized that same desire in others to find beauty and meaning in a very dark time.

The Chicago Department of Public Health reports that there are more than 24,000 people living with HIV and still hundreds who die each year from AIDS-related illnesses. While new infections are at a record low, it still remains a serious public health threat with fewer than 50 percent at viral suppression.[1] To combat the threat that HIV poses, Chicago has built a dedicated workforce of researchers, clinicians, public health professionals, and community activists. Each group conducts interventions to achieve one primary goal: to change people's behavior. Whether it's wearing condoms, getting tested, getting in care, or remaining on treatment, behavior change is one of the most difficult things anyone can do.

In my experience, using artistic means to influence behavior or to change systems is met with different reactions. Images featuring positive sexuality can stir up sexism, homophobia, and racism. Visual imagery can raise questions and concerns. Is art an acceptable way to educate or inform? Can we simultaneously celebrate community and deliver an effective public health intervention? Should a strategy to reach people be socially acceptable and scientifically proven? By using art to inspire and communicate, are we breaking the rules? When these questions

35
Sharon Zurek, director
Lora Branch, executive
producer/writer
Kevin's Room, 2001
Video
60:00 mins.
Produced by the Chicago
Department of Public Health
and Black Cat Productions

emerge, they reflect the very reason why art is needed in the first place. That art can be so provocative that its mere presence can tap into the very "isms" that fuel the epidemic is illuminating. These "isms" are the very same forces that so desperately need to be addressed before the disease can be eliminated.

In our field, we continually ask a few central questions: how do we make the public realize that HIV is still an issue? How do we combat stigma, loneliness, fear of death, and public apathy? How do we share the success stories of those who are thriving without diminishing the challenges of those who struggle to survive? One thing we all agree on is that stories need to be told.

My Story

I'm a native Chicagoan. I grew up in Chicago's Englewood and Morgan Park communities on Chicago's South Side. My mom was an elementary-school teacher, and my father was a minister. My family was large, with seven kids, a few dogs, and loads of relatives always nearby. It was a warm and protected life that afforded me a sense of place in the world and room to create whatever I wanted and be whoever I wanted. That is, until I came out.

The early 1980s were a turbulent time in the world and especially in the Branch household on 109th and Sangamon. I came out as bisexual, got kicked out of my Christian home, eschewed college life to be a DJ in the fading disco/punk and emerging house-music scene, and surrounded myself with beautiful gay boys. I spent the next few years in and out of school, working part-time, and finding love. Life was good.

I would eventually graduate from Columbia College and find my voice and career path in social services and public health. I was drawn to HIV work because of those same beautiful gay boys, most of whom were sick and some of whom had died. I lost two of my best friends, Kevin B. and Kevin S. Both were young, vibrant guys in their early thirties, and both became HIV positive and died within a couple of years of their diagnoses. One Kevin was blinded from cytomegalovirus and remained bedridden for more than a year. It was a tough period, as theirs were just two of the many funerals I attended. There were so many young men in my community once alive, working, and dancing with me in our teens—now gone.

I looked for inspirational stories to deal with my own grief and to make sense of what was happening all around. There were so few stories for, by, or about Black gay men. There was nothing in the movies, nothing on TV except for flat caricatures on the occasional sitcom—usually the butt of jokes or the flamboyant, cackling friend to the straight girl lead. I would search high and low for the little media that existed and always came back to my question: where are the stories about my community?

Among the handful of relevant films was the remarkable documentary *Tongues Untied* by Marlon T. Riggs (pl. 17), the blisteringly honest portrayal of Black vulnerability at the beginning of the AIDS pandemic. There was also Jennie Livingston's 1990 film *Paris is Burning*, a critically acclaimed documentary that portrayed gay/trans life in the Ball scene of New York City. *Paris is Burning* remains important and deeply moving, but it is also a dark and tragic glimpse into the lives of its subjects, several of whom were sick or dead by the time the film received its prominence. Where could I find the people from my neighborhood and from my family? Where

were teachers, cops, business owners, social workers, handymen, and clinicians? Who is telling *their* stories?

I wasn't the only one who felt this way. One afternoon I had lunch with three friends, Kemina Glover, Janice Layne, and Jean Pierre Campbell. All three were writers who frequently contributed articles to *Blacklines*, an off-shoot periodical of Chicago's largest gay newspaper *Windy City Times*, published by Tracy Baim. We lunched in the cafeteria of the Chicago Board of Trade building on a snowy winter workday to brainstorm. We talked about how we might leverage our collective interests, connections, writing skills, and amateur television experience to create something by and for Black gay men and women (with emphasis on Black gay men). We debated varying approaches and agreed that a cable-access series was the short-term answer. I had previously produced a show for teens entitled *Rap-It-Up* and could recruit a willing crew for support. We would create a new program that could effectively reflect a wide swath of our community with characters of various ages, personalities, professions, and classes. We wanted something smart, subtle, and accessible—an afterschool special with a punch. We tossed around names and came up with *Kevin's Room*, in memory of our two friends named Kevin. The fictitious Kevin Manning would be a social worker actively trying to help Black gay men explore and navigate life's challenges while holding a secret of his own. Characters would show up to a support group and the drama would unfold.

We developed an outline and searched for funds. It occurred to me that the idea might be attractive to the new HIV/STD Commissioner Frank Oldham. Frank was a former public health leader from New York City who came to Chicago brimming with ideas, possibilities, and optimism. Frank was also the first Black gay man to lead the HIV division and, as such, had the power to prioritize innovative programming. The city invested in many public information campaigns—typically bus ads, posters, palm cards—but none were created specifically for men of color, the one group that experienced accelerating rates of new infections each year.

I shared with Frank our vision and outline for an eight-part drama series on cable access that would feature stories of Black gay men living with and at risk for HIV. Frank was excited by the idea and found a way to support it as an innovative social-marketing strategy. After a brief search, we identified Blackcat Productions, a company that understood the vision and helped us refine our thoughts and expectations. Instead of cable access, why not try a major broadcast? Instead of shorts, why not a 60-minute drama with real actors, real locations, and real film? Instead of just Chicago, why not worldwide?

The ideas and resources are critical to making a project like this succeed, but what's really needed is a champion. Frank was one such person. He helped quickly move the *Kevin's Room* project through the many channels of approvals, but it was not without challenges. We faced numerous script rewrites and endless consultations with advisers while searching for folks to work for free or very little compensation.

Despite these hurdles, the *Kevin's Room* script was finished, the cast and crew were set, and the film was shot in twelve days (fig. 1). We filmed at various Chicago locations, including an abandoned police station, a popular gay club, and in the homes of my family and friends. It was a grueling and rewarding experience. When production ended and we began the long editing process, I hoped that audiences

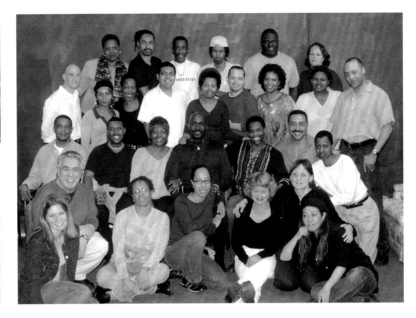

Figure 1.
Case for *Kevin's Room* VHS tape,
2001

Figure 2.
Cast and crew of *Kevin's Room:*
Trust, 2003

would find the characters as relatable as I did and that the story, while rooted in the experience of being Black, gay, and vulnerable, was appreciated as one about human beings.

Kevin's Room (pl. 35) first aired in 2001 on UPN Channel 50. The program was commercial free on a Sunday evening at 8 pm. The Friday before it aired, *Chicago Sun Times* writer Mary Mitchell, who was given a screener copy, opened her daily article with the sentence, "Thank you Lora Branch for keeping it real." My heart almost fell out of my chest in excitement that she enjoyed the film and encouraged her readers to watch—and they did. The program enjoyed a large viewing audience that evening and went on to be featured in numerous local, national, and international film festivals. We received awards and countless requests for special screenings and panel discussions. I was often amazed to arrive at a movie theater and see a line of people waiting (sometimes down the block) to see the film. This confirmation of the need to see Black gay men (and women) represented with dignity and wholeness was incredibly affirming and humbling.

We developed a second and third installment of *Kevin's Room* (in 2004 and 2006; figs. 2–3) to show the evolution of the characters over time and to introduce complex and challenging issues such as HIV serosorting, youth/adult relationships, infidelity, parenting, and community violence. Though more than a decade old, the films continue to be shown in waiting rooms, discussion groups, film festivals, on YouTube, and at special events across the country. The actors continue to be recognized for their contributions to the project, and the health department continues to support its legacy.

In addition to advocating for *Kevin's Room*, Frank formed a team to reframe the ways we could use media to raise awareness and fight HIV. Importantly, he recognized the dire need to reach difficult-to-access populations. Several amazing campaigns stemmed from his leadership, including *The Faces of AIDS* book and photo touring series (pl. 36, fig. 4). The campaign featured poignant stories of people living with or affected by HIV throughout the Midwest and was used as an advocacy tool to educate lawmakers, community leaders, and the public at large. The book was published in 2001 and distributed to more than twenty thousand people and

organizations. It was highlighted in the *Chicago Tribune* and other local and national media outlets for its searing portrayals of ordinary people leading courageous and extraordinary lives. The writer in the *Tribune* wrote: "Taken as a whole, they offer a remarkable testament of how HIV has invaded and changed whole communities." The touring exhibit featured beautifully framed posters and was displayed in Chicago's Cultural Center, O'Hare Airport, and numerous private and public events across the country.

The Chicago Department of Public Health's MOCCHA (Men of Color Coalition to Fight HIV/AIDS) media campaign was Chicago's first to show intimate portraits of men of color. To address the growing syphilis epidemic, the team also worked with contractors Jim Pickett and Judith McCray (of Juneteenth Productions) to conduct more than twenty focus groups to find the messages that would resonate with those most impacted. The focus groups revealed that people were eager to see average guys who weren't naked or sexual but relatable. This community feedback would inform one of the most impactful social-marketing campaigns to date (syphilis elimination). The campaign, along with a targeted testing blitz, resulted in a 20 percent reduction in new cases.

I continued my work with the Chicago Department of Public Health as the director of LGBT Health and later managing operations for the STI/HIV division. While there I collaboratively developed social-marketing and media campaigns to address HIV, STI, and substance use and abuse in the LGBT community. *Crystal Breaks* was one such campaign designed by advertising agency Lapiz/Leo Burnett Chicago to illuminate the challenges associated with the crystal-meth outbreak among gay men in Chicago (fig. 5).

The city's public health campaigns were incredibly important and creative devices to address the urgent public health crises of HIV. In the case of *Kevin's Room*, creating a story to combat stigma, homophobia, and racism was just as important as its message about testing, condom use, and adherence to treatment. Most importantly, the film allowed the viewers a glimpse into the characters' lives and to understand that their story was our story—of intimacy, love, longing, loss, and redemption.

Figure 3.
Promotional image for *Kevin's Room: Together*, 2006

Figure 4.
Inside page of *The Faces of AIDS* exhibition brochure, Chicago Department of Public Health

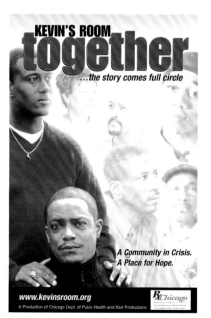

Other filmmakers have developed amazing projects since the debut of *Kevin's Room*. Patrik-Ian Polk's movie *Punks* (2001), as well as his series *Noah's Arc* (2005) and related movie *Noah's Arc: Jumping the Broom* (2008), were revolutionary with beautifully complex men and rich story lines dealing with HIV.

Nationally, the AIDS community has recognized the need for more and better images—those that disturb and those that inspire. LOGO and other media outlets, as well as many state and city health departments, have made great progress over the years to create campaigns and stories that are by and for Black gay men. Examples in many major cities like New York; Washington, DC; Miami; and Los Angeles include multidimensional people facing the real challenges of being at risk for or living with HIV.

There has never been a better time to stop the spread of HIV through scaled-up screening and prevention and to give those diagnosed a new lease on life through effective care. Art can and should be a critical vehicle to ensure knowledge of and access to these life-saving measures.

I am not living with AIDS, but the work remains a calling. I still miss my dear friends Kevin and Kevin. There are still too many people in my life who die prematurely from AIDS-related illnesses. While I'm saddened by the loss of these precious spirits, I am so inspired by those living with HIV who courageously tell their stories in spite of persistent stigma, judgment, and, in many places, persecution.

Figure 5.
Poster for *Crystal Breaks* campaign, Chicago Department of Public Health

All these heroes remind us that the fight is far from over. Where traditional public health pushes, art and activism pulls. When working well together, they inspire, empower, and educate. They challenge us in a way no single effort alone can do—to reach deeper inside and seek higher ground. Art reminds us that we must keep fighting until there is no more fighting left to do. I've never regretted the journey, and I can't wait for the day when we've won the fight.

1 *Healthy Chicago*, Chicago Department of Public Health HIV/STI Surveillance Report, December 2016.

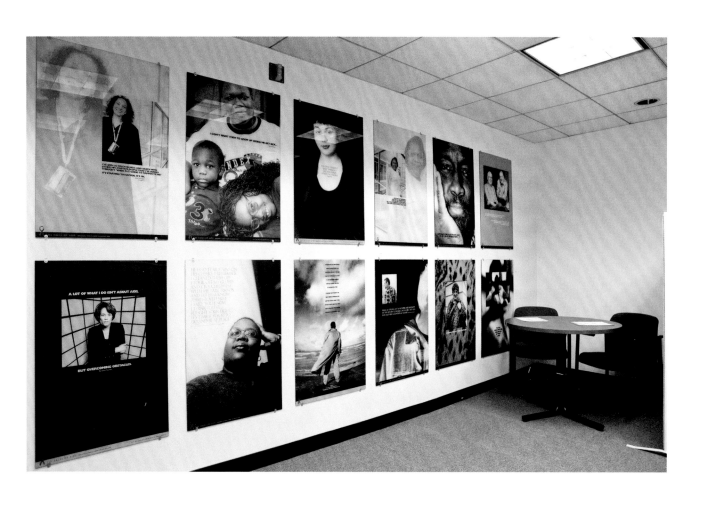

36
Various Artists

The Faces of AIDS, 1999–2000
Selection of twelve posters
Each: 36 × 24 in.
Commissioned by the Chicago
Department of Public Health

37
Israel Wright

Get the Point, 2000
Digital print from original
negative
13 × 16 in.
Courtesy of the artist

38
Israel Wright

Freely Carefree, 2000
Digital print from original
negative
16 × 13 in.
Courtesy of the artist

39
Israel Wright

Warm Embrace, 2000
Digital print from original
negative
16 × 13 in.
Courtesy of the artist

Israel Wright

Smoldering, 2000
Digital print from original
negative
13 × 16 in.
Courtesy of the artist

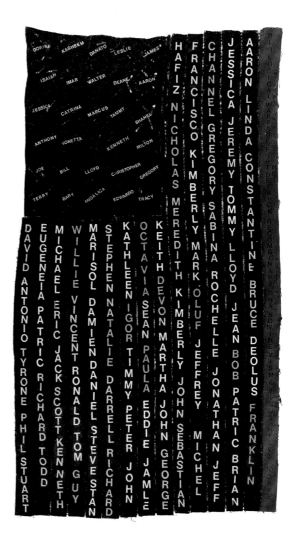

41
Howardena Pindell
Separate but Equal Genocide:
AIDS, 1991–92
Mixed media on canvas
75½ × 91 in.
Courtesy the artist and Garth
Greenan Gallery, New York

Let This Be a Lesson, or Caring for Historical Records

TEMPESTT HAZEL

I. Two Flags, Two Experiences

When asked about how AIDS impacted her and her work while living in New York City in the 1980s, and why she made the work *Separate but Equal Genocide: AIDS* between 1991 and 1992 (pl. 41), artist, curator, and activist Howardena Pindell explained,

> I lost thirteen friends from AIDS. And then I became very interested in how we weren't hearing the stats about children and infants who had died from AIDS. I called the local hospitals [in New York] and they said, 'well, we won't give you the last names, but we will give you the first names.' So, I made these two flags [which included those names] and I dedicated them to one of my cousins who died of AIDS. He was a very smart young man, went to Juilliard. He designed computer programs for Wall Street. He was only thirty-five-years old. And he had the experience of looking white. Some people saw him maybe as Latino, [though he was] Black. He said that his treatment was different—his health treatment. If he went to a hospital and they thought he was white, he would get one kind of treatment. And if they thought he was non-white he got another—that's why there are two flags.[1]

On unstretched canvas and pinned directly to the wall, *Separate but Equal Genocide: AIDS* hangs at just more than six feet tall, only slightly larger than life but still at a human scale. The edges of each flag are rough, their rectangular shapes slightly irregular, and where the fabric meets at the seam, lines are subtly empha-sized by pools of paint, or lack thereof, and the tiny openings where light and the other side shine through. With its displacement of the traditional red, white, and blue from their usual location, at first glance these stitched strips and squares of fabric don't quickly read as takes on the U.S. flag. That read is made more illegible since they were created in the reverse of how we are accustomed to seeing the flag, as ubiquitous and familiar as it is, with the white stars floating in a blue field at the top left corner and the red and white stripes stretching the length of the flag below it and extending to the right—all confined within a perfect rectangle. Or maybe what disguises its recognition is the extra stripes she included: fourteen on the lighter flag and fifteen on the darker one. Instead, these flags feel more quilt-like,

salvaged segments of something that welcomes the opportunity to be reclaimed and, once again, takes its proper place within something whole.

This work by Howardena Pindell could easily be positioned as a definitive, metaphoric work emerging from the 1980s and into the 1990s that represents the ways in which race operated during the earliest years of the AIDS epidemic and how it continues to this day. Even though as a group many of those who were suffering and struggling with the visible and hidden symptoms were ostracized from their own families and communities no matter their social status, class, or sexuality, there is still undeniable evidence of race-based discrimination within the affected group, as Pindell explains with her own story and illustrates in her work.

Although very similar, it's the differences between the two flags that make this work what I argue to be a brutally honest and biting symbol of AIDS in America that goes beyond an aesthetic expression of pain, a grappling with fear, a documentation of the realities people were experiencing, or a memorial to loved ones lost. This piece negotiates unacknowledged pain and collective disregard while pushing into the issues of racism, injustice, and blatant inequities. Every aesthetic decision by Pindell was a sharp and intentional homage to not only the thirteen friends and family members she had lost, including her cousin, but also those who looked for answers in New York City hospitals and those who had largely been written out of the story or faded from view willfully or unintentionally. With this piece, Pindell is attempting to hold the country accountable for what it says it believes and how that compares to what is actually demonstrated. All men, women, and children are not seen as equal, even when the fatal focus of their fight is not one that discriminates. AIDS transcends any identity markers that confront it, but people insist on infusing it with a human value system and suggestions of difference—all of which is explored in Pindell's piece.

Both flags are mostly blue but are drastically different in that one is a lighter, washed-out powder blue while the other is so dark in its hue that it reads as black, symbolizing a racial divide. Pindell shows her prowess as a masterful composer through what she chooses to emphasize versus what is encrypted, and how she manipulates the elements that are visible and foregrounded. Within the powder-blue flag, the symbols show through. You can clearly identify the stars and the stripes, while the names blend in as if they were threads, parts of the physical or metaphoric fabric of the flag or, in this case, the country. Or maybe that's not what they represent at all, but rather the names are being swallowed by the flag, eventually to the point of undetectability. The latter feels like the more likely case when considering the second, more deeply hued flag with its rich darkness absorbing the stars, stripes, and other elements. The names take over and push outward, assuming the position of stars and stripes simultaneously and pushing back at the shapes, colors, and color fields on which they are superimposed. They seem to be exerting their presence within a context that was attempting to consume or evaporate them, as seen with the other flag (figs. 1–2).

The one thing that is almost identical between the two parts is the bright red final stripe that runs the length of each flag at its right edge, which speaks to what I mentioned earlier; when left to its own devices, AIDS is an unbiased adversary. It's human behavior that builds biases. With this gesture the artist takes the discussion even further, suggesting that AIDS shouldn't be understood in isolation, but rather as a continuum within a history of genocide in the United States and biological

warfare starting with smallpox, which is known to have been weaponized against Native Americans in the eighteenth century. The red stripe contains lettering of its own, with terms like genetic engineering and hepatitis B vaccine.

The reason why I go into this in-depth read of *Separate but Equal Genocide: AIDS* is because when studying the work, I find it hard to imagine the exhibition *Art AIDS America* existing without it, although the original exhibition didn't include it. The show traveled from the West Coast in Los Angeles and landed in cities across the country from Tacoma, Atlanta, and the Bronx before settling in Chicago, where substantial additions to its roster were made, including the Pindell piece, hence the need for a new catalogue. The late addition of seemingly quintessential works like this one begs the question of what else is missing, which was the initial question that sparked the short essay, included at the end of this writing, that took me four months to conjure up after seeing this exhibition when it opened in Chicago in the winter of 2016. I couldn't find the words because my mind was stuck wondering if I was the only one who was seeing its neglectful tone.

It didn't take me long to discover that I wasn't the only one who was vexed by how the exhibition was a monumental memorial to AIDS in America and was celebrated as such but felt a bit like an alternate universe where Black people, Brown people, and women either didn't exist or weren't substantially impacted and didn't respond or react through visual language. But the statistics, national and global alike, say the contrary. Around the time that Howardena Pindell made *Separate but Equal Genocide: AIDS*, and according to the 1992 broadside commissioned by Visual AIDS and created by Glenn Ligon, Black people were 12 percent of the population in the United States but 29 percent of all AIDS cases. Fifty-three percent of all women with AIDS were Black and 26 percent of all men with AIDS were Black.

Figures 1 and 2.
Howardena Pindell, *Separate but Equal Genocide: AIDS* (details), 1991–92

Black children were 54 percent of all pediatric AIDS cases, and AIDS was the leading cause of death for Black women between the ages of twenty-four and thirty-six. You would be hard pressed to find this reflected within the exhibition until after it had already made its way through four cities.

From this oversight, a long list of questions emerges. Who takes responsibility for these omissions? Who needs to be held accountable? Do we have the historic mistreatment of the lesser-known stories of AIDS to blame for this work not being readily available, or was it also the responsibility of the curators to use this as an opportunity to dig deeper, seek out the hidden nooks, and generate new knowledge?

As much as I don't want to belabor this point, I feel the need to reiterate: if there's one thing that many of us know and all of us must always remind ourselves about history is that it is fundamentally flawed and fractured. There is a laundry list of reasons for this, such as the erasing of history as a strategy for gaining and maintaining power over people, the manipulation of history to justify imperialist and colonialist moves over centuries, the dilution of history to convince a people that their contributions to society, culture, and intellectual thought are minimal or nonexistent, or the distorting of history in a way that allows for the dismissal of a people's pain, suffering, and grief.

Although we don't always think of it this way, history is a mighty and ferocious tool. When done well, it has the ability to conjure up forces and galvanize coalitions of people who perhaps rarely or never had the privilege of fully knowing their lineage or their cultural, social, or geographic inheritance. An understanding and exertion of history can open our world in ways that were previously unimaginable and trigger a chain reaction that makes visible a hidden piece of human ancestry that we can no longer imagine living without access to. On the contrary, when it falls into neglectful, self-serving hands, the exploitation of history has the ability to cause the unraveling and erasure of entire cultures and truths.

But sometimes erasure is seemingly unintentional, and history becomes a victim of circumstance. When history isn't met with the resources and tools that allow for proper preservation—whether it be physical structures or the human history books who hold and transfer these knowledges—it runs the risk of being lost. Even in all its ferociousness, history is one of the most vulnerable and susceptible tools we have. Elders pass away every day. Entire archival and family collections end up destroyed because they deteriorate over time or are discarded. The keepers and caretakers of history make editorial and aesthetic decisions that prioritize some histories over others, writing out stories that will continue to remain buried just below the surface. Then, the vulnerabilities of history are further intensified when you overlay them with the realities of the most abandoned, fettered, and violently targeted populations of our planet. It makes clear the urgency of care that needs to be given and the fact that the weight of what's at stake is real.

When Western art conventions are employed as the primary tool for storytelling, entire populations of people are left out automatically. Art is a parameter that is inherently broken because it comes with its own history of discrimination and calculated amnesia that mimics other historical narratives but comes with problems distinctly its own.

Language, too, magnifies the areas of lack. While Luis Cruz Azaceta, Gerard Gaskin, Camilo Godoy (pls. 42, 43–45, 47), and a few of the other exhibited artists hail from Cuba, Trinidad and Tobago, Colombia, and Mexico, representation from across all of the Americas is low, which translates as America being used interchangeably with United States instead of stretching within the true geographic scope of the label to include South, Central, and other parts of North America.

All these things come to mind when I consider *Arts AIDS America* and the kind of development process that the first "final" exhibition demonstrates, and how that process was disrupted and its finished state uprooted as it traveled and transformed between Tacoma and Chicago. This exhibition serves as an example of how people push back against skewed narratives and how history strives for completion, because silence and neglect has been tolerated and accepted with welcoming arms within art history and curatorial practice for far too long.

It also serves as a case study for the shortcomings of art alone being used as a tool for addressing history in a dynamic way, given art's inherent social, economic, and cultural inequities. If left up to art as it is understood by conventional and Western art history, the story of AIDS and its national impact would be told primarily from the perspective of art's uplifted, mostly white, mostly male, golden children rather than finding ways to include the renegades who were operating outside of and adjacent to that narrative because they chose or have been forced to. Space must be made for those who harness a different kind of aesthetic strategy to make their work and tell their story. In this case, it means asking the questions and doing the deep long work that brings curators and art historians to art forms beyond a white Western lexicon and to the coded, cryptic, underground, and difficult-to-access expressions that emerged from the earliest decades of AIDS outside of white, privileged purviews.

II. On Generative Resistance and When Art Isn't Enough

We have the Tacoma Action Collective and many others who raised hell to thank for initiatives like #StopErasingBlackPeople and demanding more of curatorial work, ultimately making possible Alphawood's ability to move closer to a somewhat more inclusive and representative view of AIDS in America as explored through art over the past three decades. My words within this new catalogue likely wouldn't be happening had they not spoken up. There's a good chance that we would have missed out on added elements, like the exhibition *One day this kid will get larger*, curated by Danny Orendorff at the DePaul Art Museum, or the series of performances and events by *QUEER, ILL + OKAY*, had it not been for the work done in Tacoma. I, as a Black woman who has been impacted by HIV and AIDS personally through my family and loved ones, am forever indebted to them for their work. History, as a whole, is forever indebted to them for this work. For they have revealed future possibilities for and paved a way to a new approach for how curatorial work of this kind can be responsive, and how it should be done: by centering the perspectives and voices of those most impacted and marginalized—the ones most often hiding in plain sight within the discussion.

They also demonstrate that an exhibition like this must never be presented with a period but rather an ellipsis, because you'll never know the full story, which is an inherent inadequacy of curatorial and excavation practices that focus on

uncovering and presenting watershed moments in history. This exhibition missed the opportunity to posture itself as a provocation and a moment of pause in research in order to present what they found, call out the challenges they had with finding more work that speaks to what women of color and all other Black and Brown folks experienced, and be a project for discovery rather than the rigid thesis with which it was originally introduced.

Imagine if the exhibition had been initially developed and visualized to be what it was instead forced to become through several years of resistance and protest. What histories would have been unearthed organically? Who would we have found? What stories would we now know and be able to weave into the narratives we keep about AIDS in the United States, disrupting what we think we already know? We can only hope for those types of fruits from curatorial labor, because sometimes curators don't know or, in some cases, don't have access to those stories or collections. Those stories are the ones that take time to discover, and trust has to be built by showing up, listening more than speaking, and stepping into emotionally dense and guarded situations. Like the histories of most of the people who are silenced, you won't find many, if any, points of reference in the art collections of museums. You won't find many in the celebrated private collections of individuals. What I've learned as a curator who spends a majority of my time doing curatorial research, inhaling dust and sifting through forgotten boxes of personal archives and collections, is that the real gems are locked in the attics, basements, cabinets, drawers, and closets of those who haven't been inducted into art and history's institutional grips. It takes more than a search through a well-kept online database, flipping through the pages of history books, looking through the climate-controlled bellies of museums, and tapping into the minds of scholars in academia to find the materials that transform history. When people's lives and legacies are at stake, relentless curiosity, questioning, listening, humility, integrity, and patience are key. And curators must, to a certain extent, throw their own ideals and ego to the wind. A curator must let the content shape the form, not the other way around, meaning sometimes one must admit when art just isn't enough.

To that point, last fall while in Los Angeles, I was able to catch the exhibition *Axis Mundo: Queer Networks in Chicano L.A.*, an exhibition that started off as a massive archival research project on the life and legacy of artist Mundo Meza and quickly evolved into an in-depth excavation project on a largely untold history of queer artists, activists, and communities in Southern California (fig. 3). Although this was an art-historical exploration, they knew to start with the archives, because that's where the histories of artistic responses, politics, activism, and even the impact of the AIDS crisis collide through everything from mail art to zines, to protest signs and videos, sketches, photography, fashion, notebooks and other materials held in private, personal archives and cared for by loved ones. While art was naturally an important element because it was the work of Meza that sent them down this magnificent rabbit hole, the curators of *Axis Mundo* understood that a deep relationship with the ONE National Gay and Lesbian Archives at the USC Libraries was a critical part of this exhibition's development. Although the exhibition is arguably the most ambitious and largest in scale to date, *Axis Mundo* wasn't the first and only exploration into queer Chicano/a history done up to this point. It was visibly building on a series of smaller or more focused looks into those legacies, and the curators made a point to acknowledge that.

I remember moving through the multisite exhibition, studying the marvelous paintings of Mundo Meza and reading the postcards of Joey Terrill, wishing *Art AIDS America* had developed in this way and incorporated more archival "nonart" materials into the exhibition. *Axis Mundo* had a richness and abundance that made me a little embarrassed that I didn't know the story of these artists and activists who had oscillated between the street and the studio on behalf of and while moving through queer communities in the United States. It felt good to have my knowledge and awareness expanded.

In the opening essay of the exhibition catalogue, curators C. Ondine Chavoya and David Evans Frantz beautifully sum up their understanding of and approach to the project, while articulating the vast range of materials they encountered along the way as well as the gaps of the exhibition:

> As both a curatorial and scholarly endeavor, this project is deeply informed by the bounty of archives as a site of historical research and creative possibility, while acknowledging its haunting absences, omissions, and failings. Thus, *Axis Mundo* reflects the dueling pulls of the archive and nontraditional archival formations, or what has been termed by scholar Ann Cvetkovich the "archive of feelings." Extending beyond the walls of archive and counterarchive—the places one goes for "research" proper—the "archive of feelings" can encompass the physical materials (as well as conveyed memories) that friends, partners, and family members have assiduously and lovingly safeguarded: artworks, photographs, slides, letters, notebooks, school records, and other possessions. Always on the lookout for such materials, in many instances we were the first to inquire about such items. While many

Figure 3.
Installation view of *Axis Mundo: Queer Networks in Chicano L.A.*, MOCA Pacific Design Center, Los Angeles, 2017

Figure 4.
Emilio Rojas with Paul Escriva,
*The Dead Taste Sweeter
Than the Living (After Felix
Gonzalez-Torres)*, performance
at Alphawood Gallery, April 1,
2016

of the works included in *Axis Mundo* are deeply cherished objects, some hold a particularly poignant affective charge informed by loss and care.[2]

As a result of their work and research, several personal archival collections and papers have found a permanent home at ONE, ensuring their preservation, care, and accessibility for artists, scholars, curators, and others to explore as long as ONE exists.

If I were to attempt to answer my earlier question of curatorial responsibility and accountability, I would say that it is the responsibility of the curator to do due diligence. It is the responsibility of the curator to understand that while they may hold a significant amount of knowledge, curatorial practice is not a perfect art form. It has its problems and challenges, and it is the responsibility of the curator when handling massive moments in history to acknowledge those facts and tackle them bravely, with transparency, and with purpose.

III. Artists Embodying History and Controlling Their Legacies

Due to the AIDS crisis, an entire generation of artists, muses, and scribes was lost far too soon. Although he was able to produce a significant body of work in his short lifetime, Meza is one of those examples of an artist who left us wondering what he could have accomplished had his career continued far beyond 1985 after passing from complications due to AIDS. It's hard not to think of the artists, like Meza, whose lifework was never able to fully manifest because they never got the chance to fully step into the rising tide of their careers, or those who had to give up their work under the weight of their struggle and that of the people around them. I think about Howardena Pindell's cousin and the performances he never had the chance

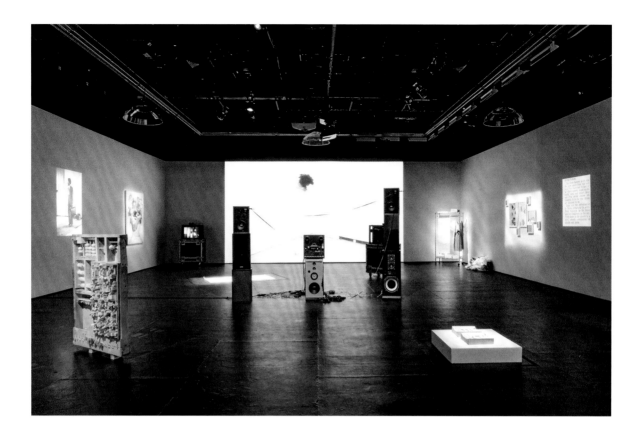

Figure 5.
Julius Eastman: That Which is Fundamental, Exhibitions A Recollection. + Predicated. The Kitchen, NYC, 2018, curated by Tiona Nekkia McClodden

to make for himself or share with the world. My heart aches for those whose ideas, gestures, and curiosities we will never have the pleasure and thrill of knowing.

But my heart swells for instances where work by these artists we thought we lost is given its proper due and is patched together like the fabrics of Pindell's flags. Artists have always and continue to find ways to embody history, giving new life to the stories waiting in the wings to be pulled into the spotlight. Artists are also ambassadors who bring a contemporary lens to historic ideas and artworks, which was the case with performances like *The Dead Taste Sweeter Than the Living (After Felix Gonzalez-Torres)* by artist Emilio Rojas with Paul Escriva (fig. 4), which moved between DePaul Art Museum and Alphawood Gallery, where the artists harnessed and embodied the energies of each exhibition and filtered it through the themes and motions they explore within their work.[3] I find these to be some of the most compelling strategies to provide the kind of care, consideration, and recontextualization that is long overdue when it comes to AIDS in the United States.

Another example of this kind of work is woven throughout the practices of interdisciplinary artist and curator Tiona Nekkia McClodden, whose work considers the concepts of biomythography, a term used by and borrowed from writer Audre Lorde, as well as re-memory and the overlaps and differences between truth and fact.[4] With a list of citations and a dose of nostalgia, the investigations and themes at the center of many of McClodden's works have helped spotlight or uproot distorted biographies of important artists who are no longer around to tell their own stories and now rely on the memories of others and the contents of archival materials to help fill in the gaps.

Over the past three or four years, McClodden has been developing a trilogy in this spirit. For one part of the trilogy, McClodden created a suite of film works that uses the strategy of embodiment to respond to poet Brad Johnson's archival

materials and biography. Another part of the trilogy, *Julius Eastman: That Which Is Fundamental*, opened in January 2018 at The Kitchen in New York City and explored the life, work, and influence of composer Julius Eastman, a Black gay composer, vocalist, and dancer who was actively producing provocative postminimalist music and performing internationally at the height of the AIDS crisis (fig. 5). For this project, McClodden and co-curator Dustin Hurt sought to reveal more than four years of research on Eastman by sharing his collection of archival materials, scores, and recordings and presenting it in a series of concerts, programs, and an exhibition. Through this project, they were able to expose his masterful works to a new audience of artists and music lovers and derail the skewed and most widely circulated telling of his story, all while bringing his body of work back to a space that championed him during his career. McClodden and Hurt's work made clear the richness of Eastman's legacy and how history is never static or set in stone. Previously, if you were to research Eastman's story, you would likely first be met with the tragic fact that he passed away young and homeless (not due to complications from HIV or AIDS), at the age of forty-nine. Now, you might first be compelled to listen to the twenty-nine-minute masterwork *Gay Guerrilla* or one of his other epic compositions.

Additionally, artists are working hard to ensure that they don't fall victim to historical neglect or erasure by making the preservation of their practice and their image a personal priority or an integral element of their process and artistic production. Chicago-based transdisciplinary artist Rashayla Marie Brown is known for her photographic self-portraits and performances in which she centers her body and uses excessive, compulsive, and performative documentation tactics as a way to have control over her own record and provide undeniable evidence that she, her work, and her ideas exist.[5] The hope is that no future curator, historian, scholar, or anyone else who taps into the historical record looking for artists or work like hers will struggle to find her name in the mix. That might be hard to imagine in the image-saturated era we find ourselves in, but why take that risk if history provides abundant examples of this happening?

There's also Patric McCoy, a Chicago born and raised retired environmental scientist, art collector, and photographer who is currently going to great lengths to catalogue, preserve, and find a permanent home for his collection of more than 1,300 artworks, photographs, and ephemera, with the goal of keeping it all intact (fig. 6). In addition to being one of the few documenters of Chicago's Black gay communities, as seen through his photographs and portraits of key figures, everyday people, and nightclubs in 1980s Chicago (pls. 1, 19–22), he is a strong advocate for the preservation and collection of original artworks by artists of the African diaspora. McCoy helps spread this message through Diasporal Rhythms, an organization he co-founded in 2003 with Carol J. Briggs, Joan Crisler, and Daniel T. Parker. McCoy's work as a collector and supporter of Black artists always comes with an undertone that stresses the importance of communities being the keepers and caretakers of their own histories.

IV. Lessons Learned

In no way do I claim to be an expert or someone who is well versed in the ways in which AIDS was and has been aestheticized and responded to by artists over the years, but I do identify myself as an asker of questions and have self-diagnosed

Figure 6.
Patric McCoy with his art
collection

myself with chronic curiosity. This is why my words are included in this revised *Art AIDS America* catalogue for Chicago. When I initially saw the exhibition, I couldn't help but move through it with the spirit of one of my dearest friends, who is currently living with HIV, walking alongside me. I could hear their voice whispering in my ear, wondering where they could find themselves in the show. But this exhibition, while flawed, served as an important spark that led all of us witnesses and truth seekers down a fraught path of acknowledgment and inclusion. And it led me into a series of questions around curatorial practice, ultimately forcing me to reflect on my own approach, the approaches of other curators and artists, and other players within the ecosystem of historic construction.

If there are lessons to be learned, they are these:

If something is about you but doesn't appear to be for you or include you, and you feel compelled to call it out, do it.

Being held accountable in the name of the historical record may be rough, but it's absolutely necessary. As cultural producers, we should always be grateful for any pushback we receive, because incredible leaps can happen in its wake. And it lets you know that people are paying attention. Hear it and respond accordingly—whether that means standing firm in your beliefs or making adjustments—for it makes the work stronger.

Building on the last lesson, while the challenges of shaping curatorial narratives are many, accountability in curatorial practice and scholarship is important. Neglect can't be tolerated. Be patient and take time to dig and discover, and widen your search.

Sometimes, you must let content shape the form, not the other way around. Tone-deaf or rigid curatorial and artistic practices only exacerbate the problems of fragmentation and neglect when it comes to historical narratives.

History is in constant need of revision, so it makes sense that the vehicles we use to tell history should be flexible in response to those revisions, which is why *Art AIDS America* is an interesting case study for how an exhibition shifts and changes according to how the public interacts and responds to it.

And finally, understand what's at stake. Inclusivity is not optional. Artistic practices that embody history are not just art making, and curating of this kind is not just exhibition making. They are history making. The stories we tell have the potential to live on long after we're gone through the work and research of future artists, scholars, and curators. That's a damn big deal. Never lose sight of that.

V. Origin Story: When the End is the Beginning

I wrote the following short essay, "When the End is the Beginning," over the course of four months, or the run of *Art AIDS America* in Chicago.[6] It was published in March 2017, just a week or so before the show's closing:

> In the final minutes of *Viral Representation: On AIDS and Art*, a day-long conference held at the University of Chicago's Logan Center that presented research on artistic responses to AIDS as part of the exhibition *Art AIDS America*, I found the nerve to raise my hand and pose a question to the roundtable that included all twelve speakers who presented or spoke that day.
>
> "Where are the women?"
>
> Tangled up with many other unnecessary words, the question slipped out of my mouth clumsily as words do when they've been stuck in my throat for a while. There was a heavy silence that followed as the speakers, only two of which were women, looked at one another to see who would offer a response.
>
> Joshua Chambers-Letson, an assistant professor of performance studies at Northwestern, cut the silence by refining my question—"women of color."
>
> Where are the women of color? Or the women? Or the people of color? Or youth? And others largely omitted from these conversations and this research? Where is the information buried? These questions—which have been raised by others such as Kia LaBeija and Sur Rodney (Sur)—have been on my mind since I first went to see the show at the Alphawood Foundation's newly adapted exhibition space in Lincoln Park. These questions seemed like obvious ones. They were the loudest silences in the building during my walkthrough of the exhibition with curator Jonathan Katz back in December. While not completely absent from the exhibition, the low presence of these voices within this art-world context doesn't quite reflect the scale of the nationwide impact that AIDS was having (and continues to have) on these communities within the U.S. during the 80s and 90s. If one were to rely solely on what the gallery walls tell us, a viewer might be led to believe that the artistic response to AIDS began as a mostly white American undertaking that revolved around gay men.

That narrative begins to expand once you start to dig into the other parts of the exhibition. The catalogue, packed with essays, additional points of reference, and beautiful plates for each work, offers more information for those who are curious, though it only goes so far as to include works from the original exhibition and not the artists who were added to customize the show based on each new location as it traveled starting with a preview version in Los Angeles to full versions in Tacoma, Atlanta, and the Bronx before settling in Chicago. (Chicago's iteration had the largest addition to the exhibition roster with several relevant local artists incorporated into the checklist.)

Then, Chicago showed up as only this city can through an ambitious lineup of programs presented by Alphawood Foundation, *QUEER, ILL + OKAY*, and a long list of partners in many corners of the city. The exhibition was pulled further into a present-day context through performances, talks, symposia, screenings, AIDS education events, tours, readings, and sister exhibitions—all of which helped to address the blind spots and blanks left exposed in the voids between works on gallery walls. It was in the programming where women, people of color, the Ls, the Bs, the Ts, the Qs, and many others who are obscured from view were given microphones.

Although we are often told to consider programming, publications, and the objects on display all as separate components that together make the whole, the truth is that these parts aren't circulated and moved forward in history in the same way. Some parts stick while others evaporate or become fragments, remembered in the minds of individuals, photos on a hard drive, a buried Facebook post, or a video in the abyss of YouTube. These events reminded the curator in me of the inherent limitations of static exhibitions and why programming is so important. Then, it reminded the historian in me of how often programming is ephemeral and doesn't reach as wide an audience as an exhibition does while a catalogue, often created leading up to an exhibition, fails to document the important dialogues and art generated once artists, writers, scholars, advocates, and the public encounter it. All parts of an exhibition are not treated equally by history and our collective memory. Chances are the work that comes after *Art AIDS America* will be built primarily from what was easily commodified—in this case, the catalogue and maybe websites and reviews, along with some printed programs and other collateral. But this work is far too important to let its elements slip away.

It took me over three months to write about this because I needed to watch how it all unfolded. Also, for me, the conversation around *Art AIDS America* being presented in Chicago wasn't simply about creating press around this opening moment. Nor was it about the giant and generous gesture of the Alphawood Foundation to make space for this exhibition when other major institutions decided not to. More than anything, *Art AIDS America* provides an historical backdrop to the complexities of these three A's—art, AIDS, and our country. It is a physical, mental, cultural, and extremely personal site for shaking out the nuances. As silly as it would be to claim that exhibition making is easy, the truth is that doing the research, collecting the work, developing didactic materials, and mounting it in a space is

the easy part of this project when compared to the work that comes next, which is to address the big questions that remain: Why are people of color largely absent from the mainstream understanding of the early impact of AIDS in the United States, and even more so in conversations about the artwork that was made in its immediate wake? With so many people of color, particularly African Americans, affected by HIV and AIDS making up such a small piece of the most widely circulated foundational narratives, what is the curator's role in derailing those fractured histories? How do we measure due diligence in scholarship and curatorial practice? Then, what conversations need to be had about the privilege and the freedom to fight and struggle in public versus having to pick and choose your battles because deciding between fighting for the survival of a wider community impacted by AIDS and fighting for your own individual survival as someone who is othered within the othered (positive, queer, woman, of color) can all be considered a matter of life and death?

I say this not as a negative critique of *Art AIDS America*, but more as a critique of the fragmenting nature of exhibition making, and as a call to those building on this history. I challenge those of us who work to fill in the gaps and pull these stories forward to see this as a point of departure into further and fuller research. I challenge us to find additional ways to capture what happened here, seek out the voices that are missing, and thoughtfully pursue a variety of ways to make this information easily accessible five, ten, or fifty years from now.

I have to say it again. Creating an historic exhibition that is anchored in the early years of AIDS and tracks its cultural and social impact in the U.S. is by no means an easy task. The work presented and uncovered is nothing short of admirable and incredible. But the shaky responses to the question I posed at the Logan Center make clear that there is still quite a bit of work to be done.

And still, I stand by these words.

1 Howardena Pindell in conversation with Naomi Beckwith and Valerie Cassel Oliver during the opening weekend of *Howardena Pindell: What Remains to be Seen* at the Museum of Contemporary Art Chicago on February 24, 2018.

2 From the essay "Axis Mundo: Constellations and Connections," written by C. Ondine Chavoya and David Evans Frantz for the catalogue *Axis Mundo: Queer Networks in Chicano L.A.*, 2017.

3 A multimedia performance inspired by the *Art AIDS America* exhibition at Alphawood Gallery and the companion exhibition *One day this kid will get larger* at DePaul Art Museum. It was a mobile, interactive event that took place at both art spaces with a procession in between on April 1, 2017.

4 This refers to Audre Lorde's book *Zami: A New Spelling of My Name—A Biomythography* (Freedom, CA: Crossing Press, Inc., 1982).

5 Rashayla Marie Brown's work came up during a conversation with Danny Orendorff, who had heard her speak at the Mary and Leigh Block Museum of Art in Chicago during a talk titled "Reframing Visibility" as part of the program "Five Takes on Tseng Kwong Chi" for the exhibition *Tseng Kwong Chi: Performing for the Camera*.

6 This essay was originally published on *Sixty Inches From Center* on March 28, 2017. It was the introduction to an interview with curator Jonathan Katz.

Luis Cruz Azaceta

AIDS, Time, Death, 1989
Acrylic and ink on paper
41 × 29½ in.
Courtesy of The New School Art
Collection

43
Gerard Gaskin
Charly and Mathyas, Ebony Ball,
Manhattan, NY, 1997
Archival inkjet print
24 × 16 in.
Courtesy of the artist

44
Gerard Gaskin

Latex Ball, Manhattan, NY, 2011
Archival inkjet print
16 × 24 in.
Courtesy of the artist

45
Gerard Gaskin

*Jasmine and Vanessa at Eric
Bazaar Ball, Brooklyn, NY*, 1999
Archival inkjet print
16 × 24 in.
Courtesy of the artist

46
Kia LaBeija

Eleven, 2015
Inkjet print
16 × 24 in.
Courtesy of the artist

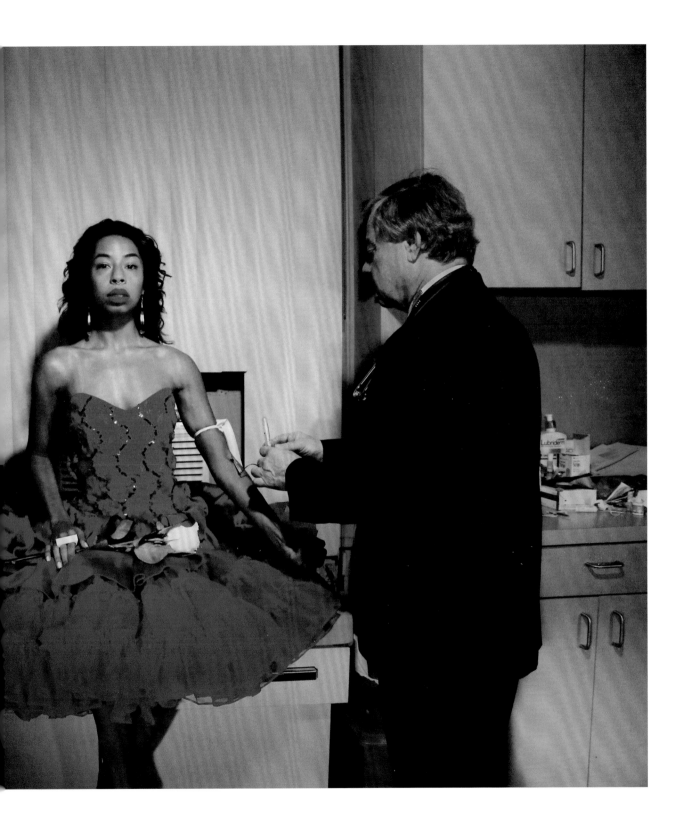

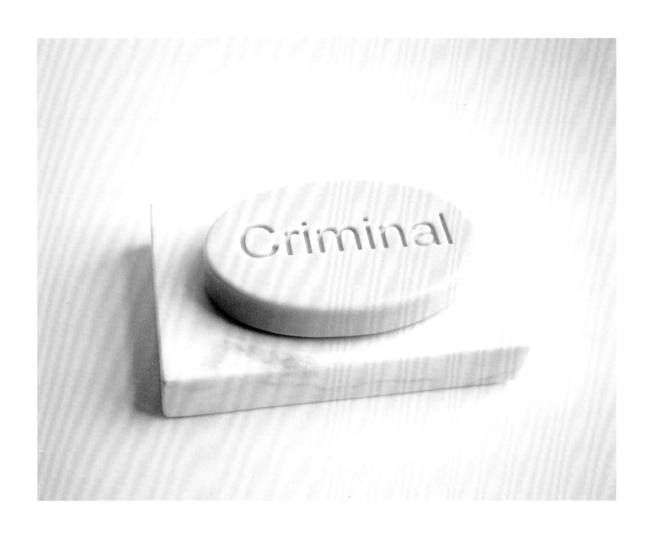

47
Camilo Godoy
Criminal (Illinois, 720 ILCS 5/12 –
5.01), 2013/16
Lavender, blood, semen, HIV,
and soap dish
3½ × 2¼ × ¾ in.
Courtesy of the artist

720 ILCS 5/12-5.01

Sec. 12-5.01. Criminal transmission of HIV.

(a) A person commits criminal transmission of HIV when he or she, with the specific intent to commit the offense:

 (1) engages in sexual activity with another without the use of a condom knowing that he or she is infected with HIV;

 (2) transfers, donates, or provides his or her blood, tissue, semen, organs, or other potentially infectious body fluids for transfusion, transplantation, insemination, or other administration to another knowing that he or she is infected with HIV; or

 (3) dispenses, delivers, exchanges, sells, or in any other way transfers to another any nonsterile intravenous or intramuscular drug paraphernalia knowing that he or she is infected with HIV.

(b) For purposes of this Section:

"HIV" means the human immunodeficiency virus or any other identified causative agent of acquired immunodeficiency syndrome.

"Sexual activity" means the insertive vaginal or anal intercourse on the part of an infected male, receptive consensual vaginal intercourse on the part of an infected woman with a male partner, or receptive consensual anal intercourse on the part of an infected man or woman with a male partner.

"Intravenous or intramuscular drug paraphernalia" means any equipment, product, or material of any kind which is peculiar to and marketed for use in injecting a substance into the human body.

(c) Nothing in this Section shall be construed to require that an infection with HIV has occurred in order for a person to have committed criminal transmission of HIV.

(d) It shall be an affirmative defense that the person exposed knew that the infected person was infected with HIV, knew that the action could result in infection with HIV, and consented to the action with that knowledge.

(d-5) A court, upon a finding of reasonable suspicion that an individual has committed the crime of criminal transmission of HIV, shall order the production of records of a person accused of the offense of criminal transmission of HIV or the attendance of a person with relevant knowledge thereof so long as the return of the records or attendance of the person pursuant to the subpoena is submitted initially to the court for an in camera inspection. Only upon a finding by the court that the records or proffered testimony are relevant to the pending offense, the information produced pursuant to the court's order shall be disclosed to the prosecuting entity and admissible if otherwise permitted by law.

(e) A person who commits criminal transmission of HIV commits a Class 2 felony.

48
Michael Qualls

Origins, 1999
Mixed media on wood with
bitumen
14 × 6 in.
Courtesy of Patric McCoy
Collection

49
Michael Qualls

Secrets, Blood, and Bones, 2000
Mixed media on wood with
bitumen
14 × 6 in.
Courtesy of Patric McCoy
Collection

50
Frederick Weston
Blue Bathroom Series: Lifestyles/
Sexual Energy, 1999
Collage
11 × 8½ in.
Courtesy of the artist

51
Frederick Weston

Blue Bathroom Series: Medication,
1999
Collage
11 × 8½ in.
Courtesy of the artist

One day this kid will get larger. One day this kid will come to know something that causes a sensation equivalent to the separation of the earth from its axis. One day this kid will reach a point where he senses a division that isn't mathematical. One day this kid will feel something stir in his heart and throat and mouth. One day this kid will find something in his mind and body and soul that makes him hungry. One day this kid will do something that causes men who wear the uniforms of priests and rabbis, men who inhabit certain stone buildings, to call for his death. One day politicians will enact legislation against this kid. One day families will give false information to their children and each child will pass that information down generationally to their families and that information will be designed to make existence intolerable for this kid. One day this kid will begin to experience all this activity in his environment and that activity and information will compel him to commit suicide or submit to danger in hopes of being murdered or submit to silence and invisibility. Or one day this kid will talk. When he begins to talk, men who develop a fear of this kid will attempt to silence him with strangling, fists, prison, suffocation, rape, intimidation, drugging, ropes, guns, laws, menace, roving gangs, bottles, knives, religion, decapitation, and immolation by fire. Doctors will pronounce this kid curable as if his brain were a virus. This kid will lose his constitutional rights against the government's invasion of his privacy. This kid will be faced with electro-shock, drugs, and conditioning therapies in laboratories tended by psychologists and research scientists. He will be subject to loss of home, civil rights, jobs, and all conceivable freedoms. All this will begin to happen in one or two years when he discovers he desires to place his naked body on the naked body of another boy.

One day this kid will get larger

DANNY ORENDORFF

One day this kid will get larger was an exhibition throughout which I attempted to communicate something urgent about the *ongoingness* of the HIV/AIDS crisis in North America, particularly for Black, Brown, and Indigenous youth, women, trans people, and their (biological or chosen) families. I sought not to correct any art-historical canons or to situate HIV/AIDS in the past; instead, I chose to emphasize the activist potential of contemporary art exhibitions grappling with HIV/AIDS to educate audiences through empathy, outrage, joy, and access to homegrown knowledge from elders and peers. I also chose to make space for information about healthcare, housing, and educational resources that exist locally, collecting flyers and informational material from a number of agencies throughout the Chicago area and distributing them within the exhibition.

Accuracy is important, particularly regarding the representation of those whom this illness persistently and disproportionately affects. So, too, is multidimensionality. Included in the exhibition were artworks, performances, conversations, screenings, playlists, zines, and flyers that I hoped would provoke an abundance of emotions, inspire people to think critically about both stigma and care in their many forms, and to reflect a broad range of life experiences.

My thinking was in large part informed by the important activist work of the Tacoma Action Collective (TAC), who were the first to critique and protest *Art AIDS America* for its lack of racial and gender diversity when it premiered at the Tacoma Art Museum in December of 2015. Organizing under the rallying cry #StopErasingBlackPeople, the direct actions performed by TAC at the site of the original exhibition intervened into the institutionalized and mainstream representation of HIV/AIDS as an illness that primarily affected (or affects) middle-class white gay men in the 1980s and 1990s, when all easily accessible statistics and data about the disease indicate otherwise both historically and today.

TAC's work inspired more inclusive revisions of the *Art AIDS America* checklist at subsequent venues and has raised important questions about the relationships between art, history, illness, and identity. A chief consideration was who had (or has) access to the time and stuff of art making about this issue in the first place, let alone who is receiving acknowledgment from powerful institutions responsible for promoting, preserving, and caring for our cultural histories.

Figure 1.
David Wojnarowicz, *Untitled (One day this kid . . .)*, 1990/91; photostat

143

When I was approached by Julie Rodrigues Widholm, director of DePaul Art Museum, about proposing an exhibition that would accompany Alphawood Foundation's presentation of *Art AIDS America* in Chicago, I couldn't stop thinking about the student body of DePaul University and the many millennials for whom HIV/AIDS might be nothing more than a historical footnote or something ominous mentioned during sex education class (if they happened to go to a school that actually offered it).

I was born in 1984, and my own personal sexual awakening and nascent understanding (or fear) of my sexuality was almost entirely filtered through the distorting media lens of AIDS panic in the 1990s. Considering all the damage stigma and misinformation has done, it became crucial to present an exhibition *for youth about youth* in an attempt to educate and do justice to the complex realities of those affected by the illness, directly or indirectly.

I wanted young people to see themselves, their families, their elders, and their friends in this exhibition. I wanted for them to think about how HIV/AIDS might affect them today or in the future. I wanted for them to see the issue through an intersectional lens, to consider how this illness factors into urgent conversations happening in the present about poverty; about equitable access to healthcare and stable housing; about racial bias in our criminal justice system; about rampant violence against trans people and women; and about self-care, community building, and pride as strategies against premature death.

The essay that follows was originally written in December 2016 and first published in the exhibition's accompanying newsprint publication when the show opened in January 2017. The publication also included poetry by Demian DinéYahzi'; artwork by Rami George and Charles Long (who also designed the publication); and personal reflections from a handful of the featured artists, including Katja Heinemann, Lenn Keller, and Shan Kelley.

+ + +

One day this kid will get larger

By Danny Orendorff

One day this kid will get larger is an exhibition that seeks to explore the many ways in which the ongoing HIV and AIDS crisis impacts the lives of not just those with a positive diagnosis, but all of us—whether we identify as a member of "at-risk" communities or not. This exhibition includes the perspectives of those who became HIV-positive at a young age; those who became HIV-positive at an old age; those born HIV-positive; HIV-positive parents; those with HIV-positive parents, family members, and friends; those who learned about HIV at school and those who did not; those who learned about HIV on television and those who did not; those who grew up fearful of, fascinated by, or even unaware of HIV; and those who work tirelessly today for justice and to educate, combat stigma against, provide care for, and foster community for those living with HIV/AIDS—and for those who have already died.

There is no single, dominant, or primary narrative of HIV and the AIDS crisis, or of the artwork made in response. Attending to the myriad issues of HIV and AIDS means attending to the urgent and intersecting issues of poverty, homelessness,

criminalization, discrimination, government neglect, corporate greed, white supremacy, and institutionalized racism within our housing, education, healthcare, and justice systems. It is a long list, and we are all implicated. HIV and AIDS are everywhere and impact nearly everything and everyone—including me (a queer identified, white, cisgender male born in the south suburbs of Chicago in 1984) and, most certainly, including you (however you identify).

In order to provide insight into the complex ways in which HIV and AIDS have irrevocably shaped our contemporary experiences of life, sex, love, power, and the state in North America, *One day this kid will get larger* features the work of over twenty-five artists working independently or collaboratively. The exhibition is organized around the theme of youth. While there is nothing universal about the experiences of youth in North America, we all nevertheless experience a childhood and adolescence of our own. We individually pass through various institutions and rites of passage (both formal and informal) as young people, discovering (or being indoctrinated into) our genders, our sexualities, our politics, our faiths, our senses of humor, and so much more in the process. Organizing the sloppy, perplexing, exhilarating weirdness of youth into cogent categories, phases, or conceptual banners is a fool's quest at best. But for the sake of providing structure to this expansive exhibition, the works in *One day this kid will get larger* are loosely grouped together by the subthemes of childhoods, educations, and nightlifes/pop cultures.

I did not arrive at the theme of youth for this exhibition without external reason, however; this theme is urgently compelled by statistics: as of 2014 (currently the most up-to-date information provided by the Centers for Disease Control and Prevention), young people (ages 13–24) account for more than one in five new HIV diagnoses each year, four out of five new HIV diagnoses are of young gay and bisexual males, and nearly half (44%) of the young people (ages 18–24) living with HIV at the end of the year 2012 did not even know they had HIV. Simultaneously, young people who do receive a positive diagnosis are the least likely group to then be linked to care, with 22 percent of newly diagnosed young people not receiving treatment of any kind within the first three months after their diagnosis. Young Black men are the most severely affected; they account for 55 percent of newly diagnosed young gay and bisexual males (Hispanic/Latino males make up the next largest group at 23%). These statistics make clear how extensively institutionalized racism and homophobia within our health and education systems have put young gay men of color at serious risk. Women—and Black women, in particular—accounted for 19 percent of new HIV diagnoses in the United States in 2014, with 87 percent of those cases attributed to heterosexual sex. As of 2013, the highest percentage (per capita) of newly identified cases of HIV was among transgender individuals, with Black trans women accounting for 56 percent of the new infections experienced by the transgender population as a whole. These trends are only exacerbated among incarcerated and economically disadvantaged populations, with Black men enduring the greatest burden of HIV infection.[1]

Prevention, education, holistic care, and the ongoing treatment of HIV and AIDS are urgent concerns intimately connected to today's movement for Black lives. For decades, and especially during the years before the rates of HIV infection and AIDS death among white people began to drop off and stabilize in the late 1990s, HIV and AIDS activists (epitomized by groups like ACT UP, GMAD, and Queer Nation)

fought tirelessly and with unparalleled passion against systemic government violence and neglect, widespread stigma, prejudice and discrimination, and corporations that looked to capitalize on fear, illness, incarceration, and death. These were uphill battles for recognition, protection from violence, and widespread justice—not too dissimilar from the concerns of those protesting today against mass incarceration, racism within our justice system, and death at the hands of the police (which is itself considered a public health epidemic within the Black community).

One day this kid will get larger borrows its title from AIDS artist and activist David Wojnarowicz's 1990 photo-text collage *Untitled (One day this kid . . .)* (fig. 1), which details his traumatic formative experiences of persecution, abuse, and abandonment. An image of the artist as a toothy young boy stands at the center of the artwork. Wojnarowicz's childhood experiences, though specific, are not unique. Today the child featured at the center of the image might look different, but his life matters—and no less urgently.

This exhibition is curated as a wake-up call, a call to arms, a plea, and a command to get involved to any and all of us who continue to mourn the dead while not supporting the living, particularly the most vulnerable among us.

HIV and AIDS are not over; they are not ready to be anthologized. We must continue to fight.

Childhoods

One day this kid will get larger begins with a question posed by Shan Kelley in his 2013 photograph *Growing Concern*: "What will you teach your children about AIDS?" (fig. 2).

The question's presumed neutrality or universality dissipates with the knowledge that Kelley is himself an HIV-positive parent in a serodifferent (mixed-HIV status) relationship, who conceived and is now raising an HIV-negative child in Mexico City.

While HIV and AIDS may not be immediately present within the blood of many families in North America, Kelley's question is nonetheless relevant to anyone shaping the knowledge and mindset of future generations of young people, who will inevitably enter the world of romantic entanglement and sexual activity.

For many children, awareness of and proximity to HIV and AIDS have been a constant and ever-present reality since birth due to their own status; the status of parents, family members, and friends; and the communities in which they are raised or that they ultimately discover or create for themselves.

For her series *On Borrowed Time/Growing Up with HIV* (2000–2004) (fig. 3), photojournalist Katja Heinemann collaborated with the staff and campers at Camp Heartland (now known as One Heartland) in Willow River, Minnesota. Campers were either born HIV-positive, are living with HIV, or have family members who

died or are living with the virus. Heinemann's photographs, while not denying the medical regimens and premature deaths endured by this community, highlight the supportive and joyful atmosphere that exists at the camp, a rare space for young people to work through shared experiences of isolation and stigma together within a diverse peer group.

Visions of community also populate the work of Oli Rodriguez, as observed in excerpts from his expansive art-meets-life investigation of family (chosen and biological), known as *The Papi Project* (2010–13) (fig. 4). Using images from the years 1978 to 1993, Rodriguez juxtaposed family photographs from his childhood with found images of his biological father—a complex man who participated in the gay cruising scenes of Chicago, Berlin, and Fort Lauderdale during the 1970s–1990s, before passing away from an AIDS-related illness in 1993—and his father's friends.

Composed of reproduced found photographs, present-day photographs of cruising sites that Rodriguez's father visited, and emails between Rodriguez and

Figure 3.
Katja Heinemann, *Closing Campfire* and *Marlena and Jimiya*, from the series *On Borrowed Time/Growing Up with HIV*, 2000–2004; giclée prints

Figure 4.
Oli Rodriguez, *The Papi Project*, archival images #80 & #71: *International Mr. Leather Lover* and *My Eagle Scout Son*, 2010–13; digital reproductions of found images

147

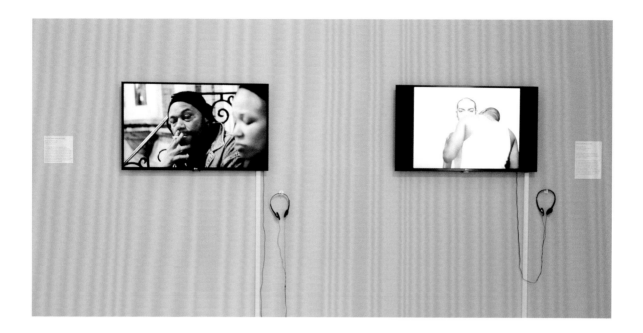

men who may have known his father (whom Rodriguez connected with via Craigslist), *The Papi Project*'s formal echoes and slippages between past and present do not resolve a complicated family dynamic, but rather embrace curiosity and uncertainty as methods of understanding.

In the short film *Bumming Cigarettes* (2012) (fig. 5, left), Tiona Nekkia McClodden drew upon the tradition of cinema vérité to depict a young Black lesbian's first HIV test and the profound conversation she has with a Black HIV-positive man several years her elder while awaiting her test results. Nuanced and intimate, *Bumming Cigarettes* allows the viewer to witness a frank intergenerational conversation that reveals much about the fear and stigma that continue to surround HIV/AIDS, assumptions about who the virus affects, and the choice to be tested.

Ivan Monforte creates moments of intimacy and affection in defiance of stigma. For his 2008 performance for camera *I Belong to You* (fig. 5, right), Monforte received hickeys (an expression of youthful passion and ownership) on both sides of his neck from an unidentified Black male for the entirety of the 1974 song "I Belong to You" by R&B trio Love Unlimited. Monforte's hickeys resemble the kinds of skin rashes and lesions commonly endured by HIV-positive individuals, while also serving as a complex metaphor for the desire to possess, transform, and love so hard it hurts.

Angela Davis Fegan focused on the deadly consequences of stigma for her site-specific installations in the DePaul Art Museum's second-floor bathrooms and the museum's window overlooking the Fullerton El stop. Fegan produced her work—consisting of letterpress text-based pieces on handmade paper—in multiples with the intent that they could be freely distributed and circulated as part of her ongoing *Lavender Menace Poster Project* (fig. 6) via art installations, protests and demonstrations (like the annual Chicago Dyke March), and local bars. Speaking with a radically queer activist voice, Fegan simultaneously expressed an anti-capitalist and DIY/T (Do-It-Yourself/Together) ethic in her choice to produce non-commodities out of handmade materials and processes.

Photojournalist Samantha Box utilized realism to delve deeply into the bonds of intimacy and support that exist among homeless LGBTQ youth living in New

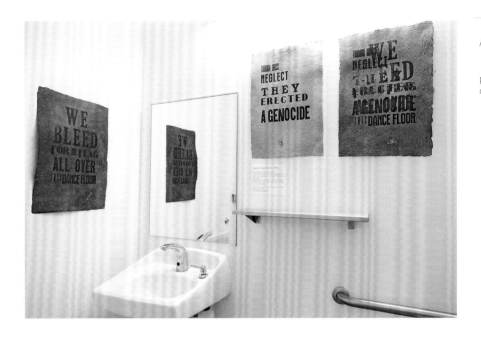

Figure 6.
Angela Davis Fegan, *Lavender Menace Posters*, December 2016; rubber ink letterpress print on handmade recycled denim paper with rose petal inclusions

York City for her series of photographs *INVISIBLE: The Shelter, The Street* (2006–12) (fig. 7). Box's photographs do not reveal the HIV status of the people featured; rather, her work is a testament to the strength and resilience of an underserved population that is incredibly vulnerable to HIV—just one of a number of other health and safety concerns plaguing this community.

In 2012, 40 percent of homeless youth identified as LGBTQ, with 68 percent reporting family rejection as the reason for their homelessness and 54 percent reporting that they experienced abuse at home. Furthermore, according to the National AIDS Housing Coalition, people who are homeless or lack stable housing are sixteen times more likely to experience HIV infection, and for those who are HIV-positive at the time that they lose their housing, obstacles to receiving treatment or reestablishing permanent housing are "exacerbated by discrimination related to HIV, sexual orientation, race, culture, mental health issues, substance use, and/or involvement with the criminal justice system."[2]

Figure 7.
Samantha Box, *Untitled*, from the series *INVISIBLE: The Shelter, The Street*, 2006–12; giclée print

Box's photographs reveal that despite the innumerable challenges facing these young people, they have joy, wonder, and a community in which they help keep one another safe, vibrant, and alive.

Educations

The artists featured in the Educations section of *One day this kid will get larger* focus their work on how young people are educated, or not, about HIV and AIDS, as well as how mainstream histories of the AIDS crisis have been written (replete with inaccuracies, erasures, and exclusions) into the broader history of the United States.

Originally produced in 1989, the portraits and anecdotes featured in *Another Image: Black Teens Coming of Age* by Bay Area photographer Lenn Keller are striking for their relevance to the experiences of teens in public school settings today (fig. 8). Sharing their experiences with racism in the classroom, gender and sexuality dynamics in their peer groups, and the negotiation of choice and risk in their sexual relationships, Keller's subjects tell stories that feel all too familiar today. Despite research that has clearly indicated for decades that comprehensive sex education in schools is more effective than abstinence-only education for reducing unplanned teen pregnancy and sexually transmitted infection rates, there is still an ongoing debate over sex education in many schools (public, private, or at home) and families all over the nation. As Keller's project further elaborates, however, it is often the interpersonal dynamics between teens and their teachers—and one another—that most powerfully inform their worldviews.

The work of Nancer Lemoins, a mother and longtime survivor of HIV (she was diagnosed in 1986), boldly demands that attention be paid to individuals too often overlooked or under-recognized by collective concepts of who HIV and AIDS affect. Lemoins translates the experiences of HIV-positive women (including herself) who identify as lesbian, are low income, live on American Indian reservations, and/or experience homelessness into portraits and text-based artworks that seem to speak directly to young people. Her screen-printed works from 2013–14 are shown in this exhibition (fig. 9) with two recently completed mixed-media drawings that look back at the 1980s and 1990s, while also considering the side effects of HIV medications (including accelerated aging).

Demian DinéYazhi' is an artist, activist, and founder of the Indigenous collective R.I.S.E.: Radical Indigenous Survivance and Empowerment. As made vividly clear in his work *Poz Since 1492* (2016), presented here as a postcard takeaway alongside a collection of other screen-printed pieces, DinéYazhi' situates the history of HIV/AIDS within the much longer and transnational history of white colonialist imperialism (fig. 10).

Figure 8.

AIDS to me is really scary. And, I don't think a lot of kids take it all that seriously, because they don't believe it will affect them. They are frightened by the stories, but still on a certain level, they don't really worry about it, because they think, "Oh, it can't happen to me." Unfortunately, it seems that the only way that a lot of people really get interested in educating themselves about it, or protecting themselves against it, is if they come directly in contact with it. There was a girl in one of my classes, who said she had a cousin, who died of AIDS. She didn't know the cousin that well, so, she wasn't too dramatically affected by it. But, now she's a lot more aware. In general though, I think more teenagers are becoming more aware, being more cautious, and are being more supportive of people who have AIDS, and things like that. I think teenagers really need to learn about AIDS because they're one of the most susceptible groups, even if they don't know it. Because of peer pressure or whatever, teens are more sexually active than ever. I think it's important for us to know more and to talk about it, because we're a group that can spread information really fast.

Kishana

Age: 16

Lenn Keller, *Kishana*, from the series *Another Image: Black Teens Coming of Age*, 1987; archival print

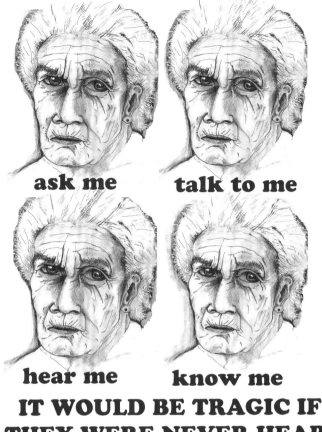

I'VE SEEN AND DONE THINGS YOU CAN'T IMAGINE.

ask me talk to me

hear me know me

IT WOULD BE TRAGIC IF THEY WERE NEVER HEARD

Figure 9.
Nancer Lemoins, *64 Years*, 2013–14; screenprint on paper

OUR GOVERNMENT CONTINUES TO IGNORE THE LIVES, DEATHS AND SUFFERING OF PEOPLE WITH HIV INFECTION BECAUSE THEY ARE QUEER, TRANS, INDIGENOUS, BLACK, HISPANIC OR POOR. TO DATE, 659,000 PEOPLE HAVE DIED. TAKE DIRECT ACTION NOW. FIGHT STIGMA. FIGHT AIDS.

R.I.S.E.: *Radical Indigenous Survivance & Empowerment*

Figure 10.
Demian DinéYazhi', *R.I.S.E.: Radical Indigenous Survivance & Empowerment*
NDN AIDS FLAG, 2016

While attending to the present-day situation of HIV within neglected, impoverished, and often isolated Indigenous communities, the artist's work and activism point to white conquest as the root cause of global genocides and pandemics, including the emergence and spread of HIV within and outside of Africa.

The work of Theodore ("Ted") Kerr similarly contests dominant HIV/AIDS narratives as a strategy for reconsidering mainstream versions of the AIDS crisis, as well as how generally accepted histories of HIV/AIDS do not adequately attend to the contingent factors of race, class, and geographic location. The lenticular photo-collages that Kerr collaboratively produced with filmmaker Jun Bae and social worker Shawn Torres for his series *Rayford Home 1987* (2016) (fig. 11) are extensions of Kerr's research into the life and death of Robert Rayford, a Black teenager in St. Louis who died of HIV complications in 1969 (as determined by medical research performed in 1987).

Rayford's case has been overlooked for decades, with mainstream historians opting instead to begin their timelines of HIV with the 1984 death of white New York City–based flight attendant Gaëtan Dugas, who has been falsely labeled "Patient Zero." Kerr connected the erasure of Rayford from collective understandings of the AIDS crisis in the United States to the mass incarceration, criminalization, and death at the hands of police violence disproportionately endured by Black individuals today. In his artwork, Kerr superimposed images that reference Michael Brown (an unarmed eighteen-year-old killed by Officer Darren Wilson in Ferguson, Missouri, in 2014) and Michael Johnson (a twenty-three-year-old who was criminalized, convicted of a felony, and sentenced by a Missouri court to over thirty years in prison for "recklessly" transmitting and exposing others to HIV) atop a found image of Rayford's childhood home.[3]

Collectively imagining alternative safe-sex practices that holistically attend to human pleasures and desires is the basis of *Inflamed* (2016), a collaborative ritual and video produced by Chaplain Christopher Jones, Ted Kerr, Niknaz, and

LJ Roberts. Together, and along with many other queer-identified participants, the unseen group gathers around a campfire to burn latex condoms, expressing their thoughts and feelings about the "imperial foundation of latex" and the forced reliance upon such corporately produced items as condoms and pharmaceuticals like PrEP (preexposure prophylaxis) in order to feel "safe" during sex, with the underlying message being that "condoms are not enough." Open-ended and speculative, the voices in *Inflamed* neither impose best practices nor shame the most intimate choices made in negotiating safety and consent in sexual relationships.

Nightlifes and Pop Cultures

The media has played a central role in collective attitudes and understandings of HIV/AIDS, as well as the direct action of countless activists who work to challenge misconceptions about the illness, accurately educate the public about how the virus is transmitted, and call out the political and corporate powers whose neglectful and profiteering (in)actions allowed the virus to spread quickly and prolifically throughout North America during the 1980s and 1990s.

While generations of activists born before 1970 waged battles in the streets and on the airwaves in their youth, many people entering young adulthood or born during and after the 1980s first became aware of HIV and the AIDS crisis on television, the primary source of news and pop culture at the time. Fictional HIV-positive characters and real HIV-positive individuals slowly made their way onto primetime melodramas, daytime talk shows, and cable reality shows by the late 1980s, during a time of widespread fear about the virus, perhaps reshaping mediated depictions and public opinions about those who were living with HIV/AIDS. Indeed, it is entirely possible that for many members of younger generations (and, likely, even for older generations), the first person they ever heard speak about HIV/AIDS from firsthand experience was either entirely fictitious or assembled together in the editing room from countless hours of reality television footage.

Film and video works by Vincent Chevalier, My Barbarian, Chris E. Vargas, and Matt Wolf revisit and reflect upon milestone and mundane moments related to HIV/AIDS in popular media. Vincent Chevalier unearthed footage of himself as a teenager recreating an exaggerated scene of status disclosure during a daytime talk show in *So . . . when did you figure out you had AIDS?* (2010) (fig. 12). Artist collective

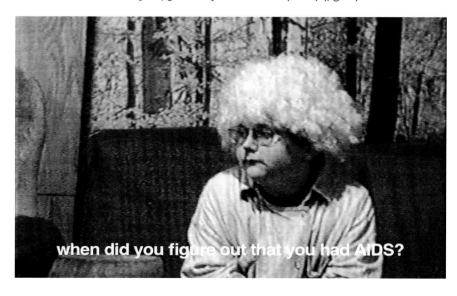

Figure 12
Vincent Chevalier, *So . . . when did you figure out you had AIDS?*, 2010; digital video

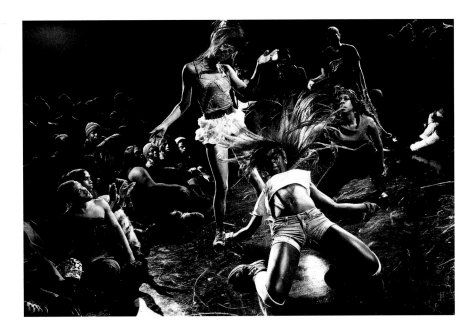

Figure 13.
Samantha Box, *Untitled*, from
the series *INVISIBLE: The Last
Battle*, 2010–17; giclée print

My Barbarian responded to the representation and influence of AIDS activist Pedro Zamora, a housemate on the second season of MTV's *The Real World*, in their performance for video *Counterpublicity* (2014). Chris E. Vargas simultaneously paid tribute to and parodied the flamboyant, closeted performer Liberace (who died of an AIDS-related illness in 1987), while also considering the dubious terms of Liberace's friendship with Ronald and Nancy Reagan, in the video *Liberaceón* (2011). Matt Wolf's early, student-made video work *Smalltown Boys* (2003) tells the story of David Wojnarowicz's fictitious daughter (born via artificial insemination), who begins a letter-writing campaign to save her favorite television show, *My So-Called Life* (featuring the Latinx, gay, and homeless character Ricky), from cancellation. Wolf's video also features home-video footage of Wojnarowicz himself, the passion, intimacy, and intensity of which contrasts starkly with the apathetic, detached qualities of the fictional story line and the accompanying images of corporate forms of AIDS activism like the ubiquitous MTV concert special.

While this mediated imagery of HIV/AIDS was proliferating, however, many gay and gender nonconforming Black and Latinx individuals congregated in urban areas around a shared and intense love for music and highly cultivated styles of dancing, voguing, pageantry, and performance to form the Ballroom community, establishing alternative families (or Houses) in the process. The Ballroom community was (and is) deeply affected by the AIDS crisis, making the rapturous expressions and euphoric bodily gestures of life, love, joy, pride, freedom, and autonomy emerging from Ball culture all the more vital, resistant, and powerful.

Rashaad Newsome pays tribute to members of the Ballroom communities of the past and present in his ornate sculptural collages. His 2014 *Ballroom Floor* links Ball culture to the tradition and aesthetic of ecstatic art, observed historically in religious or spiritual traditions. Newsome described *Ballroom Floor*, composed from "Cuban link chain, pearls, and diamonds," as "an elaborate photo-collage tapestry, based on a synthesis of the preliminary drawings for the Pantheon, the Gloucester Cathedral, and images of St. Mary's Church in Gdańsk (Poland)."[4]

A set of photographs by Samantha Box, from the series *INVISIBLE: The Last Battle* (2010–17) (fig. 13), accompanies Newsome's collage, offering an intimate look into

the performances, community, and activism of the emergent Kiki Ballroom scene of New York City—a more recent manifestation/mutation of the Ballroom community that is primarily composed of LGBTQ youth of color.

The convergence of art, music, dance, community, and activism is at the core of the work of Aay Preston-Myint, an interdisciplinary artist, activist, DJ (Nina Ramone), and co-founder of the queer dance-party and grant-making collective Chances Dances (established in Chicago in 2005), among many other creative ventures. All of Preston-Myint's pursuits inform his singular understanding of space and architecture—and particularly the potential of light, color, texture, and sound to inspire movement and action among individuals. The artist's site-specific, multimedia mural and installation for *One day this kid will get larger* (fig. 14) contains images of portals and light beams, inspired by the transformative potential of the nightclub or sex club, as well as the activism that fights to keep these queer spaces open. Produced to accompany Preston-Myint's artwork, the soundtrack that played throughout the gallery was produced by artist and current Chances Dances collective member Jacquelyn Carmen Guerrero (CQQCHIFRUIT).

Figure 14.
Installation view of *One day this kid will get larger* with Aay Preston-Myint, *Rainbows are the shadow of a presence*, 2017; site-specific mural and installation

1 The information in these paragraphs reflects data on HIV/AIDS available on the Center for Disease Control and Prevention's website as of December 2016. More information can be found at https://www.cdc.gov/.

2 This information reflects the most up-to-date information on the relationships between HIV/AIDS and homelessness offered via the National AIDS Housing Coalition website. For more information visit http://www.nationalaidshousing.org/.

3 For more information on Robert Rayford and the debunking of the "Patient Zero" myth, read Ted Kerr's essay "AIDS 1969: HIV, History, and Race," in *Drain Magazine* (*AIDS and Memory*) 13, no. 2 (2015): http://drainmag.com/aids-1969-hiv-history-and-race/.

4 "Rashaad Newsome in conversation with Laila Pedro," Brooklyn Rail (July 11, 2016): http://www.brooklynrail.org/2016/07/art/rashaad-newsome-with-laila-pedro.

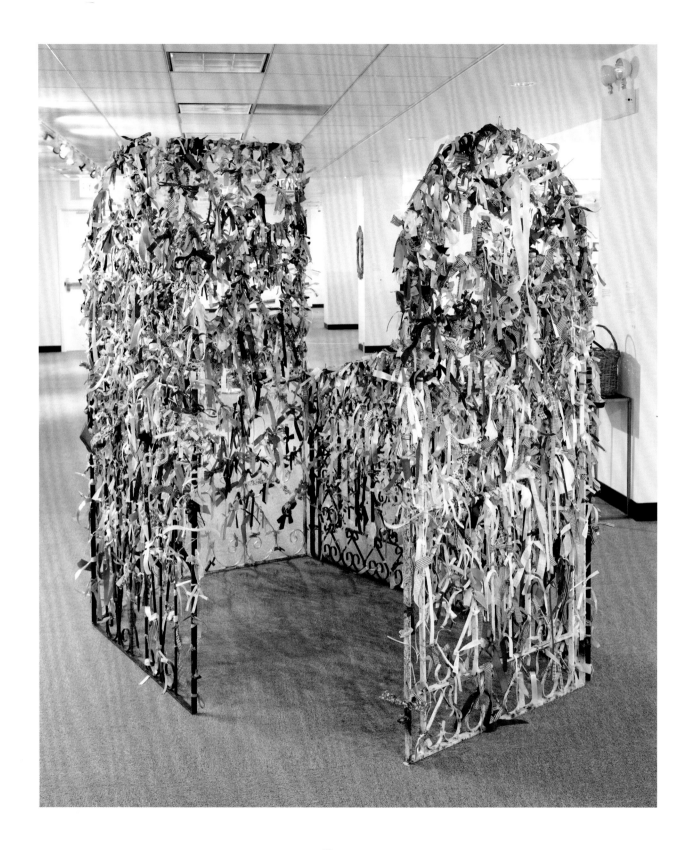

52
Karen Finley

Ribbon Gate, 2015
Eight found iron gates, cloth
ribbons
Dimensions variable
Courtesy of the artist

An Artist's Response to AIDS

KAREN FINLEY

The Black Sheep

After a funeral, someone said to me
You know I only see you at funerals
it's been three since June—
been five since June for me.
He said I've made a vow—
I only go to death parties if I know someone
before they were sick.
Why?
'cause –'cause—'cause I feel I feel so
sad 'cause I never knew their lives
and now I only know their deaths
And because we are members of the
Black Sheep family.

We are sheep with no shepherd
We are sheep with no straight and narrow
We are sheep with no meadow
We are sheep who take the dangerous pathway thru
the mountain range
to get to the other side of our soul.
We are the black sheep of the family
called Black Sheep folk.
We always speak our mind
 appreciate differences in culture
 believe in sexual preferences
 believe in no racism
 no sexism
 no religionism
and we'll fight for what we believe
but usually we're pagans.
There's always one in every family.
Even when we're surrounded by bodies
we're always alone.
You're born alone
and you die alone—
written by a black sheep.
You can't take it with you—
written by a former black sheep.

Black Sheep folk look different from their families—
It's the way we look at the world.
We're a quirk of nature—

We're a quirk of fate.
Usually our family, our city,
our country never understands us—
We knew this from when we were very young
that we were not meant to be understood.
That's right. That's our job.
Usually we're not appreciated until the next generation.
That's our life. That's our story.
Usually we're outcasts, outsiders in our own family.
Don't worry—get used to it.
My sister says—I don't understand you!
But I have hundreds of sisters with me tonight.
My brother says—I don't want you!
But I have hundreds of brothers with me here tonight!

My mother says—I don't know how to love
someone like you!
You're so different from the rest!
But I have hundreds of mamas with me here tonight!
My father says—I don't know how to hold you!
But I have many many daddies with me here tonight!
We're related to people we love who can't say
 I love you Black Sheep daughter
 I love you Black Sheep son
 I love you outcast. I love you outsider.
But tonight we love each other
That's why we're here—
to be around others like ourselves—
So it doesn't hurt quite so much.
In our world, our temple of difference
I am at my loneliest when I have something to celebrate
and try to share it with those I love
but who don't love me back.
There's always silence at the end of the phone.
There's always silence at the end of the phone.

Sister—Congratulate me!
NO I CAN'T YOU'RE TOO LOUD.
Grandma—love me!
NO I DON'T KNOW HOW TO LOVE
SOMEONE LIKE YOU.
Sometimes the Black Sheep is a soothsayer,
a psychic, a magician of sorts.

Black Sheep see the invisible—
We know each other's thoughts—
We feel fear and hatred.

Sometimes, some sheep are chosen to be sick
 to finally have average, flat, boring people say

I love you.
Sometimes Black Sheep are chosen to be sick
 so families can finally come together and say
 I love you.
Sometimes some Black Sheep are chosen to die
 so loved ones and families can finally say—
 Your life was worth living
 Your life meant something to me!
Black Sheeps' destinies are not necessarily having
families, having prescribed existences—
 like the American Dream.
Black Sheep destinies are to give meaning in life
 to be angels
 to be conscience
 to be nightmares
 to be actors in dreams.

Black Sheep can be family to strangers
We can love each other like MOTHER
FATHER SISTER BROTHER CHILD
We understand universal love
We understand unconditional love
We feel a unique responsibility, a human responsibility
for feelings for others.
We can be all things to all people
We are there at 3:30AM when you call
We are here tonight 'cause I just can't go to sleep.
I have nowhere else to go.
I'm a creature of the night—
I travel in your dreams—
I feel your nightmares—

We are your holding hand
We are your pillow, your receiver
your cuddly toy.
I feel your pain.
I wish I could relieve you of your suffering.
I wish I could relieve you of your pain.
I wish I could relieve you of your destiny.
I wish I could relieve you of your fate.
I wish I could relieve you of your illness.
I wish I could relieve you of your life.
I wish I could relieve you of your body.
I wish I could relieve you of your death.
But it's always
Silence at the end of the phone.
Silence at the end of the phone.
Silence at the end of the phone.
Silence

"The Black Sheep" ends with the single word *Silence*, yet *Silence Equals Death*, the anthem of ACT UP, the AIDS activist collective, dares us to speak out for life.

I am an artist who took that call to heart, who would not be silent. My generation lost countless friends to the disease; we knew the despair of our loved ones being denied recognition and respect, not only of their life but of their death. National policy makers condoned and participated with prejudice and intolerance alongside families who were ashamed and disapproved of their family member's identity, sexuality, lifestyle, and illness.

The pain and grief of our friends and loved ones dying too young became even more repugnant with a code of silence, when we were not allowed to mourn with dignity and grace with traditional funeral rites. Many times, families never announced their member's death, as if the person had been nonexistent. In many instances, family members were not responsive and were out of the picture. And in some cases, there was no mention of AIDS, no service was provided—an intended vanishing. There would be no funeral, no eulogy, no remembrance or wake for the deceased, neglected by the next of kin. Bodies of our friends were quickly removed. We witnessed victims not only of illness but also of intentional disappearance.

During the crisis, friends, spiritual organizations, and the community would join together to conduct memorials despite the government's and religious right's environment of condemnation. With a nation offering little protection for gay rights, and discrimination of those living with AIDS and HIV, the plan of erasure was cruel, heartless, and inevitable. Sometimes the deceased's belongings were thrown on the street, strewn as garbage by homophobic, discriminatory family members. With support of such extraordinary organizations as the Estate Project and Visual AIDS, friends would try to archive, retrieve, and store belongings, heirlooms, and artist's works. The nation vilified AIDS with legal authority from President Reagan to Senator Helms, who routinely encouraged the condemnation of the suffering without humanity and with a self-righteous, contemptuous glee. Yes, the good old days.

The genuine impulse to record the poetic witnessing of the transitions of friends living and dying from AIDS was not only heartfelt but urgent, in order to instigate change. The iconic AIDS Quilt is a magnificent example of a memorial displaying active participation and community resourcefulness. We can and will represent our loved ones who died. We will not wait for permission. We can give you countless examples of loss to articulate a time when the epidemic showed both the ugliest side of America yet also the compassion and courage to respond. Wisdom from earlier cultural political movements propelled us and provided energy, gave us sustenance, and carried us forward in their name and for our future. Art as transformative tool. That is what we as a public need to carry with us today, and why the exhibit at Alphawood is inspiring: it shows us evidence of art not only recording history, but also providing energy to empower those living with AIDS and HIV as well as to future cultural movements.

As a straight, white, educated woman, my privilege enabled me to speak out. I had nothing to lose. With my self-entitlement, I did not need to question my right, ability, and space to respond as necessary without fear. Even when I was censored, I still had a place at the media table as a straight white woman. My status positioned me as artist provocateur, not someone to be ignored but someone who could address issues without being outed. I was very aware of the role of a public

artist revealing private, personal experiences as political. It is important to note that I feel differently now about voicing for others; the politics were different then, and I would not always consider speaking for others now. Who gets to speak? Who gets to listen? Who speaks for whom?

My initial creative response was, at first, poetic: to write as *an artist as historical recorder*. To transcribe poetic witnessing; to provide voice and humanity. To try and touch hearts with intimacy, rage, and desperation. To provide a space for grief. There was anger. There still is anger. This anger flowed from my disdain for law and religious morality as a disguise for sanctioned oppression. Can artists make an impact? Can art make a difference? How can art serve to transform society? Working individually and working in collectives, artists created responses to record and communicate the devastation of our community. When so many lives ended too early, we were motivated by a collective will. We must try. We must inspire, be subversive—demand healthcare, healing, humanity, and offer perspective. It is in that directive: activism as artistic gesture that is to ignite and support social change and save lives.

The era of the AIDS crisis intersected with the culture wars. Artists were creating work that directly challenged heteronormative and patriarchal sexual identity; encouraged women's rights, queer rights, religious freedom, and liberation; questioned war; and spoke out on racism, misogyny, immigration, capitalism, healthcare, equal access, the environment, sexual fluidity, and abuse of power and policy. Art was more than decorative or aesthetic; it signaled arts politics. Artists were standing up and taking on issues directly, and they were censored. Institutions that presented artists that created political art or art that was considered indecent were threatened with being defunded. The AIDS crisis was more than the illness—it was about bodies, sexuality, power, and representation.

Art in response to AIDS began as a desperate testament to the overwhelming loss, while in a tradition of resistance. Those works also functioned as imaginative guides to restorative justice. In *Art AIDS America Chicago*, we see examples of portraiture with glitter and glamour, documentation, impressionistic regal images, and abstract moodiness. Yet all have a directness that provides an alternative story to the popular culture-preferred representations of the weak and bleak, of the destruction of AIDS. In particular, it gave space to time-based, video, and ephemeral artworks, including Marlon T. Riggs's film *Tongues Untied* (pl. 17), with poetic writing and recitation as manifesto, to be proactive of what was not being provided its own space earlier. If there was no sanctuary in which to grieve, we would create one. If there was no prayer, we would write one. If religion excommunicated or proclaimed hate, we rebooted with overwhelming love and compassion.

With the continued numbers of friends dying, I wrote "The Black Sheep." This prayer poem is meant to acknowledge the community, providing "real" family, inspiration, and love despite unacceptance by one's biological family. "The Black Sheep" would become part of the text of the performance *We Keep Our Victims Ready*, which in 1990 would be denied National Endowment of the Arts support and which would bring me and three other artists (John Fleck, Holly Hughes, Tim Miller) to the Supreme Court in 1998. "The Black Sheep" became a public sculpture in Lower Manhattan, with the text set in bronze on a concrete boulder (fig. 1). This public sculpture became public art, a spontaneous memorial where people would leave flowers, make rubbings, and bring friends to read the poem. This poem was

Figure 1.
Karen Finley, *The Black Sheep*,
1990, First Avenue between
First Street and Houston, New
York City. Presented by Creative
Time

read at the opening of *Art AIDS America Chicago* (fig. 2). I bring this up because AIDS was about policing bodies, controlling bodies, the unlawful body in violation. For me as a feminist, the relationship between gender politics was clear and in solidarity.

"The Black Sheep" became a selected prayer to be read at services, and as the crisis grew, I continued to create living installations with designed, deconstructed funeral wreaths and to write eulogies of passionate texts exclaiming experiences and reflections resulting from the illness. The personal stories of circumstance, opportunity, and independent acts of resistance brought unique responses to many friends and loved ones. The anguish and anger of purpose, the strength of mind and character, brought about difficult decisions of how to implement life, if even a terminal life. Many individuals decided to commit suicide rather than suffer from the disease, the burden—to resolve their fate on their terms. This was an act

Figure 2.
Karen Finley reciting "The
Black Sheep" at the opening
reception for *Art AIDS America
Chicago*, December 2, 2016,
Center on Halsted

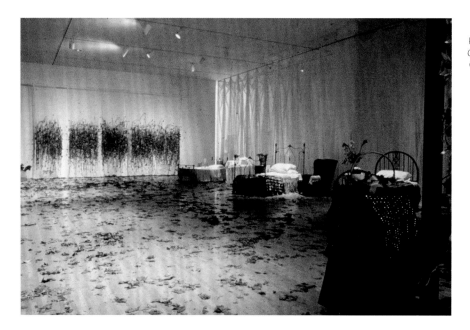

of self-determination and agency. *AIDS wouldn't kill me. I'd kill AIDS*. Yet, the trauma of suffering and the continued loss of lives created a void.

The installations became more participatory. Frustrated with the lack of public memorials for grief, I created a sanctuary exhibit, *Memento Mori* (fig. 3), where the public would walk through rituals and *tableaux vivants* related to AIDS. On the walls would be a series of poetic texts about AIDS that I would hand script with gold on black on floor-to-ceiling walls. The exhibit first opened in Newcastle upon Tyne, and for the next few years variations were presented at LA MOCA, Kitchen NYC, and the São Paulo International. This installation's purpose was to provide reenactments of caregiving. The living installation is a series of stations with beds, chairs, blankets, and pillows. Each bed has its own decorated look, in an area with nightstand and chair. In each bed lies a person who is role playing being sick; a caregiver sits next to and interacts with the patient. These *tableaux vivants* provide the portrayal of the death-bed scene—the painting in our mind, the reenactment of the scenes of illness. For this artwork is simultaneously past, present, and future. For many of the participants, they were HIV positive, caregivers, or both. These intimate scenes made public also serve to connect and visualize the dying of AIDS with intimacy and dignity, and represent humanity and the offer of compassion as a collective emotion.

Ribbon Gate (pl. 52) borrows from the tradition of tying and wearing ribbons in support of the cause. The gates are installed as an assemblage of iron, symbolic of the other side, or as gates to heaven, in circular, curving forms or as a gateway. The public is invited to tie multicolored ribbons on the gate in memory of those who died of AIDS. The ribbons weave a ritual, a gesture for acknowledgment, with a moment of interaction, honor, and remembrance.

Carnation Wall (fig. 3) is an installation in which the public creates an abstract, public mural by placing red cut flowers into floor-to-ceiling white lace panels. In placing a red flower in memory of those who have died of AIDS, the floral smell, the drying stems, and the movement of the curtains provide a haunting and traditional display of grief. The wall of flowers dries over time to a dark red brown, a reminder of blood. From a distance, the flowers look both splattered and

Figure 4.
Karen Finley, *Written in Sand*,
1992, Hallwalls, Buffalo, NY

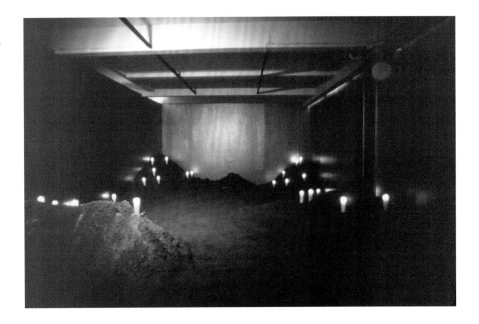

ethereal—a ghosting that is suspended. As days go by and more flowers are added, new curtains are repeated so there is a multitude of floral transparencies.

Written in Sand (fig. 4 and pl. 53) is a ritual of writing the name of those who died of AIDS in the sand. An antique or old chest is filled with sand that has meaning for the location. The public is invited to write the names of those they loved and lost to AIDS in that sand. After completion, the names are smoothed over. This ritual is to be a private space of containment of the personal gesture of writing the name of one we miss—yet the names are written over other names in sand. The time and slowness of how sand is made, the tiny specks, are captured out of its elements away from the beach, away from nature. This can also be accomplished on a larger scale. A room or gallery space is filled with sand to create a diorama of hills and valleys. The walls are painted gold. Lit candles are in the sand. The public is invited to enter the sanctuary, remove their shoes, and write the names of those they loved and lost to AIDS.

Vacant Chair (fig. 5) is a large chair that is made from fresh flowers. A smaller wooden, unadorned chair is next to the floral chair. The public sits in the chair as if sitting with the vacant chair to signify the transition space. Inspired by Victorian funerary practices, the vacant chair emphasizes the absence of the departed, the absence made present by creating a chair with flowers.

The pain is in surviving.
I said to myself, again, Oh, Thomas—have a cup of tea and get on with it.
But tonight, I couldn't.
I turned on the music loud and danced and danced and danced.
I went and saw all the friends I could.
And when I got home—
The rocking chair is still his.
A vacant chair.
A vacant place at the table.
A vacant space in the bed.[1]

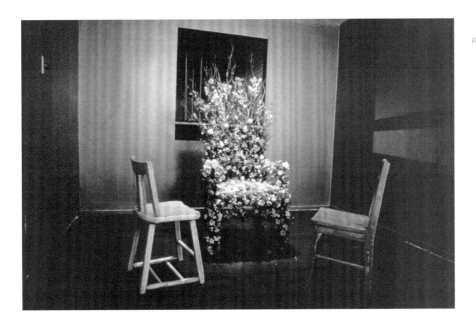

"Positive Attitude" refers to both being HIV "positive" yet having a positive attitude despite the terminal diagnosis (figs. 6–7). It is also about the imagination, to see the possibility and to not allow the circumstances to take away the humanity of joy. This perspective is also a way for the art to see and imagine the impossible, the gift, the miracle, the invisible. I owe so much, learned and gained from the generosity of my friend's legacy.

This work is inspired by the suffering of Kaposi sarcoma (KS) and the film *Philadelphia*—a film I was in as the doctor for the character played by Tom Hanks, who suffered with KS. A friend of mine also suffered from KS but still made plans for adventures and enjoyed the delicacies of life.

> I plan a trip to a forgotten castle
> A place I will never go
> But the planning makes the days go quicker

The red and purplish marks of Kaposi sarcoma that appears on the body are seen as violets, strawberries, and garnets, and a way of perception and appreciation.

Here is an excerpt from the poem "Positive Attitude":

> I can't do this anymore. I can't take your positive attitude. I can't take your looking on the bright side.
> When your body is covered with speckled spots of disease.
> You turn your marked torso over to me and whisper in my ear—these words:
> I tell myself that I am visited by raspberries, strawberries, with names of Grandeur, Royalty, and Impatience. Red lipstick kisses of flame, of crimson of dawn and sunset.
> I am luscious fabrics of calico from skirts and plaids of Scottish pipers.
> I am visited by visions of hearts, bleeding, warm, and heartfelt. Purple and stoic and martyrdom.
> I am a field of wildflowers. Lilacs, violets, tulips of imperial elegance. Heather, lavender, irises.
> I am a bouquet for all mankind.
> I am a speckled wild cat with a coat of rare beauty.

Figure 6.
Karen Finley, *Positive Attitude* storefront, 1993, Times Square, New York City. Presented by Creative Time

My strategy for creating culture was to break out of object making that would be primarily valued within the art market and capitalism. As a performing and conceptual artist, I am interested in subverting and disrupting systems of value, commodity, and representation by not creating art that exists passively. Artists who were working in different modes that were not verified by collectors purposely bypassed the traditional system. There is a feeling that having political art collected or taken out of its context neutralized its function. And to an extent I believe that. I am constantly challenged by working within and without institutions.

When Sur Rodney (Sur) curated the 25th anniversary Visual AIDS exhibit, just the thought of looking over my work brought on a certain PTSD. But with Sur's encouragement I began to review the writing and artworks I had made during the era. My participation in *Art AIDS America Chicago* comes out of being in the earlier exhibit. And part of this process was reviewing artworks, texts, lives, and loss. When curator Jonathan Katz saw the Visual AIDS exhibit, he contacted me about participating in the Chicago exhibition.

As I noted, my installation and performative strategy was to bypass the collector, object, and gallery reception and push for public space. As a white woman with an MFA, I was able to have the opportunities and work in nonprofits and museum spaces.

The expansion of the exhibition in Chicago included regional, underrepresented artists and artworks that were ephemeral and time-based. The inclusion of more artists of color and robust programming brought to focus the whiteness of the representation and influence in the art market. The expansion of the show allowed me to be able to confront, to look and reflect and learn about, my own complicity with silence with race and underrepresented artists.

Being from Chicago, I have a particular love for the city and the artists who live here. I began both my activism and my art making in the Windy City. I participated and was influenced by many cultural organizations, whether the Free Street Theater, Jane Addams Hull House, the Young Artist Studio, and School of the Art Institute of Chicago. My relationship to the location has a particular relevance for

Figure 7.
Karen Finley, *Positive Attitude*, 1993; watercolor mural, Times Square, New York City. Presented by Creative Time

me with my own experiences that intersect with the city, authority, the disease, and my memories.

This is the excerpt from the poem "Lost Hope," which I wrote in Chicago:

Today, I pick up the phone, but I just can't call to see if he did it. I said to him, "Please, please let me see you one more time." I'm here in Chicago. I can't call to see if he did it—if he got to Seconal. I haven't called to see if he got the Seconal, ground it up, and shot it up.
Or maybe he used a gun.
Or maybe he used a knife.
No, my friend is not a violent man.

There is the concern for the fetishizing of the AIDS art object as collectible. Providing rituals and artistic expression is meaningless without the activism of bodies taking risks and making change with protests and initiative. The profoundness of the experience of intimacy of the body, of death and dying, of surviving, does no service to provide nostalgia for the romanticization of AIDS. Yet, the tenderness, the anguish and honoring, the depiction of autonomy and agency demands towards surviving, towards joy, profane joy, sacred passion, erotic whimsy and delight, naked ambition and exposure, vulnerability with glitter and giggle. A call to angels, a hush for tomorrow, some sign of comfort within and without.

Make the kisses strong, I won't be here long.
Make the mouth settle, for I'll be going soon.
Make the breath slow for I don't have many left.
Make the day beautiful for it may be my last.[2]

1 Excerpt from the poem "Thomas."
2 Excerpt from the poem "David Twinkle."

53
Karen Finley

Written in Sand, 1992
Sand in found chest
Dimensions variable
Courtesy of the artist

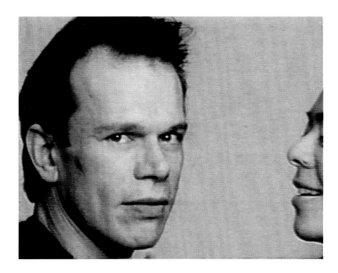

54
Tom Kalin
They are lost to vision altogether,
1989
Single-channel video
13:21 mins.
Courtesy of the Video Data
Bank at the School of the Art
Institute of Chicago

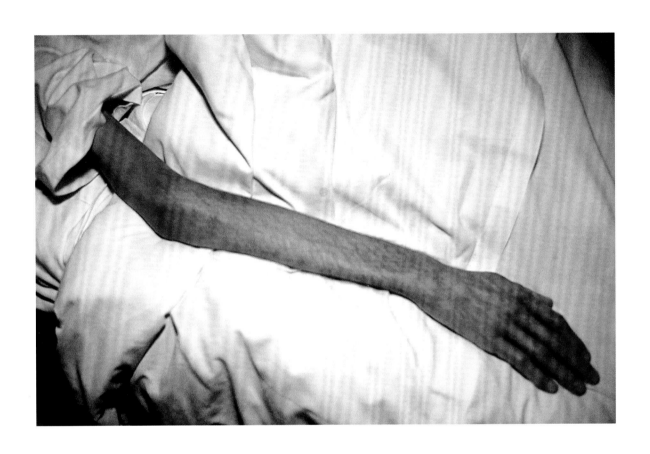

55
Nan Goldin

Gilles' arm, Paris, 1993
Cibachrome print
30 × 40 in.
Courtesy of the artist and
Matthew Marks Gallery

 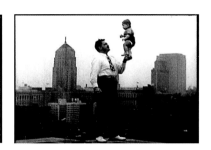

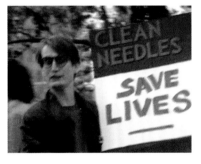

56
Gregg Bordowitz

Fast Trip, Long Drop, 1993
Single-channel video
54:04 mins.
Courtesy of the Video Data
Bank at the School of the Art
Institute of Chicago

57
David Wojnarowicz
Untitled, c. 1984
Found clock, battery, barbed
wire, globe, printed paper col-
lage, and acrylic on horse skull
13 × 24 × 10¼ in.
Collection of Dr. Daniel Berger

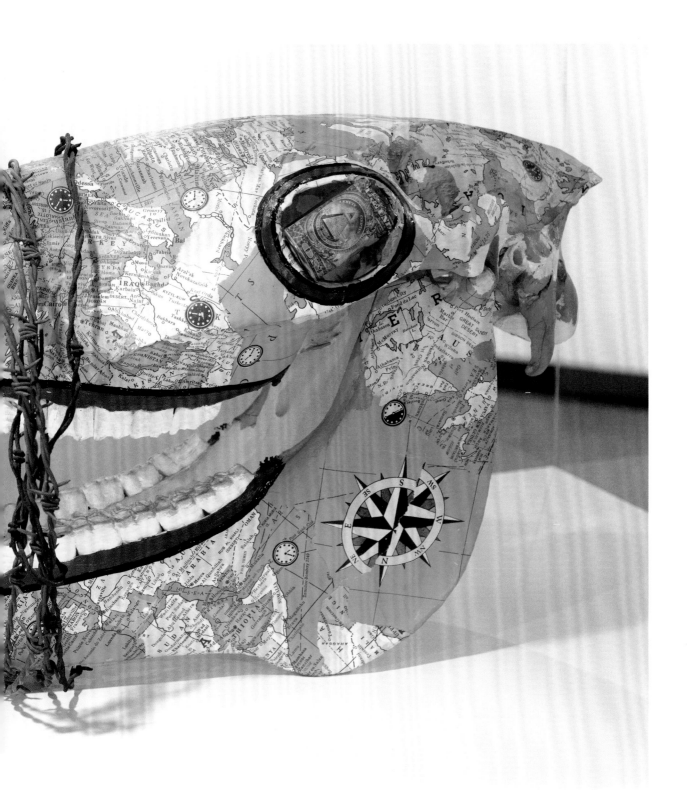

58
Arch Connelly

The More, 1984
Oil paint, faux pearls on wood
40 × 40 in.
Collection of Brooke Adams

Keith Haring

No Title, 1988
Sumi, gouache, and xerograph
collage on paper
40⅛ × 59⅞ in.
Rubell Family Collection, Miami

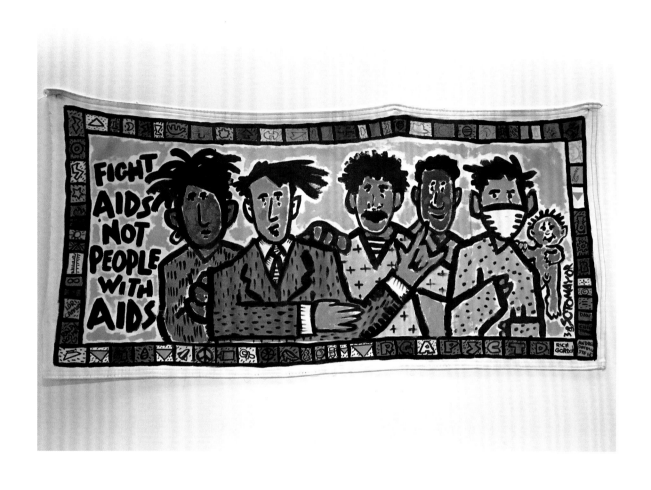

60
Daniel Sotomayor

For Paul, 1990
Acrylic on cotton
31 × 64½ in.
Gerber/Hart Library and
Archives Bequest

A new writing workshop:
Other Countries: Black Gay Men Writing.
Meetings begin June 14, 1986.
Every Saturday from 5 to 7 p.m.

61
Robert E. Penn
Fierce Love Video Sequence 2:
AIDS Activism, 2010
Art from Adversity, 2011
Digital video
12:49 mins.
Courtesy of the artist

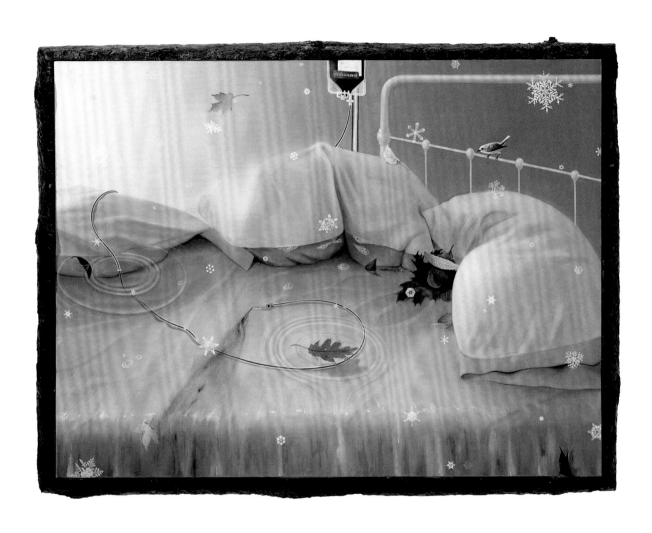

62
Frank Moore

Patient, 1997–98
Oil on canvas on wood panel
with red pine frame
49½ × 65½ × 3½ in.
Courtesy of Gesso Foundation
and Sperone Westwater Gallery,
New York

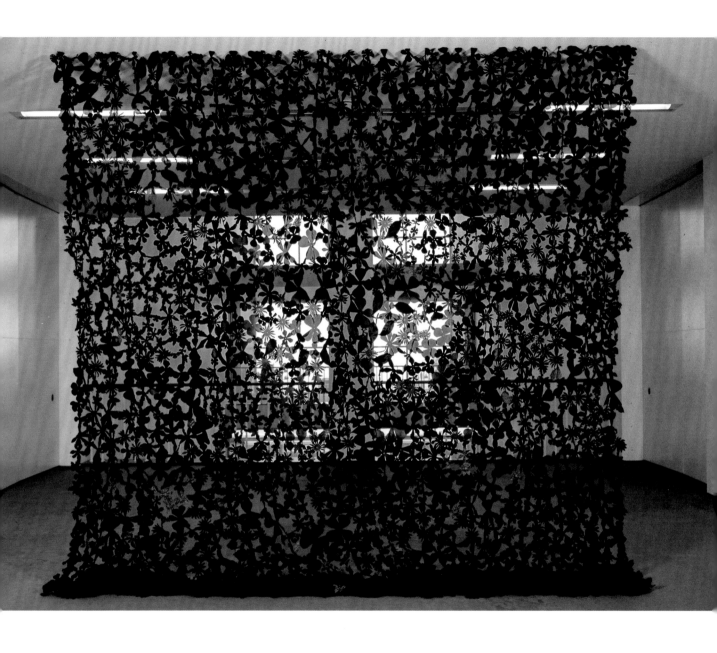

63
Jim Hodges

The end from where you are, 1998
Silk, cotton, polyester, and
thread
192 × 192 in.
Collection Museum of
Contemporary Art Chicago,
Restricted gift in memory of
John S. Baran with additional
restricted support from the
Meta S. and Ronald Berger
Family Foundation, 1999.4

Programs

Reflection

JOSEPH R. VARISCO

My name is Joseph Varisco. I have been HIV+ for seven years. When I was first diagnosed, in December 2011, I had no job, no health insurance, no savings, a mountain of student-loan debt, two degrees, and no prospects. I was utterly terrified about my future. In the tradition of my practice, however, I sought out artistic and compassionate responses to others living with HIV/AIDS, specifically in film, literature, and the performing arts worlds. I was fortunate to be living in a city where support for newly diagnosed and people living with HIV is abundant, accessible, and cutting edge. But so many of the important narratives of HIV/AIDS did not resonate with what I and my peers were going through. These narratives, while vital to our history, were missing something vital for contemporary audiences: a sense of connection to now. If we lose sight of what has happened because we cannot see it happening now, then as artists, educators, and activists we have failed our communities.

My interest in seeking to understand a contemporary experience, my own experience, led me to create an experimental performance showcase at Links Hall titled *QUEER, ILL + OKAY*. The first rendition of this program was *QUEER, ILL + OKAY?*, which was a question to myself as much as it was a prompt for the audience. Was I okay? If not, might I become okay, and what did I need to do to get there? Though filled with great doubt, I impulsively posted my status on social media after announcing it at *Salonathon*, a home for underground, emerging, and genre-defying performance art that I curated with Jane Beachy, Bindu Poroori, and Will Von Vogt. From then on, I was presented as a public face of HIV in Chicago. I participated in the photographic series *When Dogs Heal*, an exhibition that explored the companionship of dogs to those with HIV, as well as in medical studies that revealed positive effects on mental and physical health. I was interviewed by a medical journal, the *Chicago Tribune*, the AIDS Foundation of Chicago, the public radio program *Practically Speaking*, and for a video campaign for *OUT* magazine, among others. In so doing, I realized that while my speaking publicly offered the kind of support and visibility others needed, a greater benefit is to continue seeking out less visible, underrepresented voices.

Listening to others has often been a productive way for me to sort out where I am and where I could be going. To my surprise, the first *QUEER, ILL + OKAY* event, which had run on a zero-dollar budget with the help of artist volunteers from across Chicago, was accepted with powerful generosity. I was humbled by the

attendance and reaction of the audience, who received it with an almost altruistic interest. The event helped fill the needs of niche populations that were not yet visible to Chicago's communities of performance artists. As a result of its successful impact, the event attracted funding in the form of grants, individual donors, sponsorships, and community members. Indeed, it established a community of its own. This all took place while I had been, and certainly still am, discovering my personal relationship to seroconverting.

In 2016 I was invited by my friend and colleague Chris Audain to interview for a position at the newly formed Alphawood Gallery to help with *Art AIDS America*. Having done the freelance hustle for the previous five years and living on federally subsidized healthcare and food stamps, I was incredibly nervous and uncertain of how an institution would assess me professionally. At the interview, I was astonished and also deeply affirmed by the knowledge that my resilience and my relationship to communities would be valued and beneficial to developing audiences, conversations, and inclusive intersectional experiences for the exhibition. With utter gratitude, I accepted an offer to support this work.

Art AIDS America had been criticized during its earlier tour for its lack of representation by those afflicted by HIV/AIDS, particularly Black and Brown bodies. My first task was to coordinate interviews for the filming of *Art AIDS America*'s introductory video, as well as provide further suggestions for contemporary voices. I was asked to participate as a subject, too. During my interview with Tony Hirschel, director of exhibitions, I recalled a history that I had forgotten—a memory of my grandmother, who had contracted HIV and died from AIDS when I was seven. Remembering her in the context of that interview felt like a world cracking open, and it stimulated many more related memories. It created a connection to a life and history I had never expected.

The opening of the exhibition coincided with the anniversary of my HIV diagnosis, as well as the fourth year of *QUEER, ILL + OKAY*, which became part of the programming. I could never adequately summarize the impact that *Art AIDS America* had and continues to have on me, my work, and the communities I serve. The intersection of artistic, educational, social justice, activist, and other communities within the exhibition programming allowed us to model how organizations can critically engage local populations and demonstrate how the bold actions of one institution can raise the standards for all its peers. This influence has infused the spirit of *QUEER, ILL + OKAY* with even more passion and commitment, fostering engagement on a national and international level.

Art AIDS America was an astounding success and great contribution to the narrative of what it means to live with HIV/AIDS today. However, the work continues. The relationship between institutions and people can, must, and will change, as long as we continue to be in conversation with one another, allow our own positions to be challenged, and permit ourselves to be uncomfortable but willing to navigate the unfamiliar and the different. *Art AIDS America* activated something of a cosmological network in Chicago. Where the makers, individuals, audiences, and the institutions that support and serve them comingle in a constellation that allows both new and old bodies to consult, find guidance and direction, and be reminded that something remarkable happened here. Look up, you can still see it and it will remain as a mark for future generations to seek, discover, and with all my love and hope, will inspire them to create their own.

Still Here

The Imperative of
Representation Persists

CHRISTOPHER AUDAIN

There's a significant chance that if I were born a decade or so earlier, I would not be here today. Beginning in the 1980s, the HIV/AIDS epidemic was as sudden as it was fatal, and the number of beautiful souls we lost is as devastating as it is immeasurable. As a gay Black man from the South who migrated to Chicago, I represent an intersectionality with the odds stacked high against me. It is still statistically more likely for me to be either unemployed, in prison, in poverty, ill, or forgotten in this country than it is for me to be not only surviving but thriving. Inequity seems to be part of this country's DNA—it is historically pervasive and the art world is certainly not exempt from culpability. About a year after I began working as program officer at Alphawood Foundation, in May of 2015, the opportunity to present *Art AIDS America* in Chicago arose, and I took on the task of managing the programming. There had been criticism that the exhibition elsewhere had lacked equitable representation of artists of color. How could Alphawood Gallery, a pop-up space run by a foundation, make significant changes? What could we do to push the boundaries?

When the exhibition opened on World AIDS Day, December 1, 2016, it was less than a month after a new presidential administration had been elected to office. Many felt a dark cloud enveloping the nation, while others rejoiced. The election gave the exhibition and programming a new frame and sense of urgency. The artists and activists in the show were unrelenting in their fight for a right to live, and for receiving the care, dignity, and respect that every human deserves. They stood up and fought for what was right, because they had no other choice. Could the foundation rise to the occasion and use this opportunity to further fulfill its mission of working for an equitable, just, and humane society? Could we make this an opportunity to reach beyond what is normally considered philanthropic endeavors? It was important that we try.

Our approach to programming was guided by four goals: (1) diversify the exhibition by going beyond the visual arts; (2) pass the mic to artists who were women, trans, positive, and people of color; (3) build community; and (4) take, share, and apply any lessons learned. One of the first gatherings we had in the summer of 2016 was held at the DePaul Art Museum. It was a mere four days after the mass shooting at Orlando's Pulse Nightclub,[1] and you could feel the distress in the room. We had invited artists and colleagues from various arts institutions to develop programs in conjunction with the exhibition. One of the artists we invited was Joe Varisco, who became the exhibition's programming coordinator. Without Joe's dedication, energy, commitment, network, and expertise, the programming would not have been nearly as impactful or had as much reach.

For this presentation, Tony Hirschel, Alphawood's director of exhibitions, gave an overview of the works of art to be exhibited and outlined our goal to add more artists of color. This priority came as a result of the controversy and protest that occurred during the exhibition's first showing in Tacoma, Washington. On December 17, 2015, the Tacoma Action Collective (TAC) had staged a die-in during the exhibition's run at the Tacoma Art Museum (TAM). During the protest, the artists and activists displayed posters and stickers with the words "Stop erasing black people." They protested both the lack of Black representation within the exhibition and the systemic anti-Black racism they saw within the museum. TAC's mission is "to eliminate systemic oppression and structural violence while empowering the people to build autonomous communities rooted in equity and justice."

In some ways, the protestors' demands were met,[2] as the museum agreed to work with the other venues hosting the exhibition to include more Black artists. Most certainly the protests produced results. A sign was posted at TAM toward the end of the exhibition's run that read: "HIV continues to disproportionally affect African American communities. . . . These unacceptably high rates of HIV transmission are the product of structural racism in American society. Many factors exacerbate the impact of HIV, including but not limited to income inequality, gender discrimination, an affordable housing crisis, disproportionate rates of incarceration, challenges to quality education, and access to affordable medical care and antiviral medicines." It is a bit ironic, if not, perhaps, fitting, that it once again took the voice of the protestor—the ones who are most marginalized and left out—to bring awareness to what in hindsight seems like an obvious oversight.

The well-organized protest sent ripples across the country to Georgia, New York, and here in Chicago. It significantly informed the way we went about bringing the exhibition here. When we could not find an African American curator to engage for the part-time work, we brought on John Neff, who went throughout the city to meet with artists, including the collective Diasporal Rhythms, to find more local works by artists of color that dealt with HIV/AIDS.

When Bill T. Jones spoke at the DuSable Museum of African American History, it was the first time the legendary and renowned dance artist presented a piece dealing explicitly with his personal relationship with the disease. It was a powerful tribute to his loved one, Arnie Zane, who was lost to the epidemic. He led a challenging talkback about the state of the country after the election, and how we might get to a better place. It was another way we were able to bring people together and discuss challenging issues, which was also a goal of the panels.

Ultimately, we had six panels: "Disruption/Repression: How AIDS Changed America"; "Embracing Equity"; "HIV/AIDS and Race"; "Love Positive Women: HIV and Women"; "HIV and Aging"; and "Lessons in Activism." Each panel focused on diversity, equity, and the impact of HIV on our society, broadly, and people of color, in particular, and included a majority of people of color, women, trans people, and diverse generations. It was important that when people revisited this tragic moment in our history, they had the space to reflect, vent, and possibly heal from the wounds of the past. To do this in a meaningful way, we had to build community and support, and that meant getting buy-in from the community. We did not want to bring this exhibition here and say, here it is, we brought this for you, enjoy. Instead, we said, join us, share your stories, use this space, activate this space, and together we can work toward something much greater than we can do alone.

Bringing together a comprehensive roster of institutional allies was not just smart PR—it was so that people felt a shared stake in the space and had a sense of belonging. We incorporated HIV testing in the gallery as a service to visitors and to alleviate more of the fear around getting tested. Staci Boris, who joined as gallery director, facilitated a Sharing Stories program and scheduled public tours with different themes. StoryCorps helped us facilitate a way for people to record stories. About Face Theatre presented *AIDS on Stage*, a series of readings of HIV/AIDS plays that provided a retrospective look at how theater artists have addressed the health crisis through the decades.

Leslie Guy, who was curator at the DuSable Museum, suggested we contact Gerard Gaskin. Gaskin's photography offers a glimpse into the culture of the House

and Ball community, where African American and Latinx people express themselves through costume, dance, sexuality, and competition, and his three photos significantly broadened the scope of the exhibition. The Ballroom scene is also where artist Kia LaBeija gets her last name—she is a member of the Iconic House of LaBeija and uses voguing as a performance practice and as community-based work. She led a vogue workshop at the Chicago Cultural Center with artist/activists NIC Kay and Benji Hart that taught the street-style vogue, not just as a dance form but as a tool for resistance, and she performed during Kristiana Rae Colon's Black Sex Matters event at the Stony Island Arts Bank.

In an in-gallery interview with Zach Stafford,[3] who was a Chicago-based journalist at the time, Kia LaBeija discussed her practice and her life being an HIV-positive artist and advocate. By being present, she helped others with HIV feel more comfortable with themselves. At one point, she asked if anyone else at the event is HIV positive and for them to stand. One person in the audience had been diagnosed just two months previously and was having a difficult time adjusting to the news. He had not told many people, and it was a burden to bear. But Kia LaBeija's message and the strength he saw in her gave him some inspiration. Bringing this artist in had more effect than I could have hoped for—it helped give someone the courage to stand up, releasing the tension weighing him down.

Karen Finley, performance artist and NYU professor—and a true culture warrior who knows a thing or two about challenging institutions[4]—led "The Anti-Workshop: Call to Action," which brought nearly twenty artists together for a public performance that could never have taken place within the pristine walls of a traditional museum. Finley has a grace and understated brilliance about her that few possess. She spent individual time with each artist, and then led the cohort through a spectacular intervention with results that exceeded expectations.

The exhibition and the related programming touched on politics, healthcare, isolation, racism, loss, death, activism, art, courage, resilience, and triumph, among a great many other things. But what sticks with me most is the idea of trauma. There was no small wave of depression that fell over me when working on the exhibition. The frustration with our failed public sector was an all-too-familiar refrain. How did people cope with not only being sick but losing so many loved ones? Jim McDonough told me how one of the first things people did every morning during the height of the crisis was grab the newspaper to read the obituaries and see who had passed. Others talked about how sometimes you didn't even know a friend was sick, and then the next thing you know they passed away. How do you survive such trauma? If a crisis such as the HIV/AIDS epidemic were to happen again today, would more people have the courage and strength to do something about it, or would it be déjà vu all over again?

And what would our world be today had we not lost so many extraordinary visionaries? Essex Hemphill, whose work I became familiar with during this exhibition, was a remarkable poet and activist born in Chicago. He died at thirty-eight. I would often begin a program by reading one of his poems. The poem that follows spoke to me the most as I wonder if can ever escape my fate of "dying twice as fast / as any other American / between eighteen and thirty-five." As a gay Black man, I too often feel there is nowhere I truly belong. Too often I feel like an outsider, even when folks have every intention of including me: a *Cordon Negro*, isolated from my own world by unyielding barriers both concrete and nebulous.

Cordon Negro

ESSEX HEMPHILL

I drink champagne early in the morning
instead of leaving my house
with an M16 and nowhere to go.

I die twice as fast
as any other American
between eighteen and thirty-five.
This disturbs me,
but I try not to show it in public.

Each morning I open my eyes is a miracle.
The blessing of opening them
is temporary on any given day.
I could be taken out,
I could go off,
I could forget to be careful.
Even my brothers, hunted, hunt me.
I'm the only one who values my life
and sometimes I don't give a damn.

My love life can kill me.
I'm faced daily with choosing violence
or a demeanor that saves every other life
but my own.

I won't cross-over.
It's time someone else came to me
not to patronize me physically,
sexually or humorously.

I'm sick of being an endangered species,
sick of being a goddamn statistic.
So what are my choices?

I could leave with no intention
of coming home tonight,
go crazy downtown and raise hell
on a rooftop with my rifle.
I could live for a brief moment
on the six o'clock news,
or masquerade another day
through the corridors of commerce
and American dreams.

I'm dying twice as fast
as any other American.
So I pour myself a glass of champagne,
I cut it with a drop of orange juice.

After I swallow my liquid valium,
my private celebration
for being alive this morning,
I leave my shelter,
I guard my life with no apologies.
My concerns are small
and personal.

An urgent lesson I learned from working on this exhibition is that we have to stand together and find new ways to make change. We must consistently reach out to people who are different than us. Embrace diversity. Give someone a helping hand. Understand that because this country is undeniably—yet unfathomably still deniably—racist, people of color on the whole have fewer resources and means to reach their dreams. Embrace diversity, equity, and inclusion not even because it's the *right* thing to do, or popular thing to do, or because it will keep your institution current with the trend, but because it is necessary and the *only* thing to do. Don't just *say* Black lives matter—but do exclaim it loudly—take a breath, remember Eric Garner, and *make* Black lives matter. When it's your time to act, will you turn a blind eye or will you stand up and rise to the occasion? Imagine a better world: How will you help us get there?

Throughout the exhibition, this same idea reverberated with me: with just a slight change in circumstance, I could be dead. Another soul taken too soon. But here I am. I am still here. My lived experience and intersectional identity was the guiding force to create programming that would complement and deepen the impact of the exhibition. While the Alphawood Gallery space is now gone, the work remains. It was never about the physical building, but about building community, networks, and bonds that can never be broken. About new relationships that stand the test of time and adversity. I thank those who came before me that fought tirelessly for a more just world. I thank those who are fighting now, and those who continue the perpetual pursuit for a better society. And here, I want to thank all the speakers, artists, activists, and administrators who joined us in this endeavor. Your passion and collaboration are what made this work truly life-changing and the Chicago presentation outstanding.

1 On June 12, 2016, a gunman killed forty-nine people and wounded fifty-eight at Pulse, a gay nightclub in Orlando, Florida.

2 "We are protesting the erasure of black voices from a nationally touring collection of art called 'Art AIDS America,' curated by Jonathan Katz and Rock Hushka. This historical and ongoing erasure of black people from the HIV/AIDS narrative is part of larger systems of anti-black oppression and we ask for your support in demanding the show be changed to better represent those most effected, black people." From http://stoperasingblackpeoplenow .tumblr.com/ [accessed May 20, 2016].

3 http://adage.com/article/digital/grindr-jumps -a-media-strategy-magazine/309142/ [accessed May 23, 2017].

4 "In 1990, performance artists Karen Finley, Tim Miller, John Fleck, and Holly Hughes, later known as the 'NEA Four' had their grants vetoed by NEA Chairman John Frohnmayer," http:// www.chicagotribune.com/la-et-entertainment -news-updates-march-a-brief-history-of-the -1489686723-htmlstory.html [accessed February 19, 2018]. The team sued the federal government in the case "National Endowment for the Arts v. Finley, 524 U.S. 569 (1998)" over the indecency clause that was added and used to rescind grants already awarded to artists. The District Court and U.S. Court of Appeals ruled in Finley's Favor; however, the U.S. Supreme Court overturned the decision.

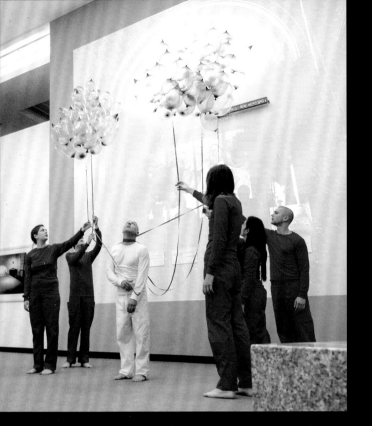

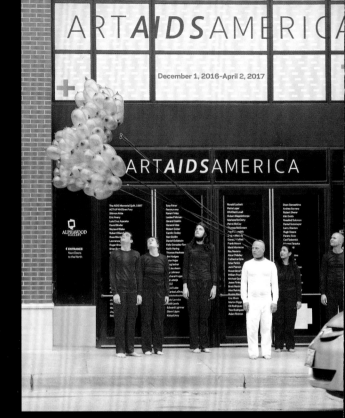

Joseph Ravens's *Condom Cloud* was first performed in the early 1990s, when the artist was grappling with his feelings of fear, anger, shame, and loss during the AIDS epidemic.

Performers: Joseph Ravens, Michael Lee Bridges, Jake Eveker, Keegan Condon, Steph Meza, and Holly Arsenault

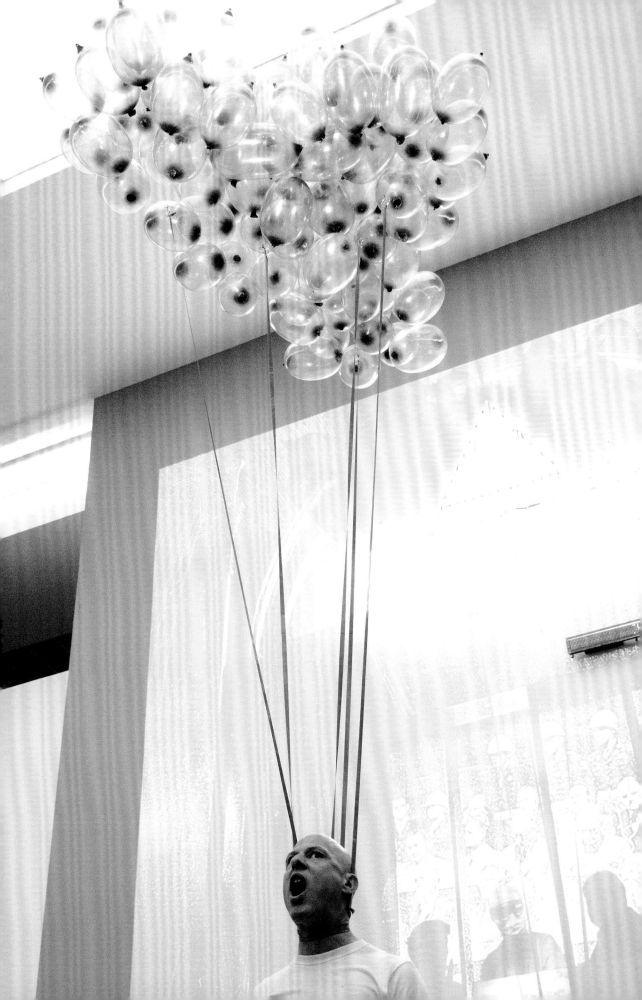

Disruption/Repression: How AIDS Changed America Panel Discussion

December 3, 2016

Medicine, politics, art, activism, sex, culture—everything in the United States changed after the first reports of a mysterious illness in 1981. In the face of intense fear, repression, and prejudice, brave activists took to the streets in protest while enduring great loss; their goal was to create change and, ultimately, find compassion for the suffering and departed. This panel of an ACT UP/Chicago founder, artists, activists, scholars, and medical and museum professionals explored the response to HIV/AIDS at the height of the crisis, how it relates to today, and how it informs their work.

Moderator: Lora Branch (public health advocate)
Panel: Peter Carpenter (Dance Department of Columbia College Chicago), Jeanne Kracher (ACT UP/Chicago and Crossroads Fund), Mary Patten (ACT UP/Chicago and School of the Art Institute of Chicago), Dr. Renslow Sherer (University of Chicago), Stephanie Stebich (Executive Director, Tacoma Art Museum), and Robert Vazquez-Pacheco (Gran Fury)

Lora Branch: In 1981, I was just a newly out, Frankie Knuckles devotee, disco house music DJ, and a part-time college freshman, in that order. My crew was comprised of gay men, sexually ambiguous women, and my big sister Lynn, whose generous spirit supported my new chapter in life and whose ready sofa protected me from the judgment of my very religious parents. . . . At the same time, my best friends and I had frequent debates about whether this new mysterious illness was a real threat to us, and we convinced ourselves that we didn't do poppers, we weren't living in New York, we weren't living in San Francisco, and we weren't white, we were okay. Like so many others, we learned the truth and by the mid-90s, my friends had died from HIV-related illnesses, as had so many in my circle of friends and chosen family. It would be ten years later that I would have my first job in the HIV-services landscape here in Chicago on the west side. And since then, I sought ways to blend meaningful art elements into my life and music, and later producing the film series called *Kevin's Room*, which was in part a tribute to my lost friends and an intentional attempt to crash the comfort of the Black community that was, in my opinion, in deep denial.

Jeanne Kracher and Mary Patten: ACT UP was the AIDS Coalition to Unleash Power and . . . whenever ACT UP met anywhere, we would start off the meeting by saying: "We are a diverse nonpartisan group of individuals united in anger and committed to direct action to end the AIDS crisis." We weren't just activists, we were also caregivers. We were self-educators and educators. We were grassroots researchers, and we were an army of lovers. The biggest lessons that we learned were around solidarity and this idea of "how do we work together across communities?"— across race, gender, class, neighborhoods.

Dr. Renslow Sherer: While we look back and we remember, we should understand how much better things are now, near a normal life expectancy of a person diagnosed, freedom to come forward.... When we talk about health and human rights, we [need to] use an expanded definition of health. It's not just one virus or its conditions or its co-morbidities, but actually part of that is a good education; is a clean environment; is adequate access to food, safety, and security in our own communities. [There were] 1,200 cases in Chicago in 2013. I think we have every reason to think we can bring that below a thousand and even down to near zero. We can eliminate new HIV in Chicago by finding everybody who is positive and giving them treatment. Not easy to do, but it's doable.

Robert Vazquez-Pacheco: This is a plague that makes all of us do more and become more than what we are, more than what we believe we are, and it makes us struggle, it makes us fight, and it makes us reach for something else. It makes us reach for what we think are things that are truly human, respect. It's love. It is the power of our commitment that has brought us here, that has given us all of this work, and that will continue to give us all this work because we have to change what has happened. We've lost so many; we cannot afford to lose anyone else. I think that if anything, what we've learned is how powerful art is and how powerful images are and how powerful it is when you work with and within the dominant media ...one of the most effective ways to work is when people are not expecting you or not expecting that message to be where it is.

Left to right: Christopher Audain, Lora Branch, Mary Patten, Jeanne Kracher, Dr. Renslow Sherer, Robert Vazquez-Pacheco, Peter Carpenter, Stephanie Stebich

193

Peter Carpenter: For myself and for a number of other artists, the AIDS crisis exposed the need for developing a core and coalitional politics that reached across divisions of gender, sexuality, class, race, et cetera. I have a deep admiration for the work that ACT UP has done, and I just want to say that that work resonated out to other places. . . . In addition to the aesthetics, the kind of structure of what I would say, the choreographic structure of ACT UP, influenced the choreographic structure of things happening on the concert stage.

Stephanie Stebich: We had a protest at the Tacoma Art Museum in fall of 2015 targeting our curator Rock Hushka, the exhibition *ART AIDS America,* and the museum by a group called Tacoma Action Collective (TAC), inspired by the Black Lives Matter movement. They protested against a host of things, not particularly art or museums. They asked the question, "Where were the African American artists in the exhibition?" There were several, but not enough by their reckoning. Now we could say, "Wait, that wasn't the focus of the exhibition. It's not a history of African Americans lost to AIDS or AIDS, it's really how AIDS has changed the American art field," but perception is reality, and so we wanted to acknowledge their concern and their protest. We asked ourselves some hard questions, and we wanted to make the exhibition part of the change that was needed and wanted, because why should art museums be absent from major national conversations? If we're having a conversation about race in America, why would art museums be exempt from this? So that conversation came to our doorstep, and we decided we were going to welcome the conversation versus step away from it. TAC was active primarily on social media and we said, "Guess what, let's do a press release, let's get the newspaper in this, let's have a bigger community conversation." I'm really proud of my team, because it wasn't always fun. We see ourselves as a learning institution, both for the public and for ourselves. We had a number of face-to-face conversations with TAC leaders and our trustees and with other groups in the community. In the weeks of conversation, where we talked about things that we could do together on this important topic of making sure there was greater representation of African American artists in *Art AIDS America* as it traveled . . . was to tell our sister institutions who were equally committed to this project that they needed to do more to represent their whole community in the exhibition. They said yes, please, and so some of the community engagement programs that we developed we shared with our colleagues. . . . [T]he protest in Tacoma has made the exhibition and museum better and stronger and started a conversation that really needs to go on beyond this exhibition, and in museums around the country.

Embracing Equity Panel Discussion

with performance by Bindu Poroori and Ajooni Kaur
January 11, 2017

Embracing Equity was a candid conversation led by arts professionals on how to break down the barriers and structures that create a lack of equitable representation in the arts and arts institutions. The program began with spoken-word performances by Bindu Poroori and Ajooni Kaur.

Moderator: Tracye Matthews (Center for the Study of Race, Politics, and Culture at the University of Chicago)
Panel: Aymar Jean Christian (Open TV and Northwestern University), Anthony Hirschel (Alphawood Gallery), Kiam Marcelo Junio (visual and performance artist), Charles Long (artist and activist), and Amina Ross (artist)

Tracye Matthews: When I entered the museum field in the early 1990s, everyone was abuzz with talk about multiculturalism and the need to diversify museum audiences. Ironically, the institutions with a history of excluding the work of minorities as staff and as makers received large amounts of funding in order to create projects and outreach programs that would ostensibly build their minority constituency. At the same time, smaller and ethnically specific institutions were

Left to right: Tracye Matthews, Charles Long, Kiam Marcelo Junio, Amina Ross, Aymar Jean Christian, Anthony Hirschel

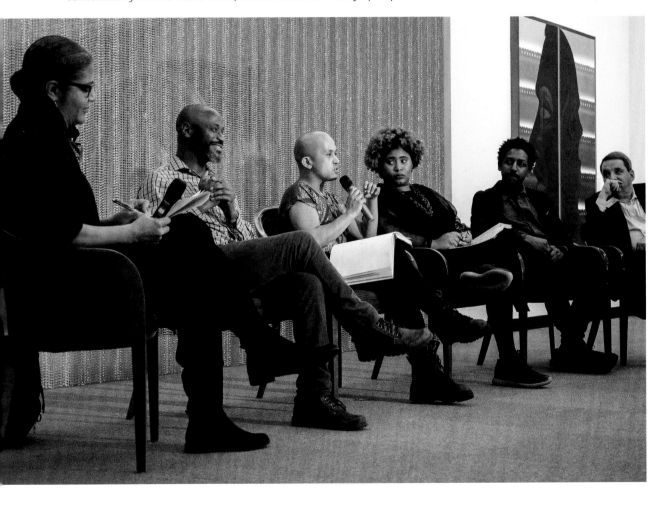

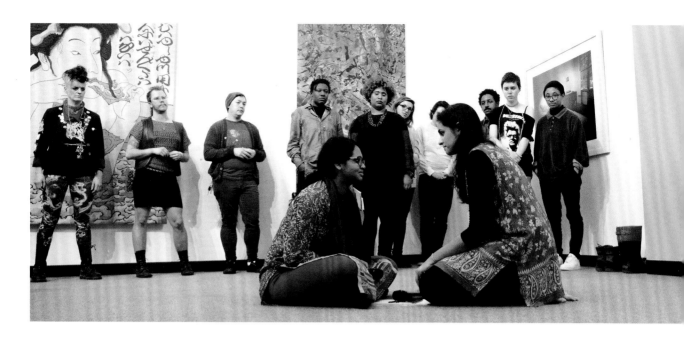

hard pressed to find funding for general operating and capacity building.... Similar conversations among museum and art insiders are happening today, driven in no small part by the shifting demographics of the U.S. and the worry that they will become irrelevant in a majority minority America. We've seen major surveys and reports on the race and gender demographics of the staff at various cultural institutions in the last few years and what have we learned? #MuseumsSoWhite, #ArtsSoWhite.... Access to universities, internships, networks of power, mentoring are all very important issues that impact the lack of diversity in museums and the art world.... Can we expect greater inclusion in the arts to improve in this age of growing wealth inequality? And how will the conversations around equity in the arts change or diminish in this new political era?

Aymar Jean Christian: In 2015 I started a platform called OpenTV Beta... to develop artists that the industry was not developing. We've released about fifteen hours of original programming, mostly by Chicago-based queer, trans, cis women, and artists of color, and it's really compelled me to think that you have to have productions and exhibitions that are run by the people you want to represent in order to have the representation. It really comes down to who's in the room, who's making decisions.

Amina Ross: Is your inclusion working if the validity of my work is questioned, if the validity of my presence is doubted, if every white face scans the room when I'm at a meeting and not so secretly wonders if I am only there because I am Black, femme, and queer? Am I included if not so secretly I am not wanted and if my presence cannot be sustained financially, mentally, and emotionally? Am I included if the people I share a room with would rather see me dead or refuse to acknowledge that we're dying? Is this a corrective panel? What is ever an adequate remedy and is my soothing voice a medication? I wonder.

Charles Long: I do think we have to start at the impetus, and I'm going to be a little flagrant right now. That two white cis men can sit and decide that they're going to

decide what an entire retrospective of a disease that killed a good majority of my people looks like and could do that with such hubris and not really see what the problem was IS the problem. We are sitting in the spaces that were never ours to begin with, discussing canons that were never ours to begin with. So, in the context of when we talk about how do we change institutions, in my activist mind I say don't change them, blow them up, because they don't make any sense.

Amina Ross: I think that sometimes people let artists get away with saying things that administrators may be a bit too shy to say. As someone who works between—I curate things, work in the education department of MCA, and I'm an artist— wanting to maintain that power and freedom that maybe I invented, but maintaining and occupying that space of being vocal, just as a most basic step in those environments and not feeling like I have to shut up for anybody, I think is really important.

Kiam Marcelo Junio: Thinking about my role as an artist, I really connect that also to the role of a shaman, of a witch, of a storyteller, and that's a responsibility that I carry and that I take seriously.

Anthony Hirschel: We can't just depend on institutions and the people within them who have been formed within and by those institutions to just say today we're going to think entirely differently about everything, today we'll include new people, we're open to ideas that yesterday we weren't open to. It's in the power of imagination and self-confidence. If people can imagine themselves in those institutions, they can imagine themselves leading those institutions and being board members. . . . You've got to believe in yourself that you can do this, that you belong there as much as everybody else, understand what it takes to make that institution stronger and better, and that's how those institutions will get stronger. It will never happen if you just hope that the institution itself is going to suddenly wake up and be different. They move much too slowly. It's about recognizing the power is in the people who are going to make those changes. They're the ones able to see it.

January 27, 2017
DuSable Museum of African American History

Alphawood Foundation partnered with the DuSable Museum of African American History to welcome award-winning artist, choreographer, dancer, theater director, and writer Bill T. Jones to Chicago. Jones's multimedia presentation included video, readings, photographs, and dance and was informed by his own struggle to deal with loss while finding the strength to persevere. His body of work has focused on mortality and uncovering our common humanity in the face of sorrow.

Bill T. Jones: A slip of white coming out of the red plastic bag was the last I saw of Arnie. Bedsheets that catch the shit and the piss, blood, dead skin, the slipping body are not human.

I reached out—and at that very moment, the nervous driver spun the tires and peeled out of my driveway. . . . Arnie was gone. His ashes would be mailed back to me in a box a few weeks later.

My friends and family had put the bedroom back together and I woke the next morning thinking, for one brief second, that it was just another beautiful early spring day. As I sat up, though, my body began to weep even before my mind recognized the cause for grieving. The world would never be the same. Everything I would make from that day on would recall how it had changed. Everything I did for myself would be in the name of what we had been.

Robert Mapplethorpe, *Bill T. Jones and Arnie Zane*, 1985; photograph

+ + +

Rebellion I always knew. Transgression I have had to learn. Demian Acquavella, the dancer, had purple splotches over his beau-sculpted arms and torso. What did he think? Demian, with the amazing ass and thighs. Someone had looked at him, wanted him, and ultimately shared with him that which would kill them both, which could kill us all.

We were at City Center performing *History of Collage*. It was a costume piece, and each dancer was asked to choose his outfit. Demian put us all to shame with his bravado, his sense of style. He had chosen to wear a translucent black chiffon tutu with a dancer's belt and combat boots. I was backstage; suddenly I overheard the technicians, agitated, repulsed, amused: "There's a guy out there with his dick out."

It was a mischievous, angry thing to do. I understand this now. Demian was saying, "This is the source of my power, my sexualized self. Look at me. I'm melting from within but look at me. I dare you to look at me." By daring us to look, he said he was not afraid.

HIV/AIDS and Race Panel Discussion

with performance by Po' Chop
February 8, 2017

In the United States, HIV/AIDS disproportionately impacts communities of color, specifically Black/African American and Latinx/Hispanic populations, with youth, and women-identified persons most affected. In 2014, the Center for Disease Control reported African Americans represent 12 percent of the population, but account for 44 percent of HIV diagnoses. This program focusing on race delved deep into why and worked toward solutions.

Moderator: Lora Branch (public health advocate)
Panel: Erik Glenn (Chicago Black Gay Men's Caucus), David Ernesto Munar (Howard Brown Health), Hadeis Safi (Center on Halsted), Sista Yaa Simpson (The Association of Clinical Trial Services), and Chay Yew (Victory Gardens Theater)

David Ernesto Munar: Our bodies as people of color (my family is from Colombia; I am Latino), our bodies as LGBTQ people, as immigrants from immigrant families, are literally under attack, like we were in the early eighties and nineties. The terror is here. We are living a moment that we will have museums about someday, about how we comported ourselves, how we responded, how we healed, how we helped each other, how we struggled, how we survived the terror. I know people who are green-card holders. I know people who are undocumented. I know people who are naturalized U.S. citizens who are terrified about what will happen to them, to their care, to their services, to their access to their HIV medication, to their birth control, to their jobs, to their homes, to their family, to their kids, to their parents. . . . This is not a new experience for people who have been marginalized. What it means for the AIDS epidemic is that we are going to struggle to reach people like never before, to help them get access to PrEP if they need it, to PEP if they need it, to condoms if they need them, to care if they need it, to primary care, to meds. For a variety of very tangible reasons, because resources may not be there, institutions may not be supported, the funding streams may not survive, just the terror itself is going to scare people away and create conditions where they don't even want to come forward. . . . We are connected across the country—red districts, blue districts, purple districts. We are connected by how we vote. We have to tell the truth about what is happening, how it is impacting us individually, how it's impacting the things that we care about; we have to tell the truth about the real consequences of the civil discord that is occurring in the country. We have to participate in democracy— there really is no other choice, because it is about HIV, but it's about everything we care about and everyone we care about.

Sista Yaa Simpson: Yesterday was National Black HIV/AIDS Awareness Day. Eighteen years and we are still talking about it. Same old things with the same old issues. But what's different is me, because I'm not going to stop talking. I'm not going to give up. I'm not going to be depressed. I am determined. . . . We are not here to be equally sick, we are here to be equitably better.

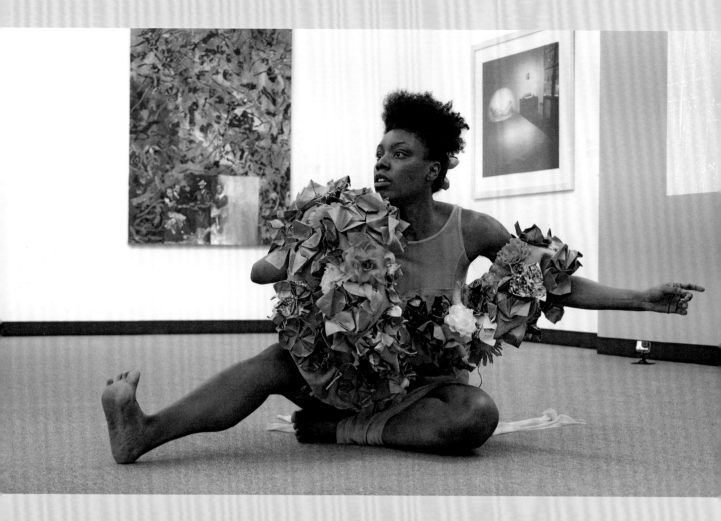

Hadeis Safi: We need to listen to the people that are coming to us and telling us that they need help. I tell them to take this step and this step and this step, but we are not taking the time to sit and listen to people's real issues. . . . That's where you lost them. If you get them linked in but if you don't know their real problem, it's not their reality. If you don't sit in that reality with them and if you don't sit in that moment, we don't take that twenty minutes, that thirty minutes, that three months, that six months to be there with them so they know they are not alone, we lost them, and we did them wrong.

Chay Yew: We are the storytellers, and the reason I became a storyteller is because of a seminal AIDS play back in the eighties called *The Normal Heart* that radicalized me from wanting to be in musical theater to writing political theater and directing political plays. I think telling stories brings testimonials to life, finding ways like playwrights from Tony Kushner to Craig Lucas, we are out there in a different sort of way to make sure that there's visibility. We try to put a human face on it, and it's sometimes a very difficult battle, too. Nonetheless, this is not a time for us to be complacent. . . . We want to build bridges, let us know what we can do. The theater is not a building; it's a conversation, so always feel free to be a part of our conversation.

Erik Glenn: The best way to figure out how to bring services and science to people is to activate people to participate in that change. We really need to recruit. We need to have an army in the most loving version of an army possible. I know that in the men

that we have met in our work, something really awesome happens when they're together that doesn't have anything to do with any kind of charity, saving souls, me giving them expert advice or information. It's really about them giving it to each other and us building those spaces for it to happen.... I don't subscribe to the sense that there are voiceless people out in the world, although that's a phrase that is thrown around a lot, that we need to give voice to people. It's rather amplifying voices that are already there. Either giving the venue for it, putting the metaphorical bullhorn in front of someone's face, but also supporting them in that process so they don't feel like they are alone and they are confident in lifting their voices. I think some of our work is in figuring out how to do best by the communities we serve without taking their power away.

Lora Branch: One of the most accessible references for communities is the church, and Reverend Stevens is here from West Side Pastors' Coalition. We have a lot of resources that are underutilized that I think can do amazing work that we have to tap into, and we have this thing in common. Bring people out. It's that theme if you haven't heard anything else tonight, it resonated with me that we have to get people up out of their comfort zones and pull out that energy.

David Ernesto Munar: I am interested in grassroots peer-to-peer education about disclosure, about talking about HIV status, talking about viral suppression, talking about PrEP, talking about PEP.... I want people to take into account how science can work for you, how technology can work for you. We are not here to police sex but rather help people have more fulfilling sex lives. We have to make sure that we can testify when the science is well crafted, when it's been well vetted, and make sure the new science is informed by people who look like us and look like the people we are trying to serve.

Left to right: Lora Branch, David Ernesto Munar, Chay Yew, Erik Glenn, Sista Yaa Simpson, Hadeis Safi

Artist Kia LaBeija in Conversation with Zach Stafford

with performance by McKenzie Chinn
February 17, 2017

Art AIDS America artist Kia LaBeija discussed her artistic practice, which includes photography and voguing, with Zach Stafford, nationally known Chicago-based journalist and editor-at-large for *OUT Magazine*. Kia LaBeija was born with HIV and lost her mother at age fourteen. She aims for her work to break through a silence that many experience, creating a community and a space to heal.

Zach: What is it like to have your status? You're inviting people into really intimate moments like [in your photograph *Mourning Sickness*], representing the morning sickness from meds. So, your work isn't only about being a positive person, but it's about bringing people into moments that we're not thinking about, moments of mourning a mother, throwing up in the morning from your meds, being alone. We always think about HIV only as death, and all these really complicated things. Of struggling to be alive and then living beautifully, even, because your work is so beautiful. What is it like to produce work that is kind of reimagining, or not reimagining but giving people an access point, to seeing folks as fully developed people?

Kia: It's really hard, actually, because over the years, I've become a person living with HIV in the world. That's how a lot of people see me. And that's not easy, because that's not everything I am. It's definitely a very important part of who I am and an important part of my story and everything that I've experienced up

Kia LaBeija

Performance by
McKenzie Chinn and
John Cicora

until this point in my life, but it's not easy. But the thing is that I continue to make work and I continue to talk about it because of those moments where someone's like, "I have HIV too" and this made me feel really good about myself. Or this made me feel like I'm having a better day because I saw something that was so beautiful, that's more about how we can live with HIV and reimagine what HIV looks like today, whereas a lot of time we see so many images that can be just so tense. And this is not to invalidate any of that. But it's just to show a different side, a different perspective that you don't see all the time. And to also be able to showcase someone living with HIV who's thriving, who does see themselves as beautiful. Because as people living with HIV, there's a lot of times where you can feel not beautiful because the world is telling you that this thing you have inside of you is ugly and it's dirty and it's transmittable, and it's infectious. And all these scary, negative things. They always try to tell you, "Oh, it's not about what's outside that counts. It's about what's on the inside." But when you feel like what is on the inside is so dirty, it can be hard to love yourself. So, it's difficult work, but it's really fulfilling because I don't feel so alone anymore. I'm able to be in spaces, have a seat at the table. I'm in the room, and I'm able to connect with other people who have similar experiences or completely different experiences, but we have something in common. . . . The other thing about this narrative of HIV and AIDS is that we don't talk a lot about women, and we never talk about children. And for a long time, I felt like I was the only one. When I started to put out this work, I started getting hit by a lot of pos, I will call them pos babies. Other babies that were born in the late eighties and the early nineties that were told like you not gonna make it past four, five, six, seven. But are here 26, 27, 28, 29, 30, 31, 32. And I was like, wow, we're all still here. But we never get talked about. And not even just that but also children had parents living with HIV that died of AIDS-related causes. They don't get any recognition either. We don't talk about that, you know. AIDS is a gay white man's disease in the eyes of the narrative, and I think there are a lot of people that worked really hard to shift the narrative, and I'm proud to be one of those people.

Brenda Wolfe: In 2015 there were about 7,500 new infections among women. Women account for about 25 percent of new AIDS diagnoses. And, that's been relatively unchanged since 1999. It's not because we don't know what to do. We know what to do. There's just too many barriers and challenges for women to be able to get into care. So, what really is the driver behind HIV transmission in women? Well, like women it's complex and multifaceted. You don't necessarily have to be engaging in any type of high-risk behavior. All it may take is living in an area where there is a high prevalence or high incident rate. Partner incarceration increases HIV risk. . . . Isolation and stigma create a barrier. . . . HIV providers, who are not experienced in prescribing transgender-affirming hormone therapy, are often reluctant to prescribe hormones with their antiviral medications. Individuals may be forced to change or choose between true self and life. Lack of resources. . . . Family responsibilities. . . . Often, sometimes, just taking their medications reminds them that someone at some point in their life has deceived them, someone that they thought that they trusted and loved.

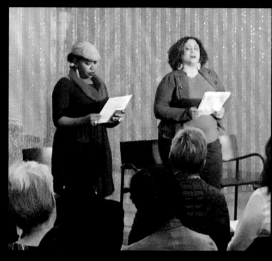

Performance by Felicia Holman and Meida McNeal

Teyanna Veasy: [Being HIV positive] has changed my life. It hasn't just always been a negative thing, it's been a positive thing. I wouldn't be here without being involved in HIV. I wouldn't be at Howard Brown with being involved with HIV. But, it has allowed me to be able to give back and to love on people who are not loved on as much as they need to be.

Mary Miller: For me, [being HIV positive] was a dirty, dark secret and a lot of hiding and trying not to let people find out and a lot of hiding on my job and fear of losing my job if anyone ever did find out. So, it's important to be out in the community and to support and share stories.

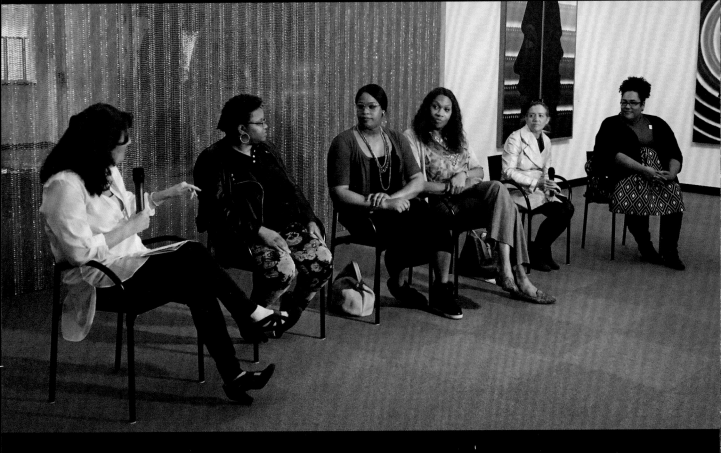

Left to right: Brenda Wolfe, LeSherri James, Teyanna Veasy, Marissa Miller, Mary Miller, Jacqueline Boyd

LeSherri James: That's all I heard—she's pregnant and she has HIV. I didn't hear anything good about it. I heard people praying for me. My daughter is HIV negative, my son is HIV negative.... I was okay with being pregnant, taking my meds, being adherent, going to the doctor. I had a good support system for that thanks to my mom. But, for my being pregnant for the world, that's a different story. That's just, you just lay back and be pregnant and let the world tell you what to do, I guess. I don't know, it wasn't the best experience in the world for me.

Marissa Miller: It doesn't matter who I went to bed with, it matters what happened once I went to bed. Was there a condom present or was there a prevention method present? So, I think sometimes we have to look at the bigger conversation, and those are scary conversations because they involve us. They involve us exposing those fears that are still attached to HIV. Women are too scared to tell their partner, "We're going to use a condom." Why? 'Cause he might think I'm cheating. Or, if I ask him to use a condom and he says no then he's going to go somewhere he doesn't have to use a condom. So, those are things that are often missed in conversations because we have genderized HIV. This is not a disease of gender. It's a disease of behavior.

AIDS on Stage

March 6–27, 2017

About Face Theatre presented a series of readings from HIV/AIDS-focused plays that provided a retrospective look at how theater artists have addressed the devastating health crisis throughout the decades.

As Is

William Hoffman's landmark Drama Desk–winning and Tony-nominated play *As Is* was among the first to explore how the AIDS pandemic affected the LGBT community. The play tells the story of a man's life turned on its head after he is diagnosed with AIDS—who he turns to, who turns away from him, and how the world reacts to the beginning of the crisis.

Jeffrey

This Obie Award–winning play by Paul Rudnick laughs in defiance at the fear around the AIDS crisis. Jeffrey's exploits take him across New York City, from hoedown charity galas to the confessional of a church, but he faces his biggest challenge yet when he falls in love.

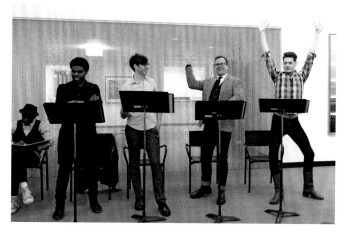

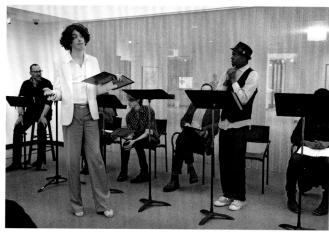

About Face Theatre's reading
of *Jeffrey*

In the Continuum

This Obie Award–winning and Pulitzer Prize–nominated drama by Danai Gurira and Nikkole Salter puts a human face on the devastating impact of AIDS in Africa and America through the lives of two unforgettably courageous women. Living worlds apart, one in South Central Los Angeles and the other in Harare, Zimbabwe, each experiences a kaleidoscopic weekend of life-changing revelations in this surprisingly comic story of parallel denials and self-discoveries.

And All the Dead Lie Down

When an unexpected phone call upsets Alvin and Foss's usual Saturday routine, the couple must navigate a minefield of long-suppressed resentments, past histories, and hurt feelings. Harrison David Rivers's *And All the Dead Lie Down* is a portrait of a serodiscordant couple at a crossroads, a couple pondering the questions: Is love enough to sustain a relationship? And is it worth the risk?

The Anti-Workshop:
CALL TO ACTION with Karen Finley

March 12, 2017

The Anti-Workshop: CALL TO ACTION, led and conceived by renowned performance artist and *Art AIDS America* participant Karen Finley, was a one-week study, occupation, and reaction through performance to the *Art AIDS America Chicago* exhibition. A multidisciplinary cohort of eighteen artists, activists, and educators from across Chicago responded to the exhibition by exploring questions like: How do artists, activists, educators, and audience respond to and engage with the history and art without succumbing to nostalgia and passivity? How do we inspire creative practice in the face of current political concerns, while maintaining the movement of art AIDS activism?

Ultimately divided into four groups related to locations in the gallery—NORTH, SOUTH, EAST, and WEST—the artists collaborated to produce new works that responded both to the historical works in the exhibition as well as the political climate of today, most poignantly rallying to the call of "artist as criminal" and "art as dangerous." On Sunday, March 12, visitors were invited to witness and experience the resulting artist interventions that transformed trauma and political turmoil into creative reimagining and envisioning. The aim was to awaken and empower everyone to a sharper focus and greater purpose.

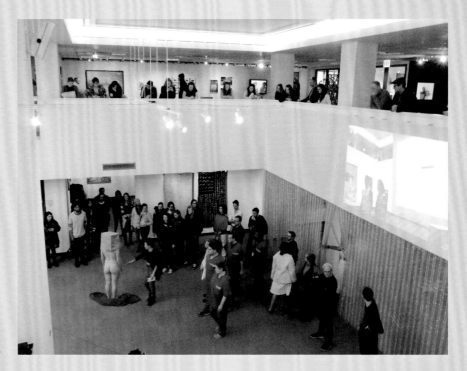

Karen Finley's *CALL TO ACTION*

CALL TO ACTION will reflect, create, and activate the gallery spaces with the charge to strive and build on the legacy of artistic activism that lives in the gallery. Working in collaboration, or as a series of individual responses, artists will form collectives inspired by the practice of Gran Fury, ACT UP, and from our communities. We will construct a series of creative responses to today's urgent political moments, immigration, executive orders, gentrification, gender-neutral bathrooms, violence, boycotts, racism, sexism, homophobia, neglected and marginalized voices, and engage in social practice art with poetics, music, portraits of protest, or celebration.

CALL TO ACTION is an art action forum to occupy, to not succumb to the distance of the viewing public, to acknowledge resistance, seize the urgency, the public sphere emerging us to our present moment and imagining our future potential. The art is in dialogue with today yet inspired by collective responses, while acknowledging the working within community. Of course, there are spaces of disremembering, abstraction, and voicing marginalization, ritual as opportunities for recognition.

CALL TO ACTION responses will be considered in a multitude of ways and that is the challenge and the delight. Looking at the exhibit historically as a language of a cultural movement continuum we will recognize and continue speaking out, being engaged with our art activism together whether humor, parody, criticism, or joy, sequins, selfies, karaoke, or disco—the engagement does not have to encircle earlier policies but instead swirl with immediate issues and/or other related concerns.

Left: Sean Parris and Karen Finley; Right: Sean Estelle and Morgan McNaught

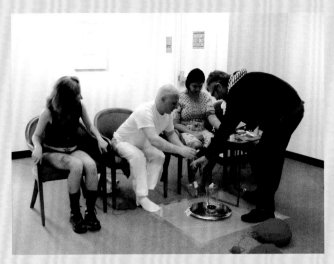

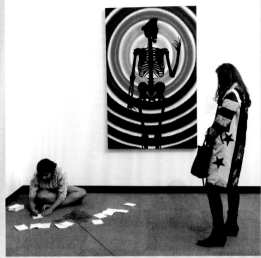

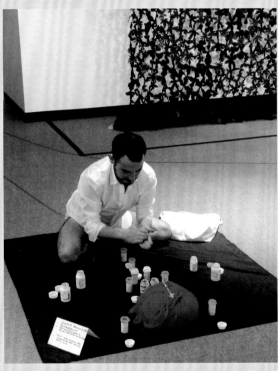

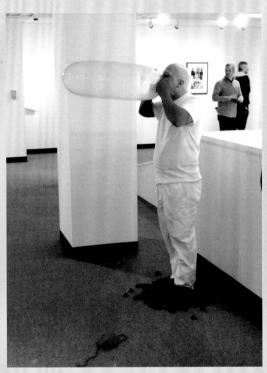

NORTH

blood bandits

Sid Branca, Chris Kellner, Bindu Poroori, Joseph Ravens, and Joseph Varisco

What criminalizes the blood, the body, the heart, the mind? Four individuals disqualify themselves from donating blood, and then come together to donate blood. Branca performed a tattoo on their bodies while projected across a space where Poroori offered handmade visas while recounting confabulated histories of origin to America. Ravens, clad in a white jumpsuit with long red silk opera gloves, stood upon a pile of black condoms that he inflated until they popped, rising and collapsing with the movement, while a few steps away, Varisco assembled and disassembled an altar of his HIV medications. Performers were tethered together by red yarn, which they followed into an HIV testing room, where Kellner drew blood from each of them into a shared vessel in defiance of criminalization laws.

Clockwise from top left: Sid Branca, Joseph Ravens, Bindu Poroori, Chris Kellner; Bindu Poroori and Karen Finley; Joseph Ravens; Joseph Varisco

Clockwise from top left: Joan Giroux, Isaac Gomez, Michael Lee Bridges, Christopher Audain, Jane Beachy; Joan Giroux; Michael Lee Bridges and Jane Beachy with visitors

SOUTH

PENNY FOR YOUR . . .

Christopher Audain, Jane Beachy, Michael Lee Bridges, Joan Giroux, and Isaac Gomez Soft focus. Preservation of memory. Temporal. The root of us. Care. How do we care for one another? How do we care for ourselves? Visitors were invited to take a penny to enter the care area. Giroux wandered the gallery with a platter of pennies, while Beachy, Gomez, and Bridges, in hospital scrubs with prescription pads of hot pink triangles, inquired about afflictions, both literal and figurative. To finish, Audain sang selections of music in an attempt to transform the burdens people carried.

EAST

the invitations

Sean Estelle, Maggie Mascal, Morgan McNaught, and Sean Parris

The east invited u to investigate the mystery and transformation of ur personal self to ur universe itself thru ritual / words as medicine / / air as oracle / / art as connection / within the four walls of the gallery / the white cube / the institution there is a code / a script / boundaries that must be observed and we are he/a/r/e to tear it up / find radical vulnerability within ourselves and within you to will a SACRED SPACE into existence / come and be renewed. Estelle wrote spells derived from texts of the Yerba Mala collective on sheets of paper and placed them around the gallery. McNaught performed as oracle, listening and responding to questions as audience members were escorted by the vocal and instrumental incantations of Parris and Mascal.

Left to right: Sean Parris, Maggie Mascal, Morgan McNaught

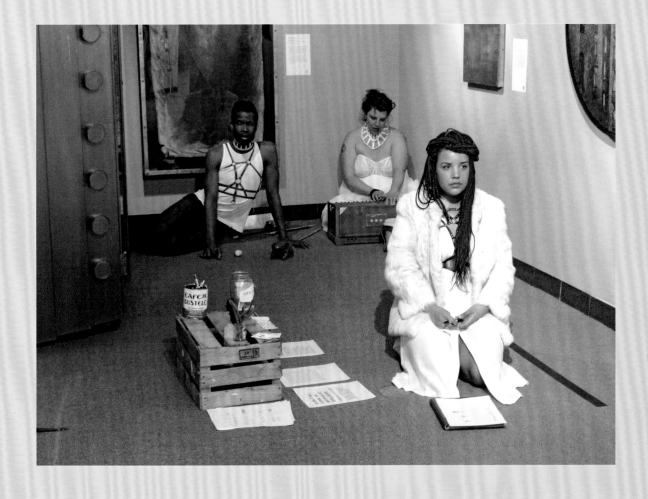

WEST

Art AIDS (Who's) America(?)

Ivan Bujan, Bea Cordelia, Ricardo Gamboa, and Emilio Rojas

Performers used their bodies to invoke individual dialogues with artworks in the gallery. Cordelia's *Touch Me* placed intimacy, agency, objection, and abjection in the gallery, asking visitors to consider their relationships to queer modes of sexuality and the dehumanization of queer, and especially trans, bodies. In *A Performance for A_____ or A Curse for _____*, Gamboa used Frank Moore's painting *Patient* (1997–98) to tell the story of his mother's gay childhood friend on Chicago's South Side who died of AIDS, drawing attention to the politics of who is archived, grievable, and remembered (and who is not). Inspired by Joey Terrill's painting *Still-Life with Forget-Me-Nots and One Week's Dose of Truvada* (2012), Bujan's installation *Blue (State Intimacies)* addressed commoditization of health in the age of PrEP and the systemic violence that maintains high rates of HIV among Black and Brown communities in the United States. In *Untitled (weight)*, Rojas dialogued with a rock removed from a site filled with historical desire. The sea washing away our past, bodies lying on top of one another, like the landscape of the shore paved as a form of erasure when we needed love most.

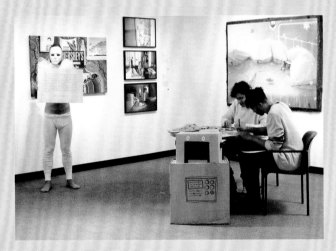

Top: Ivan Bujan, Ricardo Gamboa, and visitor

Bottom: Emilio Rojas

Anti-Workshop collective actions

HIV and Aging Panel Discussion

with performance by the Chicago Gay Men's Chorus
March 22, 2017

The Care Plan presented a discussion addressing a generational shift in HIV/AIDS culture. With the continued advances in health-care treatment and therapy, early detection, and preventative tests for seropositive individuals having grown sharply, life expectancy of HIV-positive populations has created the possibility of senior years. How has this shifted our perspective on the history and future of HIV/AIDS? What are the long-term support systems?

Moderator: Jacqueline Boyd (aging specialist, LGBTQI advocate, and founder of The Care Plan)
Panel: Roy A. Ferguson (Hines VA Hospital), Dr. Brenikki Floyd (University of Illinois at Chicago), Thomas Hunter (Chicago House and Social Service Agency), Kelly Rice (Howard Brown Health), Greg Sanchez (AIDS Foundation of Chicago), and Brenda Simmons (Chicago Women's AIDS Project)

Jacqueline Boyd: As a provider for older adults living with HIV, I've witnessed first-hand some of the overwhelming challenges that my clients who are HIV positive are living with every single day. That can range from coordination of medical care to finding providers that are both HIV competent and understand the needs of older adults. It can be isolation and just the sheer fact that maybe you lost a large part of your peer group in your twenties and thirties and those folks aren't there to hold each other up and to do the grocery shopping, to stop by, to make sure that you're not feeling alone. I've seen people struggle with survivor's guilt, with a lack of providers, a lack of qualified providers, and with stigma. I tend to think that aging service providers are about twenty years behind the mainstream in terms of even understanding the needs of HIV-positive folks.

Kelly Rice: We need to have routine HIV care be part of primary care as well. We have 15 percent of new infections in people that are over the age of fifty. And so we have to have providers that are having conversations about sex, or having

Left to right: Jacqueline Boyd, Roy A. Ferguson, Kelly Rice, Brenda Simmons, Thomas Hunter, Dr. Brenikki Floyd, and Greg Sanchez

conversations about substance use so that prevention is not just for young folks. It is for older folks as well. And also so that we can catch people and an infection very early so that we are better able to treat.

Roy A. Ferguson: When it comes to the discrepancies between the youth and the older people, it exists. The youth aren't even here today. . . . I know everything about being twenty years old. I know everything about being fifty years old. I know everything about being all the ages in between. No twenty-year-old has any idea what it's like to be sixty-five, and there's the reality of it. I don't think it's just unique to HIV issues. I think it's just the way our culture, being a very youth-centered culture, there's not the value that they have of people that have been around and living longer and dealing with this.

Brenikki Floyd: Academia can do a better job to . . . engage the communities that we want to help, and listen to them to find out what are their needs and have them be a part of, whether it's developing a program, whether it's developing a support group, whether it's improving the communication, doctor-patient communication, whether it's, you know, being able to address social determinants of health.

Thomas Hunter: There's a lot of scientific medical research being done on aging with HIV. . . . The funding for a lot of that research comes from the government, and we have to make sure that the funding keeps coming. With the current administration, I'm afraid that some of that might be cut off. So it's very important that the CDC [Centers for Disease Control and Prevention], National Institutes of Health, and the Ryan White Program continue to get funded so we can move ahead and make progress.

Greg Sanchez: [To folks who are aging with HIV] I would say . . . get out of your shell. Don't keep it in. Find support. Do something. Do something that gives you purpose. I'm so grateful to be here today. This is purpose, and purpose for me keeps me going. It gives me a reason for tomorrow. So, I would say get involved. Don't be silent. Find the help you need and the support, and if you don't find it in the places that you're looking, look someplace else.

of performance at DePaul
Art Museum

The Dead Taste Sweeter Than the Living (After Felix Gonzalez-Torres)
by Emilio Rojas in Collaboration with Paul Escriva

April 1, 2017
DePaul Art Museum and Alphawood Gallery

Chicago-based artist Emilio Rojas's multimedia performance *The Dead Taste Sweeter Than the Living* was conceived specifically for the *Art AIDS America* exhibition at Alphawood Gallery and the companion exhibition *One day this kid will get larger* at the nearby DePaul Art Museum (DPAM). Following a talk by award-winning writer and activist Kenyon Farrow and historian Jennifer Brier at DPAM, this mobile interactive event took place at both art spaces with a procession down Fullerton Avenue in between. Rojas's ongoing project began and continues with the daily collection of pieces of candy from Felix Gonzalez-Torres's *"Untitled" (Portrait of Ross in LA)*, 1991, at the Art Institute of Chicago. He uses these elements in public performances to initiate a dialogue around mourning, grief, celebration, and the impact of loss in queer communities through the AIDS crisis.

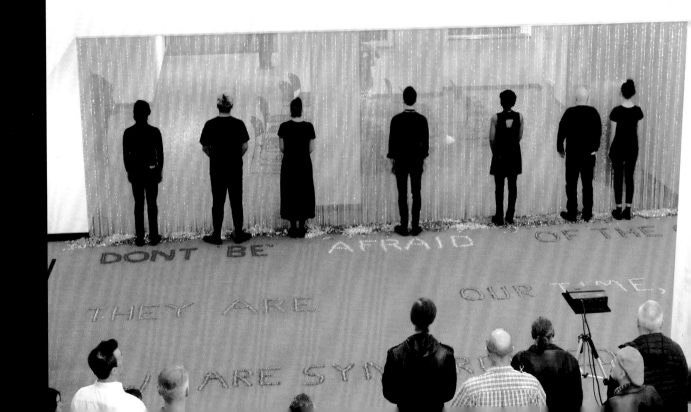

Lessons in Activism Panel Discussion

April 2, 2017

As we looked to the future, we reflected on the many lessons that shifted the political paradigm and galvanized a polarized nation toward action. This panel investigated these collective strategies in discussion with artistic, educational, and activist leaders.

Moderator: Jennifer Brier (University of Illinois–Chicago Gender and Women's Studies Director and *In Plain Sight: A Women's History of HIV/AIDS in Chicago* Project Director)

Panel: Maxx Boykin (AIDS Foundation of Chicago), Graunk Enzenberger (Pink Angels), Ricardo Jiménez (Vida/SIDA), Rae Lewis-Thornton (activist and Emmy Award winner), and Oli Rodriguez (artist)

Read by Chris Audain:

> We can win, we can lose. We can fall down, we can get up and do it over again better. We can go for it as if we have nothing to lose, knowing we have everything to lose. We can tear up a dance floor and put it all back together again. We can talk loud in public. We can be fierce. We can be small. We can be mighty. We can be too much. We can be just enough, just in time. We can. We have to.
>
> —Bill T. Jones from his memoir, *Last Night on Earth*

Jennifer Brier: I'm struck by how often I find myself returning to what I have learned studying the history of HIV/AIDS to help me navigate this moment.... I've been thinking about seven lessons that we might put on the table.... The first one: people most affected by cultural, social, and political abandonment of a particular problem of a particular time, HIV/AIDS, the rise of fascism, police brutality, must be at the center of how we collectively produce conditions of survival. Two, I think we need an inside and outside strategy to affect meaningful and lasting change. Three, banning immigration of anybody, period, never produces solutions to the problems that it seeks to do. My fourth lesson is that the government is not and has never been a unified entity acting in one voice. Lesson number five, we need to attend to the emotional and affective impact and consequence of our resistance. We need to attend to the emotional cost of that anger and recognize what it can do when our bodies and souls are under attack. We need sustaining practices that we can turn to when we are mentally and physically exhausted.... The sixth lesson is a counterpoint to that which is that art and cultural production has to be an engine of resistance, and it's necessary to make sustainable change possible.... Lesson number seven, we cannot fall into the trap of building a single-issue movement, because it will fail to address the needs of the most disenfranchised, and that means it will fail. So, AIDS activism was never only about AIDS; it was always also about poverty and about housing and about naming healthcare as a right. It

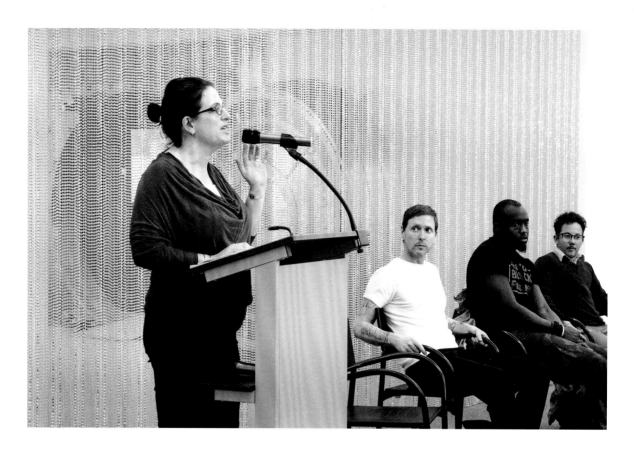

Left to right: Jennifer Brier, Graunk Enzenberger, Maxx Boykin, Oli Rodriguez

was about sexual and reproductive health, it was about mass incarceration. Saying that those are distractions, because otherwise we are working with problems too big to conquer, will always fail to garner the widest and deepest support that we need at this moment. We have the capacity to think about the intersections and move in multiple directions at once, and we can resist abandonment based on homophobia, misogyny, and anti-Black racism. We need to build coalitions and work to support and heal the most disenfranchised, rather than producing solutions for the few.

Maxx Boykin: When I think about this time that we're currently in right now, I think about how we must continuously fight, but we must continually uplift the people that are the most marginalized in this. Trans women, specifically Black trans women, that have been continuously killed in this country. Women that continue to be harassed, harmed, raped, but also understanding the sex workers that do this work because that is either the only work they can do or because they like it and uplifting them to make sure that they are safe as well. To think about how we continue to advise for people to have PrEP but also push against the insurance companies and the pharmaceutical companies to make sure that anything that they put out is actually affordable for the communities that are most impacted by this.

Oli Rodriguez: I currently have work called *The Papi Project* here at *Art AIDS America*, as well as an installation at the DePaul Art Museum. I work in photography, video, installation, writing, and I'm from Chicago, grew up in Humboldt Park, also West

Left to right: Ricardo Jiménez and Rae Lewis-Thornton

Town. The project really explores intersectionality and thinking about gender and thinking about race. I write in my prologue that I wasn't birthed but raised by AIDS, so "Papi," means father but also a term of endearment and also, "hey papi," like it's very sexualized, so I'm looking at all those different layers and also family archival images and cruising landscapes, which are here. And considering how much AIDS opened up so much space and gentrification that occurred throughout the eighties and nineties throughout Chicago.

Ricardo Jiménez: I'm an immigrant to this country. My parents came here in the fifties, so I started my activism at the age of fifteen, for better housing, better education. I'm also one of the founders of the Puerto Rican Cultural Center, which has been around for forty-three years. . . . In 1988, when the epidemic of HIV, in fact it was "the gay plague," started, the community of one of the most marginalized communities along with the African Americans was the Latino community. And they were left behind completely. But we were seeing people dying, and when we have a funeral in our community, it's big, it's huge. You're going to see a lot of people you've never seen. But during that time, because of the embarrassment, they were having closed caskets, unannounced and private, that of course was very unusual. So we took it on, the Puerto Rican Cultural Center where we have no funds, how do we step in to humanize this situation? And that's why we call the organization that we started, VIDA/SIDA. *Vida* means life, SIDA is AIDS in Spanish. You have life even though you have AIDS. And that started our work over probably twenty-eight years in order to direct services that were being marginalized during that time to the Latino and African American communities in Humboldt

Park. Today of course, it's a different Humboldt Park, the gentrified Humboldt Park, but we still have work to do. The stigmatization, the stigma that still exists in the Latino community and the African American community is one that we have to take on, you know?

Rae Lewis-Thornton: I am the first African American woman to tell my story of living with AIDS on the cover of a magazine, *Essence*, December 1994. We are credited with changing the face of AIDS for Black women in America. And I have spent the last twenty-two years doing this work. I don't meet any of the stereotypes. I'm a heterosexual, drug-free Black woman with twenty-seven years of education. I believe that the work that needs to be done for a population of women like me is still relevant. You know, I was listening to the first presentation, and I thought about how we shape the paradigm and the lessons we should learn from just even how we shape the paradigm. There was a Ryan White but there was also a Hydeia Broadbent, who was the first young girl; she was infected. She was one of the first orphans that became public. Her mom was a drug user. She was left in the hospital. That talks about the whole need to even adopt children with HIV and care for children. So that's left out of the paradigm at some level. We talked about what Ronald Reagan did, which was nothing. We talked about the senators who spoke against HIV, but then we don't talk about Jesse Jackson, who was the first presidential candidate with an AIDS policy. And in 1983, he was meeting with gay activists, he was sleeping in AIDS hospice, and so, even how we remember the story, how we remember the story, you all hear me? So, we need lessons, but the paradigm needs to be honest. And it needs to be in its fullness.

Jennifer Brier: What do we remember when we remember the history?... How do we sort of push back against our own memories? How do we not assume that what we remember is all that happened?

Audience Member: You have the power to control the narrative. Your daily life is activism, so all you need to do is find a way to share your story with people who need to hear your story.

Maxx Boykin: You can't say, I'm here to end the HIV epidemic if you are not actually talking about ending prisons, without talking about changing the way in which we police in this country. You cannot say that I'm trying to end the HIV epidemic with also saying we're cutting schools. That shit don't make no sense, we have to think about that when we are talking about ending HIV and making sure that we are putting adequate resources to the communities that need it the most. [We want to] make sure that people can live long healthy lives, that we actually put our money where our mouth is and put that in perspective.

Graunk Enzenberger: Education is the most important thing, and if we don't pull for the politicians who support education, that's the main, it's such a simple, I mean it's not a simple solution, but it's the basic part of everything. If you are not voting for politicians who support education, education is where it starts. The later generations, we're done, you know, but teaching younger people, educating them is what's going to stop things from happening or start things happening.

Jennifer Brier: There's a phrase from the 1980s, "AIDS does not discriminate," maybe some of you know that phrase. This idea that anyone can become infected with HIV, and it turns out that that is true, [but] what it hides is the reality that HIV is fueled by inequality. So, yes, anybody, any human body can be infected with HIV, but HIV travels along lines of inequality, and until we understand that and think about what it means to say that certain people have a higher likelihood of contracting HIV for a whole host of reasons, I think Rae's point about viral suppression and what it means to think about the relationship between treatment and prevention, another argument from back in the day, you can't have prevention without treatment, and you can't have treatment without prevention. Or whether it means to think about how mass incarceration has changed, fundamentally, the course of HIV in this city, and then in this country, but in this city, in particular, and what it means to think about the fact that there are lots of maps that line up perfectly when you think about the maps of HIV. There have been some amazing studies done of maps of the South Bronx and where firehouses close are the same neighborhoods where there are higher incidents of HIV. So that's about the way the state disinvestment looks and what happens as a result of state disinvestment, and so I think that until we're able to understand that when we're talking about AIDS, we're never just talking about HIV. I feel like that is really the lesson, and that is true today as it was true in 1987, as it was true in 1979, when we didn't even have the word yet.

Salonathon: Call Forth the Future

April 2, 2017

Artists: Molly Brennan, Alexa Græ, The Ricky Harris, Erin Kilmurray, Jordy Marilyn, Matthew Sherbach, Lucy Stoole, and Quinn Tsan

To close the exhibition, Alphawood Gallery presented this special edition of the weekly performance series *Salonathon* (2011–18) that responded to *Art AIDS America Chicago* and leaned purposefully toward the future. The program was curated by Jane Beachy, Bindu Poroori, Joseph Varisco, and Will Von Vogt.

> The thought of being a creator, of engendering, of shaping is nothing without its continuous great confirmation and embodiment in the world, nothing without the thousand-fold assent from Things and animals—and our enjoyment of it is so indescribably beautiful and rich only because it is full of inherited memories of the engendering and birthing of millions. In one creative thought a thousand forgotten nights of love come to life again and fill it with majesty and exaltation. And those who come together in the nights and are entwined in rocking delight perform a solemn task and gather sweetness, depth, and strength for the song of some future poet, who will appear in order to say ecstasies that are unsayable. And they call forth the future.
>
> —Rainer Maria Rilke, *Letters to a Young Poet*

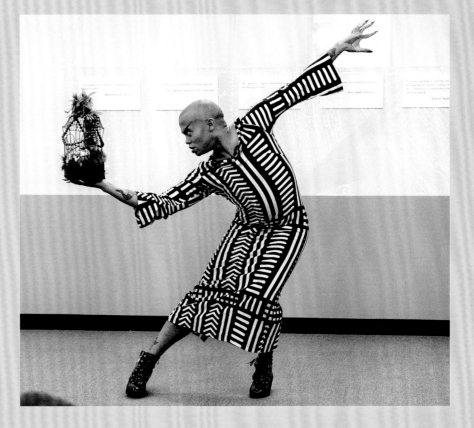

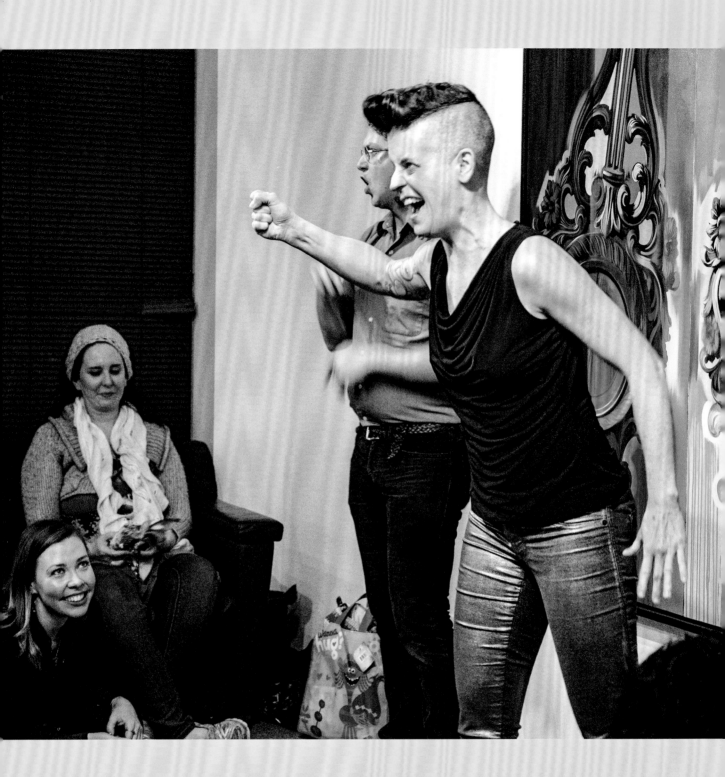

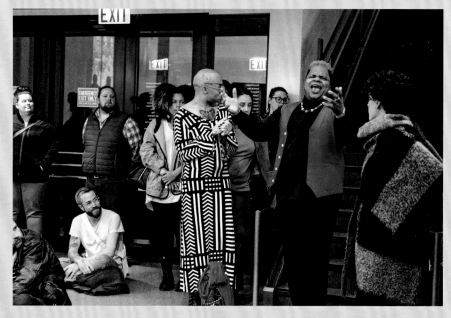

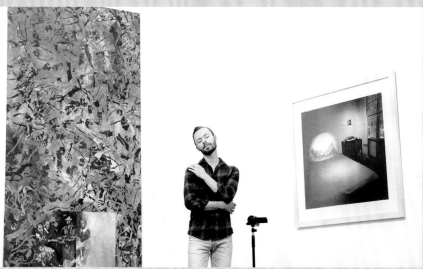

Opposite: Molly Brennan

Right, top to bottom: Joseph
Varisco; The Ricky Harris;
Matthew Sherbach

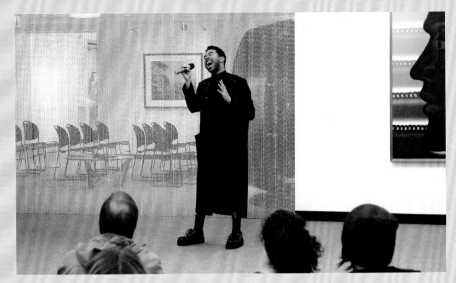

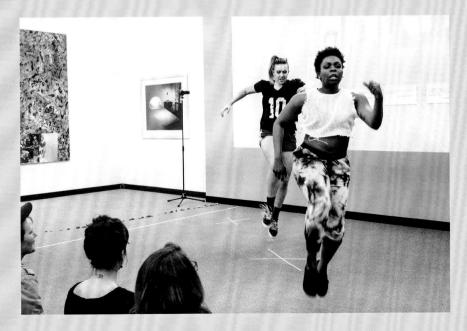

Left, top to bottom: Alexa Grae;
Quinn Tsan; Kaitlin Webster
and Alyssa Gregory perform-
ing an excerpt from Erin
Kilmurray's *SEARCH PARTY*

Right: Lucy Stoole

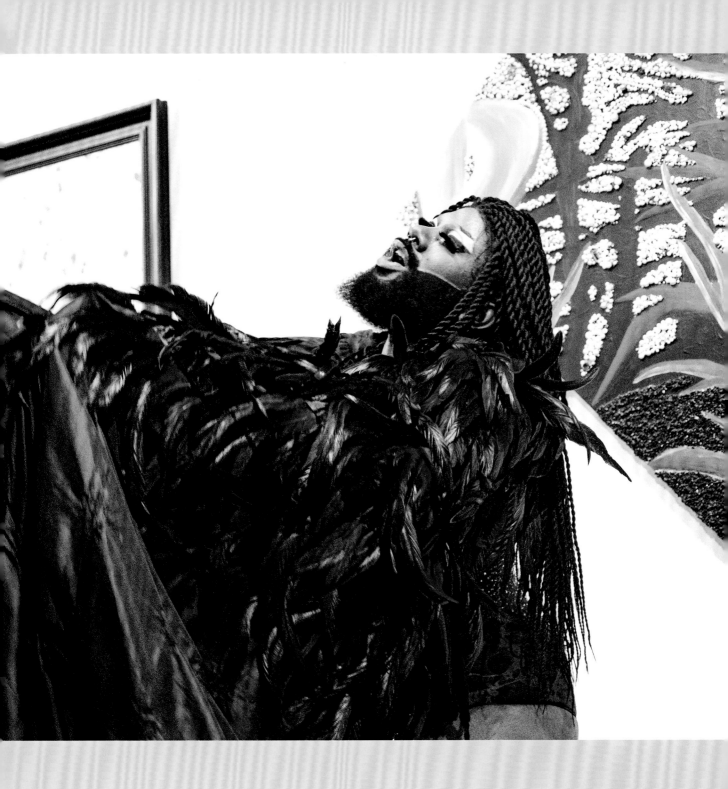

Art AIDS America Chicago
Program List

Throughout the run of the exhibition, Alphawood Gallery offered engaging events related to issues raised by the content of the exhibition, from artistic inclusion to activism, health to history. Daily free HIV testing was hosted at Alphawood Gallery and provided by established health-care organizations, including Howard Brown Health, Center on Halsted, Chicago House, and Test Positive Aware Network. Admission and all in-gallery programming were free and open to the public, and took place at Alphawood Gallery unless otherwise noted.

PANEL | *We're Still Here: HIV/AIDS Then and Now*
November 30, 2016
Center on Halsted

This panel discussion on the impact of HIV/AIDS on arts and culture featured *Art AIDS America* co-curator Jonathan Katz, Alphawood Director of Exhibitions Anthony Hirschel, Victory Gardens Theater Artistic Director Chay Yew, and playwright Karen Hartman, followed by QUEER, ILL + OKAY performances by Phillip Blacknbrilliant, Joan Giroux, and a short film by Xena Ellison + Elizabeth Mputu.

PRESS CONFERENCE | *Chicago Department of Public Health Releases Annual HIV/STI Surveillance Report*
December 1, 2016

In conjunction with World AIDS Day and the launch of *Art AIDS America*, Alphawood Gallery hosted the Chicago Department of Public Health's release of their annual HIV/STI Surveillance Report outlining the city's continued progress in reducing HIV transmission. The report showed that more people newly diagnosed with HIV in Chicago are being linked to vital care early, the first step necessary to achieve viral suppression; reduce risk of transmission; and live longer, healthier lives. The 2016 HIV/STI Surveillance Report revealed that 79 percent of new HIV diagnoses are linked to HIV medical care within one month of diagnosis, placing Chicago well ahead of national rates and on track to meet the National HIV/AIDS Strategy goal of 85 percent by 2020. Chicago has seen an overall downward trend in new HIV infections and late diagnoses.

TOUR and PERFORMANCE | *Exhibition Tour and Performance of Roz and Ray*
December 1, 2016
Alphawood Gallery and Victory Gardens Theater

This World AIDS Day event in collaboration with Victory Gardens Theater began with a tour of the *Art AIDS America* exhibition on its opening night. Howard Brown Health joined to launch the free HIV walk-in testing program. A reception took place at Victory Gardens before the performance of Karen Hartman's *Roz and Ray* *(see page 235)*.

LECTURE | How AIDS Changed American Art—An Illustrated Lecture by Jonathan Katz
with performance by avery r. young
December 3, 2016

Widely considered merely a tragic tangent within U.S. culture, AIDS has, in fact, been one of the most powerful shaping forces in American art since the 1980s. The repression of AIDS's role in the making of American culture is entirely consistent with the long-standing repression of public dialogue about AIDS in general—but repression is nonetheless the sign of great power. In this talk, Jonathan Katz, co-curator of *Art AIDS America*, and director of the PhD program in Visual Studies at the University at Buffalo, SUNY, illustrated how AIDS has fundamentally shifted the American cultural landscape, exploring not only the manifold losses AIDS has inflicted at but also how, in response to both AIDS and the prejudice it has engendered, a plague has rewritten both the form and content of American art. A spoken-word performance by avery r. young opened the program.

PANEL | Disruption/Repression: How AIDS Changed America
with performance of *Condom Cloud* by Joseph Ravens
December 3, 2016
(see pages 192–94)

PANEL | Embracing Equity
with performances by Ajooni Kaur and Bindu Poroori
January 11, 2017
(see pages 195–97)

SHARING STORIES | Open Conversation
January 14–March 25, 2017

This weekly program created a space within the exhibition for dialogue and community. In the 2nd floor lounge area, visitors listened to personal stories of individuals who experienced HIV/AIDS in different ways: Steven Braun, Nanica Brown, Sam Gatling, Joan Giroux, Phillip Lambert X Blacknbrilliant, Rae Lewis-Thornton, David Ernesto Munar, Hadeis Safi, and Joey Terrill.

PERFORMANCE | Bill T. Jones Presents Return
DuSable Museum of African American History
January 27, 2017
(see pages 198–99)

READING | Poetry AIDS Chicago
February 2, 2017

The Poetry Foundation presented a poetic tour of the exhibition, bringing together Chicago-based queer and trans poets who read works inspired by the themes in *Art AIDS America*. The program featured Bea Cordelia, T. Clutch Fleischmann, Ruben Quesada, and avery r. young.

WORKSHOP | *Quilting Bee*
February 4, 2017

This program offered participants the opportunity to celebrate the life of a loved one who died of AIDS-related causes by making a panel to add to *The NAMES Project AIDS Memorial Quilt*. The session was led by Nanica Brown, a longtime volunteer with The NAMES Project Chicago and the local chapter representative. A second workshop took place at the Center on Halsted.

PANEL | *HIV/AIDS and Race*
with performance by Po' Chop
February 8, 2017
(see pages 200–202)

CONVERSATION | *Artist Kia LaBeija in Conversation with Zach Stafford*
with performance by McKenzie Chinn
February 17, 2017
(see pages 203–4)

PANEL | *Love Positive Women: HIV and Women*
with performance by Felicia Holman and Meida McNeal of Honey Pot Performance
February 22, 2017
(see pages 205–6)

THEATER | *AIDS on Stage*
March 6–27, 2017
(see pages 207–8)

SYMPOSIUM | *Viral Representation: On AIDS and Art*
March 10, 2017, Alphawood Gallery, and March 11, 2017, Reva and David Logan Center for the Arts, University of Chicago

Sponsored by the Alphawood Foundation, an anonymous donor, the Reva and David Logan Center for the Arts, and the Department of Art History at the University of Chicago, this symposium brought together scholars, artists, collectors, and curators to address how artists have responded to and reflected on AIDS in America. In presentations that drew from art history, performance studies, and more, conference participants addressed such issues as why artists created work that implicitly rather than explicitly addressed AIDS, the afterlives of AIDS activism, and how AIDS changed American art. An artist panel looked at a broad range of artistic strategies during the worst years of the plague. The conference sought to address the current political climate, which demanded asking questions of political strategy with vigor reminiscent of the early years of AIDS activism.

Amelia Jones delivered the keynote address, "Queer Communion: Ron Athey's Coalitional Performance of Extremity and Generosity," which examined the generative effect of Athey's performance on an entire community of artists. The presentations included a welcome by Matthew Jesse Jackson, and talks by the following scholars and artists: Jonathan D. Katz, "How AIDS Changed American Art," an in-depth examination of why so much art about AIDS doesn't appear to be

art about AIDS; David Getsy, "On Being a Public Artist with AIDS in '80s America: Scott Burton and Conformational Masking," which analyzed the camouflaged AIDS politics of Burton's public sculptures; Joshua Chambers-Letson, "Tseng Kwon-Chi and the Party's End," a powerful account of the culture wars of the 1980s; Patric McCoy, "Inadvertent Photojournalism during the AIDS Epidemic," a presentation of his own photographs documenting the impact of AIDS on Black communities in Chicago; Oli Rodriguez, "The Papi Project," a discussion of his book retracing the sexual behavior of his family members during the emergence of AIDS in Chicago; Kate Pollasch, on parsing the embedded codes of Chicago imagist Roger Brown's artistic practice within the history of AIDS in Chicago; Avram Finkelstein, an investigation of the dominant visual narratives constructed around HIV/AIDS from the perspective of his involvement in the Silence=Death Project; Derek Conrad Murray, "Cruising Towards a Queer of Color Critique," which unpacked how recent Black queer representation has been shaped by and critically reworks specific and sometimes problematic representational antecedents; Theodoros Triandos, "'Mutually Incompatible Readings': AIDS, Allegory, and the Limits of Postmodernist Criticism," a critique of how the dominant critical methodology of the art journal *October* enabled a repression of the subject of AIDS; Jih-Fei Cheng, "Development is a Façade: Dean Sameshima's 'In Between (Days Without You)' (1998) and the Queer Ecologies of Downtown Los Angeles," an address on the repurposing of queer history, including AIDS art and activism, in urban redevelopment in Los Angeles.

TOUR | Exhibition Tour led by Joey Terrill
March 11, 2017

Los Angeles–based artist and activist Joey Terrill, whose work was included in the exhibition, led a tour of *Art AIDS America*. Terrill is a formative figure in the Chicano art movement and AIDS cultural activism, and is a former board member (1992–97) of VIVA!, the first gay and lesbian Latino art organization in L.A. Terrill's work explores the intersection of ethnic and sexual identity, reflecting the politics and creative synergy of Chicano and queer art circles in Los Angeles. Over the last thirty years, he has created seminal portraits of everyday queer life in the barrio and at the same time worked in HIV/AIDS activism.

PERFORMANCE | The Anti-Workshop: CALL TO ACTION with Karen Finley
Sunday, March 12, 2017
(see pages 209–15)

PANEL | HIV and Aging
with performance by the Chicago Gay Men's Chorus
March 22, 2017
(see pages 216–17)

PERFORMANCE | Goodman Theatre Presents "Who Tells Your Story?"
March 26, 2017

Over a four-week period, Goodman Theatre hosted a series of narrative writing and performance workshops in the gallery to explore what we leave behind and who tells our stories when we can no longer speak. Inspired by the work in *Art*

AIDS America, the stories created in the workshops were part of this curated performance. This program was part of Goodman Theatre's IN THESE TIMES, a series of events and discussions that examine the power of art in times of upheaval and crisis.

GALLERY TALK | *Art AIDS Action: Cruising History, Cruising Politics*
March 31, 2017

Art AIDS America Chicago artist Oli Rodriguez and art historian Virginia Solomon discussed General Idea and Gran Fury, queer space, movements and meanings, activist strategies, hybrid spaces, and Chicago's shifting histories and landscapes.

PERFORMANCE | The Dead Taste Sweeter Than the Living (After Felix Gonzalez-Torres) *by Emilio Rojas in collaboration with Paul Escriva*
April 1, 2017
(see pages 218–19)

PANEL | *Lessons in Activism*
with performance of *Condom Cloud* by Joseph Ravens
April 2, 2017
(see pages 220–24)

PERFORMANCE | Salonathon*: Call Forth the Future*
April 2, 2017
(see pages 225–29)

Programs Presented by Community Allies

Post Black Folk Art in America 1930–1980–2016
Intuit: The Center for Intuitive and Outsider Art
July 15, 2016–January 8, 2017

This exhibition revisited the Corcoran Gallery of Art's 1982 presentation of *Black Folk Art in America 1930–1980*. On view during the height of the AIDS crisis, that exhibition featured artists affected and inspired to speak through their art about HIV/AIDS. *Post Black Folk Art in America 1930–1980–2016* was curated by Faheem Majeed and featured artists such as Ronald Lockett, who created more than 350 works before dying from HIV/AIDS-related pneumonia.

Keep the Shadow, Ere the Substance Fade: Mourning during the AIDS Crisis
Block Museum of Art, Northwestern University, Evanston, IL
September 17–December 11, 2016

During much of the twentieth century, death was a private and comparatively silent event. However, during the HIV/AIDS crisis in the 1980s and 1990s, a polit-

icized resurgence of highly visible and public acts of mourning emphasized the body ravaged by the virus. In some ways, these practices paralleled the public and material mourning practices of the nineteenth century. By juxtaposing objects and artworks related to mourning from the Victorian Era—intricately woven hairworks and ornate brooches kept as bodily relics of the deceased—and during the AIDS crisis, *Keep the Shadow* examined two analogous cultures of bereavement. The exhibition proposed that these historical periods uniquely relied on the materiality of the individual body, and items associated with it, as relics in order to grapple with mortality and persevere in the face of death. The exhibition was curated by 2015–16 Block Museum Graduate Fellow C. C. McKee and included artists Eric Avery, Felix Gonzalez-Torres, David Grieger, Robert Mapplethorpe, Richard Mock, Domingo Orejudos, Andres Serrano, and Leonard Rifas.

Roz and Ray
Victory Gardens Theater
November 11–December 11, 2016

Victory Gardens presented *Roz and Ray,* the gripping untold story of one doctor's ethical struggle at the onset of the AIDS crisis in the 1980s. Dr. Roz thinks she's found the right cure in a new miracle drug for Ray Leon's twins with hemophilia. However, unspeakable tragedy strikes, and it is discovered that Ray's sons face immediate danger. Victory Gardens Theater presented this powerful new work by playwright Karen Hartman, which tells a tragic yet ultimately heartfelt story about a deep friendship during a devastating chapter of medical and queer history.

Whit Forrester: Affinity in the Tall Grasses of California
International Museum of Surgical Science
November 18, 2016–February 26, 2017

Artist Whit Forrester documented the workings of medical cannabis farms in upstate California and illuminated the history of cannabis legalization in the Golden State as a treatment for symptoms of HIV/AIDS.

In Plain Sight: A Women's History of HIV/AIDS in Chicago
Sulzer Regional Library, November 19, 2016–January 16, 2017; Hyde Park Art Center, February 6–16, 2017; Beverly Arts Center, February 26–April 16, 2017

History Moves' mobile exhibition *In Plain Sight* was on tour. Created in cooperation with the Women's Interagency HIV Study Chicago, the exhibition demonstrated that women living with HIV have moved from the margins of what was once a deadly epidemic to becoming survivors and history makers.

Save Our Poonie's! Resistance. Healing. Legacy.
Links Hall
November 20, 2016

Poonie's is named for Poonie Dodson, a much-loved Chicago dancer and choreographer who died of AIDS in the early 1990s. Originally inspired by Patrick's Cabaret in Minneapolis, Poonie's Cabaret welcomes all forms of expression. *Save Our Poonie's: Resistance. Healing. Legacy.* featured curators Joseph Varisco, Carole

McCurdy, Rebecca Kling, and J'Sun Howard with works from Emilio Rojas and Paul Escriva, Xena Ellison and Elizabeth Mputu, Bea Cordelia and Mar Curran.

Cartooning AIDS
Gerber/Hart Library and Archives
December 5, 2016–March 2018

This presentation in the Howard Brown Health Clark Waiting Room featured the political cartoons of Daniel Sotomayor and looked at how issues surrounding AIDS were engaged through political cartoons, comic books, trading cards, and zines for the purpose of political critique, education, and awareness.

QUEER, ILL + OKAY
Oracle Public Access Theatre
December 9, 10, 16, 17, 2016

Independent curator and *Art AIDS America* Program Coordinator Joseph Varisco presented the fourth annual performance showcase exploring intersections of what it means to be LGBTQIA and live today with HIV and/or other forms of chronic illness. QIO examines, challenges, and reinvents narratives that unearth the history of stigma surrounding HIV and illness across multiple generations and disciplines. The event featured fourteen artists from across the country, including avery r. young, Tim'm West, Kay Ulanday Barrett, Lucas Baisch, Michelle Zacarias, and Bea Cordelia.

Express Talks: Art AIDS America
Art Institute of Chicago
January 25, February 22, March 29, 2017

These in-gallery talks focused on works in the Art Institute's collection by artists included in *Art AIDS America Chicago*.

One day this kid will get larger
DePaul Art Museum
January 26–April 2, 2017

This group exhibition included emerging contemporary artists who address the ongoing HIV/AIDS pandemic in North America through the lens of childhood, education, popular culture, and race. This exhibition was guest curated by Danny Orendorff and made possible through the generosity of Alphawood Foundation Chicago.

Precariat
Hyde Park Art Center
February 5–March 12, 2017

The exhibition *Precariat* featured interdisciplinary artists who produce work in response to identity, social issues, and activism. The spectrum of how closely the artist's queer identity informs their practice varied, but each individual's work confronts socially constructed ideals.

The Legacy LIVE Series Presents the Film Short Fuse: Story of an AIDS Activist
Alphawood Gallery
February 5, 2017

The Legacy LIVE Series presented the rarely seen, award-winning 1990 documentary *Short Fuse: Story of an AIDS Activist*, about the fiery, funny, passionate life of Daniel Sotomayor, the nation's first openly gay political cartoonist and ACT UP/Chicago AIDS activist. The film follows his struggle to balance life, death, and protest against some of the most explosive footage of AIDS activism ever captured in Chicago. This film screening commemorated the 25th anniversary of Daniel's passing and was followed by a Q and A with several of Daniel's closest friends: Lori Cannon, founder of Open Hand/Vital Bridges/Heartland Health Outreach, ACT UP/Chicago activist; Owen Keehnen, LGBT history biographer, ACT UP/Chicago activist; Tim Miller, ACT UP/Chicago activist; Victor Salvo, executive director, The Legacy Project. The Legacy LIVE Series is a joint venture of Center on Halsted and The Legacy Project.

LookOut Presents Written in Sand: Collected AIDS Writings by Karen Finley
Steppenwolf Theatre Company
February 10, 11, 2017

Renowned performance artist and activist Karen Finley presented *Written in Sand: Collected AIDS Writings*, a powerful and moving collection of spoken-word pieces reflecting on the AIDS epidemic. In 2013, Finley was invited to participate in Visual AIDS's 25th anniversary exhibition, curated by Sur Rodney (Sur) in New York City. While revisiting her art and writing on the subject, Finley gathered her poetic responses and discovered that it had become its own narrative, its own body of work. Sections of performance texts, poetry, letters, and fragments express the loss and magnitude of personal suffering and compassion within a larger world of homophobia, denial, and injustice. Some of these writings are those that were censored and considered indecent, bringing her and three other artists (John Fleck, Holly Hughes, Tim Miller) to the Supreme Court.

Unsettling the Canon / Decolonizing Arts Education
School of the Art Institute of Chicago
February 23, 2017

How can we free art and art education from dominant, Eurocentric, white supremacist, cisgender, patriarchal, heterosexual, colorist, ableist systems? What can we learn from community-based and grassroots activist models? Moderated by Oli Rodriguez, this discussion included presentations by Eunsong Kim and Gelare Khishgozaran, Libia Bianibi, D. Denenge Duyst-Akpem, Aram Han Sifuentes, Amina Ross, Sarah Ross, Eseosa Edebiri, and Kiki Salem, with Maribel Ang, Keish Lozano, and Brianna McIntire.

OUT at CHM
Chicago History Museum
March 3, 2017

How was art used to speak out about the AIDS pandemic, advocate for its victims, and critique public response to this health crisis? Drawing on two exhibitions on view in Chicago—*Art AIDS America Chicago* at Alphawood Gallery and *One day this kid will get larger* at DePaul Art Museum—this panel examined artists who participated as activists in the AIDS crisis and contemporary artists responding to that time and to ongoing HIV health issues. Moderated by Joseph Varisco, Alphawood Gallery program coordinator and founder of QUEER, ILL + OKAY, panelists included John Neff, artist and lecturer at SAIC; Mary Patten, SAIC professor, artist, activist, and a founder of ACT UP/Chicago; Oli Rodriguez, artist and founder of *The Papi Project*; and Alisa Swindell, Gallery 400 curatorial assistant, activist, and PhD candidate in art history at the University of Illinois at Chicago.

PrEP-ing Chicago Women: New innovations in sexual health, prevention, and pleasure
140 S. Dearborn St.
March 8, 2017

This interactive workshop explored how HIV affects Chicago women and presented the newest information about the revolutionary HIV prevention pill, PrEP. Experts from many aspects of the Chicago prevention field discussed what PrEP means for women, community efforts to support women's sexual health, and how you and your agency can integrate PrEP education and services to support women. Sponsored by AIDS Foundation of Chicago, Chicago Foundation for Women, and the Chicago PrEP Working Group.

In Conversation: Patric McCoy, John Neff, Peter Coviello
LATITUDE
March 24, 2017

LATITUDE hosted a panel discussion featuring Patric McCoy, John Neff, and Peter Coviello focusing on imaging and archiving queer history, especially as it intersects with the ongoing HIV/AIDS crisis and other queer issues. In the fall of 2016, LATITUDE worked with the Alphawood Foundation to produce the work of six artists added to the Chicago iteration of *Art AIDS America*. This event was born out of conversations in the lab with John Neff and Patric McCoy as they selected Patric's work for *Art AIDS America* and a desire to share these important conversations with the public.

Taking Turns: Stories from HIV/AIDS Unit 371 with author MK Czerwiec
DePaul Art Museum
March 30, 2017

Comics have a long history in the arenas of public health messaging, political activism, and memoir. Comics can bear witness to stigmatized realities, create a new medium for representation, and inspire community engagement and empowerment. This lecture contextualized MK Czerwiec's new graphic memoir *Taking Turns: Stories from HIV/AIDS Care Unit 371* within the history of comics about HIV and AIDS.

Community Allies

About Face Theatre
Affinity Community Services
AIDS Foundation of Chicago
American Theater Company
Art Institute of Chicago
Audience Architects
Beverly Art Center
Block Museum of Art, Northwestern University
Howard Brown Health
Roger Brown Study Archive
CALOR
The Care Plan
Center on Halsted
Chicago Academy for the Arts
Chicago Area HIV Integrated Services Council
Chicago Artists Coalition
Chicago Black Gay Men's Caucus
Chicago Catholic Charities
Chicago Dancers United
Chicago Department of Cultural Affairs and
 Special Events
Chicago Department of Public Health
Chicago History Museum
Chicago House and Social Service Agency Inc.
Chicago Sinfonietta
Columbia College/Dance Center of Columbia
 College
Crossroads Fund
DePaul Art Museum
Diasporal Rhythms
DIFFA
DuSable Museum of African American History
Equality Illinois Education Project
Expo Chicago
Free Street Theater
Gerber/Hart Library and Archives
Goodman Theatre
Hyde Park Art Center
Illinois Caucus for Adolescent Health
Illinois Department of Public Health
Illinois Safe School Alliance
International Museum of Surgical Science
Intuit: The Center for Intuitive and Outsider Art
Jane Addams Hull-House Museum
Joel Hall Dancers and Center
Joffrey Ballet of Chicago
Bill T. Jones/Arnie Zane Company
Lakeside Pride Music Ensembles
Lambda Legal
Leather Archives and Museum
Legacy Project

Links Hall
Literature for All of Us
Logan Center for the Arts, University of Chicago
Loyola University Museum of Art
Ann and Robert H. Lurie Children's Hospital of
 Chicago Center for Gender, Sexuality, and
 HIV Prevention
Morten Group
Museum of Contemporary Art Chicago
National Museum of Mexican Art
Northalsted Business Alliance
Northwestern University
Old Town School of Folk Music
OPEN Center for the Arts
Open TV
Poetry Foundation
PrEP4Love
Pride Action Tank
Pride Films and Plays
Project Fierce Chicago
QUEER, ILL + OKAY
Rad Remedy
School of the Art Institute of Chicago
Sex Worker Outreach Project (SWOP)
Silk Road Rising
Smart Museum of Art, University of Chicago
South Shore Arts Inc.
South Side Community Art Center
Steppenwolf Theatre Company
StoryCorps
TACTS (The Association of Clinical Trials
 Services)
Test Positive Aware Network (TPAN)
Threewalls
University of Chicago
University of Illinois–Chicago
Victory Gardens Theater
Vida/SIDA
Visceral Dance Chicago
Visual AIDS
Windy City Performing Arts
Windy City Times

Exhibition Checklist

Only works that were added to the *Art AIDS America* exhibition after its initial presentation at Tacoma Art Museum, select site-specific installations, and tour replacements are reproduced as Plates in this catalogue.

ACT UP NY/Gran Fury
Active New York, New York, 1987–95
Let the Record Show . . ., 1987/re-created 2015
Mixed-media installation
Dimensions variable
Courtesy of Gran Fury and courtesy New Museum, New York. William Olander Memorial Fund

Kissing Doesn't Kill, 1989
Four-color lithograph on cardstock; this example originally printed for the Chicago Transit Authority
11½ × 37 in. (29.2 × 94 cm)
Collection of Fred Eychaner
[Pl. 12]

Shimon Attie
Born Los Angeles, California, 1957
Untitled Memory (projection of Axel H.), 1998
Ektacolor photograph
Edition 1 of 3
32 × 38¾ in. (81.3 × 98.4 cm)
Courtesy of the artist and Jack Shainman Gallery, New York

Eric Avery
Born Milwaukee, Wisconsin, 1948
HIV Condom Filled Piñatas, 1993
Molded-paper woodcuts
Edition open
Each: 8½ in. dia. (21.6 cm)
Courtesy of the artist
[Pl. 4]

The Stuff of Life, 1993
Three-color linoleum block print on Okawara paper and wallpaper reproductions
Edition open
Original sheet: 72 × 32 in. (183 × 81 cm)
Courtesy of the artist
[Pl. 4]

Luis Cruz Azaceta
Born Havana, Cuba, 1942
AIDS, Time, Death, 1989
Acrylic and ink on paper
41 × 29½ in. (104.1 × 74.9 cm)
Courtesy of The New School Art Collection
[Pl. 42]

David Binder
Born Flint, Michigan, 1961
John Parker, Founder of The National AIDS Brigade, Exchanging Clean Needles, 1988–89
Black and white archival pigment print
20 × 24 in. (50.8 × 61 cm)
Courtesy of Contact Press Images, New York

Nayland Blake
Born New York, New York, 1960
Every 12 Minutes, 1991
Clock movement and aluminum
Edition of 10
Diameter: 11 in. (27.9 cm)
Courtesy of Matthew Marks Gallery

Robert Blanchon
Born Boston, Massachusetts, 1965
Died Chicago, Illinois, 1999
Stains #1 & #2, 1994
Two chromogenic color prints and silver-leaf frames
Each: 12½ × 15½ in. (31.8 × 39.4 cm)
Collection of Jackie Chang

Ross Bleckner
Born New York, New York, 1949
Brain Rust, 2013
Oil on linen
96 × 72 in. (243.8 × 182.9 cm)
Courtesy of Mary Boone Gallery, New York

Gregg Bordowitz
Born Brooklyn, New York, 1964
Fast Trip, Long Drop, 1993
Single-channel video
54:04 mins.
Courtesy of the Video Data Bank at the School of the Art Institute of Chicago
[Pl. 56]

Lawrence Brose
Born Buffalo, New York, 1951
An Individual Desires Solution, 1986
Super-8mm transferred to digital video
16:00 mins.
Courtesy of the artist
[Pl. 18]

Roger Brown
Born Hamilton, Alabama, 1941
Died Atlanta, Georgia, 1997
Peach Light, 1983
Oil on canvas
72 × 48½ in. (182.9 × 123.2 cm)
School of the Art Institute of Chicago and the Brown Family, Courtesy of Kavi Gupta
[Pl. 30]

Illusion, 1985
Oil on canvas
72 × 60 in. (182.9 × 152.4 cm)
School of the Art Institute of Chicago and the Brown Family, Courtesy of Kavi Gupta
[Pl. 31]

Brian Buczak
Born Detroit, Michigan, 1954
Died New York, New York, 1987
Corpse, 1982
Acrylic on canvas in five parts
33 × 165 in. (83.8 × 419.1 cm)
Gift of Geoffrey Hendricks and the Brian Buczak Estate to the Leslie-Lohman Museum of Gay and Lesbian Art
[Pl. 2]

Séance, 1985
Acrylic on canvas
86 × 48 in. (218.4 × 121.9 cm)
Collection of Geoffrey
Hendricks

Scott Burton
Born Greensboro, Alabama,
1939
Died New York, New York,
1989
Two-Part Chair, 1986
Deer Island granite
Edition 3 of 5
40 × 23 × 36 in. (101.6 × 58.4 ×
91.4 cm)
Albright-Knox Art Gallery,
Buffalo, New York, Sarah
Norton Goodyear Fund, 1997,
1997:1a–b

Jerome Caja
Born, Cleveland, Ohio, 1958
Died San Francisco, California,
1995
Little Yellow Angels, 1984–93
Nail polish and mixed media
on plastic with artist's frame
20 × 16 × 5 in. (50.8 × 40.6 ×
12.7 cm)
Collection of Jeff Parker and
James Collins

Shroud of Curad, 1993
Blood and eyeliner on ban-
dage with artist's frame and
nail polish
7 × 5 × 2 in. (17.8 × 12.7 ×
5.1 cm)
Collection of Jeff Parker and
James Collins

Mark I. Chester
Born Milwaukee, Wisconsin,
1950
*Robert Chesley—ks portraits
with harddick & superman
spandex, #1–#6,* from the
series *Diary of a Thought
Criminal*, 1989, printed 2015
Pigment print
30 × 40 in. (76.2 × 101.6 cm)
Courtesy of the artist

Judy Chicago
Born Chicago, Illinois, 1939
*Homosexual Holocaust, Study for
Pink Triangle Torture*, 1989
Sprayed acrylic, photo-
silkscreen, and oil on canvas
53 × 42 in. (134.6 × 106.7 cm)
Courtesy of the artist

Sue Coe
Born Tamworth, Staffordshire,
England, 1951
Kaposi's Sarcoma, 1993
Color woodcut on heavy
cream wove paper
Artist's proof, limited edition
23½ × 17½ in. (59.7 × 44.5 cm)
Private collection, courtesy of
Galerie St. Etienne, New York

Willie Cole
Born Somerville, New Jersey,
1955
How Do You Spell America? #2,
1993
Oil stick, chalk, and latex on
Masonite and wood
49¼ × 96½ × 4½ in. (125 ×
245.1 × 11.4 cm)
The Bronx Museum of the Arts,
Gift of Jennifer McSweeney
[Pl. 16]

Arch Connelly
Born Chicago, Illinois, 1950
Died New York, New York, 1993
The More, 1984
Oil paint, faux pearls on wood
40 × 40 in. (101.6 × 101.6 cm)
Collection of Brooke Adams
[Pl. 58]

Blurry Self-Portrait, 1987
Sequins
20 × 16 in. (50.8 × 40.6 cm)
Collection of Roberto Juarez
and David Freberg

Ryan Conrad
Born Newport, Rhode Island,
1983
b. 1983, 2008
Xerox print and offset-printed
postcards
Print: 24 × 42 in. (61 ×
106.7 cm)
Each postcard: 4 × 6 in. (10.2 ×
15.2 cm)
Courtesy of the artist

David Cannon Dashiell
Born Tokyo, Japan, 1952
Died San Francisco, California,
1993
Preliminary figure sketch for
Queer Mysteries, 1992
Graphite on paper
9 × 6½ in. (22.9 × 16.5 cm)
Courtesy of the Estate and
Visual AIDS

Study for Queer Mysteries, 1992
Graphite on vellum
17 × 14 in. (43.2 × 35.6 cm)
University of California,
Berkeley Art Museum and
Pacific Film Archive. Museum
purchase: Bequest of Phoebe
Apperson Hearst, by exchange,
2013.73.1
[Pl. 23]

Study for Queer Mysteries, 1992
Graphite on vellum
17 × 14 in. (43.2 × 35.6 cm)
University of California,
Berkeley Art Museum and
Pacific Film Archive. Museum
purchase: Bequest of Phoebe
Apperson Hearst, by exchange,
2013.73.2
[Pl. 24]

Study for Queer Mysteries, 1992
Graphite on vellum
17 × 14 in. (43.2 × 35.6 cm)
University of California,
Berkeley Art Museum and
Pacific Film Archive. Museum
purchase: Bequest of Phoebe
Apperson Hearst, by exchange,
2013.73.3
[Pl. 25]

Niki de Saint Phalle
Born Neuilly-sur-Seine, France,
1930
Died San Diego, California,
2002
*AIDS, you can't catch it holding
hands*, 1987
Book
52 pages
10 × 8 in. (25.4 × 20.3 cm)
The Lapis Press, San Francisco

Jimmy DeSana
Born Detroit, Michigan, 1949
Died New York, New York,
1990
Stool, 1986
Cibachrome print
16 × 20 in. (40.6 × 50.8 cm)
Courtesy of the Jimmy DeSana
Trust and Salon 94, New York

William Downs
Born Greenville,
South Carolina, 1974
I'll Say Goodbye Before We Meet,
2013–16
Mixed media and ink wash on
found folders hung in a grid
of 42
Primarily 15 × 18 in. folders
Courtesy of the artist and
Sandler Hudson Gallery
[Pl. 28]

John Dugdale
Born Stamford, Connecticut,
1960
Life's Evening Hour, 1998,
printed 2010
Toned gelatin silver print
Edition 1 of 6
20 × 16 in. (50.8 × 40.6 cm)
Courtesy of Holden Luntz
Gallery, Palm Beach

Chloe Dzubilo
Born Middletown, Connecticut,
1960
Died New York, New York, 2011
Untitled (Corrupt HIV Activism),
2009
Ink on paper
8½ × 5 in. (21.6 × 12.7 cm)
Chloe Dzubilo Papers, Fales
Library, New York University

Michael Ehle
Born Salinas, California, 1953
Died Seattle, Washington,
1999
Fakir, 1992
Gouache on rice paper
72 × 36 in. (182.9 × 91.4 cm)
Tacoma Art Museum, Gift of
Greg Kucera and Larry Yocom,
2002.24

Joy Episalla
Born Bronxville, New York,
1957
pillow 5, 2003–14
Archival pigment print on
Hahnemuehle photo rag
paper and Plexiglas
18 × 45 × ½ in. (45.7 × 114.3 ×
1.3 cm)
Courtesy of the artist

Robert Farber
Born Hartsdale, New York,
1948
Died New York, New York, 1995
Every Ten Minutes, 1991
Audio
Duration variable
Courtesy of Visual AIDS

Tony Feher
Born Albuquerque,
New Mexico, 1956
Died New York, New York,
2016
Penny Piece, 1995/2016
Glass jar with lid, U.S. pennies,
and painted wood shelf
6¼ × 77¼ × 5⅞ in. (17.5 × 197.8 ×
14.9 cm)
The Art Institute of Chicago,
Modern and Contemporary
Discretionary Fund
[Pl. 5]

fierce pussy
Formed New York, New York,
1991
For the Record, 2013
Two offset prints on newsprint
Two panels, installed: 22⅝ ×
70 in. (57.5 × 177.8 cm)
Courtesy of the artists

Karen Finley
Born Chicago, Illinois, 1956
Written in Sand, 1992
Sand in found chest
Dimensions variable
Courtesy of the artist
[Pl. 53]

Ribbon Gate, 2015
Eight found iron gates, cloth
ribbons
Dimensions variable
Courtesy of the artist
[Pl. 52]

Louise Fishman
Born Philadelphia,
Pennsylvania, 1939
MARY, 1993
Oil on linen
32 × 20 in. (81.3 × 50.8 cm)
Courtesy of the artist and
Cheim & Read, New York

Gerard Gaskin
Born Port of Spain, Trinidad,
1969
*Charly and Mathyas, Ebony Ball,
Manhattan, NY*, 1997
Archival inkjet print
24 × 16 in. (61 × 40.6 cm)
Courtesy of the artist
[Pl. 43]

*Jasmine and Vanessa at Eric
Bazaar Ball, Brooklyn, NY*, 1999
Archival inkjet print
16 × 24 in. (40.6 × 61 cm)
Courtesy of the artist
[Pl. 45]

Latex Ball, Manhattan, NY, 2011
Archival inkjet print
16 × 24 in. (40.6 × 61 cm)
Courtesy of the artist
[Pl. 44]

General Idea
Active 1969–94
Blue (Cobalt) PLA©EBO, 1991
Gouache on computer print-
out, chromogenic color print
in aluminum box, 2 labels
(photocopy on color
adhesive-backed paper)
Edition of 3, with 1 artist's
proof
12⅝ × 9 × 1 in. (31.8 × 22.9 ×
2.5 cm)
Collection of Richard Gerrig
and Timothy Peterson

White AIDS #3, 1992
Gesso on canvas
60 × 60 in. (152.4 × 152.4 cm)
The Art Institute of
Chicago, Gift of Society for
Contemporary Art
[Pl. 7]

Robert Gober
Born Wallingford, Connecticut,
1954
Untitled, 1985
Graphite on paper
14 × 16¾ in. (35.6 × 42.9 cm)
Collection of the artist

Drain, 1990
Cast pewter
Edition of 8, with 2 artist's
proofs, artist's proof 1 of 2
Diameter: 3¾ in. (9.5 cm)
Depth: 1¾ in. (4.4 cm)
Collection of the artist

Camilo Godoy
Born Bogota, Colombia, 1989
*Criminal (Illinois, 720 ILCS 5/12–
5.01)*, 2013/16
Lavender, blood, semen, HIV,
and soap dish
3½ × 2¼ × ¾ in. (8.9 × 5.7 ×
1.9 cm)
Courtesy of the artist
[Pl. 47]

Nan Goldin
Born Washington, DC, 1953
Gilles' arm, Paris, 1993
Cibachrome print
30 × 40 in. (76.2 × 101.6 cm)
Courtesy of the artist and
Matthew Marks Gallery
[Pl. 55]

Daniel Goldstein
Born Mount Vernon, New York,
1950
Icarian I Incline, 1993
Leather, sweat, wood, copper,
felt, and Plexiglas
73 × 37 × 6 in. (185.4 × 94 ×
15.2 cm)
Collection of Richard Gere

Felix Gonzalez-Torres
Born Guáimaro, Cuba, 1957
Died Miami, Florida, 1996
"Untitled" (Still Life), 1989
Print on paper, endless copies
6 in. (15.2 cm) at ideal height ×
11 × 8½ in. (27.9 × 21.6 cm)
(original paper size)
Collection of Robert Harshorn
Shimshak and Marion Brenner

"Untitled" (Water), 1995
Strands of beads and hang-
ing device
Dimensions vary with
installation
The Baltimore Museum of Art,
Purchase with exchange funds
from Bequest of Sadie A. May,
1995.73

Keith Haring
Born Reading, Pennsylvania,
1958
Died New York, New York,
1990
No Title, 1988
Sumi, gouache, and xerograph
collage on paper
40¾ × 59¾ in. (103.2 ×
151.4 cm)
Rubell Family Collection,
Miami
[Pl. 59]

Altar Piece, 1990, cast 1996
Bronze with white gold-leaf
patina
Edition 2 of 9
60 × 81 × 2 in. (152.4 × 205.7 ×
5.1 cm)
Denver Art Museum, Gift of
Yoko Ono, 1996.204 A–C

Thomas Haukaas
Born San Juan, Puerto Rico,
1950
Tribal affiliation: Sicangu
Lakota
More Time Expected, 2002
Handmade ink and pencil on
antique ledger paper
16½ × 27½ in. (41.9 × 69.9 cm)
Tacoma Art Museum, Gift of
Greg Kucera and Larry Yocom
in honor of Rock Hushka,
2008.10

Jim Hodges
Born Spokane, Washington,
1957
The end from where you are,
1998
Silk, cotton, polyester, and
thread
192 × 192 in. (487.7 × 487.7 cm)
Collection Museum of
Contemporary Art Chicago,
Restricted gift in memory of
John S. Baran with additional
restricted support from the
Meta S. and Ronald Berger
Family Foundation, 1999.4
[Pl. 63]

Jenny Holzer
Born Gallipolis, Ohio, 1950
*Untitled (Expiring for Love Is
Beautiful but Stupid)*, 1983–85
Packaged latex condoms with
printed text
Each: 2⅜ × 2¾ in. (6 × 5.7 cm)
Mildred Lane Kemper Art
Museum, Washington
University in St. Louis,
Anonymous gift, 2001, WU
2001.0008 a–b

*Untitled (In a Dream You Saw
a Way to Survive and You Were
Full of Joy)*, 1983–85
Packaged latex condoms with
printed text
Each: 2⅛ × 2⅛ in. (5.4 × 5.4 cm)
Mildred Lane Kemper Art
Museum, Washington
University in St. Louis,
Anonymous gift, 2001, WU
2001.0005 a–b

*Untitled (Men Don't Protect You
Anymore)*, 1983–85
Packaged latex condoms with
printed text
Each packet of two: 2⅛ × 4¼ in.
(5.4 × 10.8 cm)
Mildred Lane Kemper Art
Museum, Washington
University in St. Louis,
Anonymous gift, 2001, WU
2001.0006 a–e

*Untitled (Protect Me from What
I Want)*, 1983–85
Packaged latex condoms with
printed text
Each: 2⅜ × 2¾ in. (6 × 5.7 cm)
Mildred Lane Kemper Art
Museum, Washington
University in St. Louis,
Anonymous gift, 2001, WU
2001.0007 a–b

Jonathan Horowitz
Born New York, New York,
1966
*Archival Iris Print of an Image
Downloaded from the Internet
with Two Copies of the New York
Post Rotting in Their Frames*,
2004
Two framed newspapers and
one framed Iris print
Edition 2 of 3, with 1 artist's
proof
Overall: 30½ × 24½ in. (77.5 ×
62.2 cm)
Courtesy of the artist and
Gavin Brown's Enterprise,
New York

Peter Hujar
Born Trenton, New Jersey, 1934
Died New York, New York, 1987
Ruined Bed, Newark, 1985
Vintage gelatin silver print
14½ × 14½ in. (36.8 × 36.8 cm)
Leslie-Lohman Museum of
Gay and Lesbian Art, Gift of
Peter Hujar Archive

Doug Ischar
Born Honolulu, Hawaii, 1948
Untitled, 1985
Gelatin silver print
11½ × 16¾ in. (28.3 × 42.8 cm)
The Art Institute of Chicago,
Gift of Joyce Neimanas and
Robert Heinecken
[Pl. 11]

Derek Jackson
Born Boston, Massachusetts,
1972
Perfect Kiss, 2007
Slideshow with found music
and original still imagery
7:00 mins.
Courtesy of the artist

Bill Jacobson
Born Norwich, Connecticut,
1955
Interim Portrait #373, 1992
Chromogenic color print
24 × 20 in. (61 × 50.8 cm)
Courtesy of Julie Saul Gallery,
New York

Some Planes #208, 2007
Pigment print on Epson
Ultrasmooth Fine Art paper
49½ × 36 in. (125.7 × 91.4 cm)
Courtesy of Julie Saul Gallery,
New York

Ray Johnson
Born Detroit, Michigan, 1927
Died Sag Harbor, New York,
1995
*Untitled (Blue Boots with AIDS
Stamp)*, 1966–92+
Collage on cardboard panel
14 × 11¾ in. (35.6 × 28.9 cm)
Courtesy of the Ray Johnson
Estate and Richard L. Feigen &
Co., New York

Untitled, 1982–88–90–91–92+
Collage on illustration board
11¾ × 10 in. (29.8 × 25.4 cm)
Courtesy of the Ray Johnson
Estate and Richard L. Feigen &
Co., New York

Tom Kalin
Born Chicago, Illinois, 1962
They are lost to vision altogether,
1989
Single-channel video
13:21 mins.
Courtesy of the Video Data
Bank at the School of the Art
Institute of Chicago
[Pl. 54]

Deborah Kass
Born San Antonio, Texas, 1952
Still Here, 2007
Oil and acrylic on canvas
45 × 63 in. (114.3 × 160 cm)
Private collection

Barbara Kruger
Born Newark, New Jersey, 1945
*"Untitled" (We will no longer be
seen and not heard)*, 1985
Nine lithographs, eight in color
and one with silver leaf, in
artist frames
Edition 25 of 50
Each 20½ × 20½ in. (52.1 ×
52.1 cm)
Collection of Jordan D.
Schnitzer
[Pl. 6]

Kia LaBeija
Born New York, New York,
1990
In My Room, from the series
24, 2014
Inkjet print
13 × 19 in. (33 × 48.3 cm)
Courtesy of the artist

Kia and Mommy, from the
series 24, 2014
Inkjet print
13 × 19 in. (33 × 48.3 cm)
Courtesy of the artist

Mourning Sickness, from the series *24,* 2014
Inkjet print
13 × 19 in. (33 × 48.3 cm)
Courtesy of the artist

Eleven, 2015
Inkjet print
16 × 24 in. (40.6 × 61 cm)
Courtesy of the artist
[Pl. 46]

LADZ (John Arsenault and Adrian Gilliland)
John Arsenault, born Haverhill, Massachusetts, 1971
Adrian Gilliland, born Douglas, Arizona, 1980
Eden #31, 2012
Chromogenic color print
32 × 52½ in. (81.3 × 133.4 cm)
Courtesy of the artists

David Lebe
Born New York, New York, 1948
Morning Ritual 29, 1994
Gelatin silver print
5 × 6¼ in. (12.7 × 15.9 cm)
Courtesy of the artist

Charles LeDray
Born Seattle, Washington, 1960
Untitled, 1991
Teddy bear, fabric, wood box, and metal hinges
16 × 10¼ × 5½ in. (40.6 × 26 × 14 cm)
The Bronx Museum of the Arts, Gift of Carol Dorsky, 2014.19.3

Annie Leibovitz
Born Waterbury, Connecticut, 1949
Kerie Campbell, member of WORLD, San Francisco, 1993
Chromogenic color print
40 × 30 in. (101.6 × 76.2 cm)
Courtesy of Contact Press Images, New York

Rudy Lemcke
Born St. Louis, Missouri, 1951
Foscarnet, 1989
Graphite on Fabriano Roma paper
26½ × 19½ in. (67.3 × 49.5 cm)
Courtesy of the artist

The Uninvited, 2003
Single-channel video
13:39 mins.
Courtesy of the artist

Keith Lewis
Born Bellefonte, Pennsylvania, 1959
Our Dear Bob (Pin in Memory of Bob Ford), 1995
Sterling silver, 14-karat gold plate, and copper plate
5 × 2½ × 1⅜ in. (12.7 × 6.4 × 3.5 cm)
Tacoma Art Museum, Museum purchase with funds from Sharon Campbell and Phil Baldwin, 2003.79

Of Rarity Untold (Scene from an Imaginary Libretto by Ronald Firbank), 1997
Sterling silver, copper, and enamel on fine silver
2⅜ × 2⅜ × ⅝ in. (6 × 6 × 1.6 cm)
Tacoma Art Museum, Promised gift of Sharon Campbell

Edward Lightner
Born Bakersfield, California, 1960
Do You Smell My Virus, 2003
Acrylic, plastic, photo, lettering, and wood
16½ × 30 in. (41.9 × 76.2 cm)
Courtesy of the artist

Glenn Ligon
Born Bronx, New York, 1960
My Fear is Your Fear, 1995
Screenprint on black wove paper
Edition 8/325 (20 AP)
12¼ × 9¼ in. (30.8 × 23.2 cm)
Collection of Esther McGowan
[Pl. 8]

Kalup Linzy
Born Stuckey, Florida, 1977
Lollypop, 2006
Single-channel video
3:24 mins.
Collection of Driek and Michael Zirinsky

Ronald Lockett
Born Bessemer, Alabama, 1965
Died Bessemer, Alabama, 1998
Facing Extinction, 1994
Welder's chalk on metal mounted on wood
49¾ × 47¼ × 3½ in. (125.4 × 121 × 8.9 cm)
High Museum of Art, Atlanta; T. Marshall Hahn Collection, 1996.179
[Pl. 15]

Patte Loper
Born Denver, Colorado, 1967
Architecture Review 1978 (After The Shoot), 2006
Oil and acrylic on paper
50 × 62 in. (127 × 157.5 cm)
Private collection

Whitfield Lovell
Born Bronx, New York, 1959
Wreath, 2000
Charcoal, wood, and barbed wire
23 × 23 × 6½ in. (58.4 × 58.4 × 16.5 cm)
The Bronx Museum of the Arts, Museum purchase
[Pl. 27]

Robert Mapplethorpe
Born Floral Park, New York, 1946
Died Boston, Massachusetts, 1989
Untitled (Flowers), from the portfolio *Flowers,* 1983
Toned photogravure
Edition 5 of 40
31¼ × 24½ in. (79.4 × 62.2 cm)
Courtesy of Cheim & Read, New York

Marlene McCarty
Born Lexington, Kentucky, 1957
Love, AIDS, Riot, 1989–90
Heat transfer on canvas
24 × 24 in. (61 × 61 cm)
Collection of Bruno Jakob

Patric McCoy
Born Chicago, Illinois, 1946
Afghan Zo, 1983–85/2016
Digital print from original negative
9 × 12 in. (22.9 × 30.5 cm)
Courtesy of the artist
[Pl. 22]

Loyal Concierge, 1983–85/2016
Digital print from original negative
12 × 9 in. (30.5 × 22.9 cm)
Courtesy of the artist
[Pl. 19]

Only 18 Pawns, 1983–85/2016
Digital print from original negative
12 × 9 in. (30.5 × 22.9 cm)
Courtesy of the artist
[Pl. 1]

Sunglass 1, 1983–85/2016
Digital print from original negative
12 × 9 in. (30.5 × 22.9 cm)
Courtesy of the artist
[Pl. 21]

Youngblood, 1983–85/2016
Digital print from original negative
12 × 9 in. (30.5 × 22.9 cm)
Courtesy of the artist
[Pl. 20]

Thomas McGovern
Born Kansas City, Missouri, 1957
Political Funeral for Jon Greenberg, NYC, from the series *Bearing Witness (to AIDS),* 1993
Gelatin silver print
14¾ × 22 in. (37.5 × 55.9 cm)
Courtesy of the artist

Ann P. Meredith
Born Hot Springs, Arkansas,
1948
*Until that Last Breath! San
Francisco, CA*, June 1987
Gelatin silver print mounted
on Masonite
32 × 43 × ¼ in. (81.3 × 109.2 ×
0.6 cm)
Collection of the Oakland
Museum of California, Gift of
the artist

*AIDS—JUDGEMENT HAS COME,
Slidell, Louisiana*, 1989, printed
2015
Inkjet print
Exhibition print
20 × 30 in. (50.8 × 76.2 cm)
Courtesy of the Arthur
and Elizabeth Schlesinger
Library on the History of
Women, Radcliffe Institute
for Advanced Study, Harvard
University

Duane Michals
Born McKeesport,
Pennsylvania, 1932
*The Father Prepares His Dead
Son for Burial*, 1991
Gelatin silver print with
hand-applied text
Edition 6 of 25
11 × 14 in. (27.9 × 35.6 cm)
Courtesy of DC Moore Gallery,
New York

Donald Moffett
Born San Antonio, Texas, 1955
Homo Senses, 1989
Cibachrome transparency
mounted in lightbox
46 × 57 × 7 in. (116.8 × 144.8 ×
17.8 cm)
Collection of the Leslie-
Lohman Museum of Gay and
Lesbian Art, Founder's Gift
[Pl. 26]

Frank Moore
Born New York, New York, 1953
Died New York, New York,
2002
Patient, 1997–98
Oil on canvas on wood panel
with red pine frame
49½ × 65½ × 3½ in. (125.7 ×
166.4 × 8.9 cm)
Courtesy of Gesso Foundation
and Sperone Westwater
Gallery, New York
[Pl. 62]

Mark Morrisroe
Born Malden, Massachusetts,
1959
Died New York, New York,
1989
Untitled [Self-Portrait], c. 1988
T-665 Polaroid
Exhibition print
4¼ × 3⅜ in. (10.8 × 8.6 cm)
The Estate of Mark Morrisroe
(Ringier Collection) at
Fotomuseum Winterthur,
Switzerland

Untitled [Self-Portrait], 1989
T-665 Polaroid
Exhibition print
3⅜ × 4¼ in. (8.6 × 10.8 cm)
The Estate of Mark Morrisroe
(Ringier Collection) at
Fotomuseum Winterthur,
Switzerland, Gift from Brent
Sikkema

Untitled [Self-Portrait], 1989
T-665 Polaroid
Exhibition print
3⅜ × 4¼ in. (8.6 × 10.8 cm)
The Estate of Mark Morrisroe
(Ringier Collection) at
Fotomuseum Winterthur,
Switzerland

**The NAMES Project
Foundation**
Established 1987
The AIDS Memorial Quilt, 1987
Quilt panels, mixed media
Dimensions variable
Courtesy of The NAMES
Project Foundation, Atlanta,
Georgia
[Pl. 29]

Ray Navarro
Born Hawthorne, California,
1964
Died New York, New York,
1990
Fabricated by Zoe Leonard
Born Liberty, New York, 1961
Equipped, 1990
Three black and white photo-
graphs and plaques
12½ × 18¾ in. (31.8 × 47.6 cm);
12¼ × 18 in. (31.1 × 45.7 cm);
and 18¼ × 12 in. (46.4 ×
30.5 cm)
Collection of Dr. Daniel Berger

Alice O'Malley
Born Buffalo, New York, 1962
*"New Yorkers Demand"—Chloe
Dzubilo, ACT UP Die-in, NYC*,
c. 1994, printed 2015
Archival gelatin silver print
Artist's proof
20 × 16 in. (50.8 × 40.6 cm)
Courtesy of the artist

Catherine Opie
Born Sandusky, Ohio, 1961
*San Francisco City Hall,
Candlelight March for AIDS #1*,
1986
Pigment print
Edition 1 of 3 with 2 artist's
proofs
12½ × 18 in. (31.8 × 45.7 cm)
Courtesy of the artist and
Regen Projects, Los Angeles

*San Francisco City Hall,
Candlelight March for AIDS #2*,
1986
Pigment print
Edition 1 of 3 with 2 artist's
proofs
18 × 12½ in. (45.7 × 31.8 cm)
Courtesy of the artist and
Regen Projects, Los Angeles

*Ron Athey/The Sick Man (from
Deliverance)*, 2000
Polaroid
110 × 41 in. (279.4 × 104.1 cm)
Collection of Marc and Livia
Straus Family Collection

Izhar Patkin
Born Haifa, Israel, 1955
Unveiling of a Modern Chastity,
1981
Rubber paste, latex theatrical
wounds, and printing ink on
a stretched linen canvas
72 × 48 in. (182.9 × 121.9 cm)
Courtesy of the artist

Robert E. Penn
Born Kansas City, Missouri,
1948
*Fierce Love Video Sequence 2:
AIDS Activism*, 2010
Art from Adversity, 2011
Digital video
12:49 mins.
Courtesy of the artist
[Pl. 61]

Jack Pierson
Born Plymouth,
Massachusetts, 1960
Cry, 2009
Metal, wood, and paint
20 × 61 × 1 in. (50.8 × 154.9 ×
2.5 cm)
Courtesy of Elizabeth Leach
Gallery, Portland, Oregon, and
Cheim & Read, New York

Howardena Pindell
Born Philadelphia,
Pennsylvania, 1943
Separate but Equal Genocide:
AIDS, 1991–92
Mixed media on canvas
75⅓ × 91 in. (191.8 × 231.1 cm)
Courtesy the artist and Garth
Greenan Gallery, New York
[Pl. 41]

Lari Pittman
Born Los Angeles, California,
1952
Spiritual and Needy, 1991–92
Acrylic and enamel on wood
panel
82 × 66 in. (208.3 × 167.6 cm)
Collection of Liz and Eric
Lefkofsky

William Powhida
Born New York, New York,
1976
Safe Sex Rules, 2008
Graphite, watercolor, and
colored pencil on paper
Produced for Visual AIDS
broadside project, 2008
22 × 15 in. (55.9 × 38.1 cm)
Courtesy of the artist and
Visual AIDS

Michael Qualls
Born Chicago, Illinois, 1961
Died Chicago, Illinois, 2005
Origins, 1999
Mixed media on wood with
bitumen
14 × 6 in. (35.6 × 15.2 cm)
Courtesy of Patric McCoy
Collection
[Pl. 48]

Secrets, Blood, and Bones, 2000
Mixed media on wood with
bitumen
14 × 6 in. (35.6 × 15.2 cm)
Courtesy of Patric McCoy
Collection
[Pl. 49]

Jesse Finley Reed
Born Duxbury, Massachusetts,
1974
Decorative Barrier, 6ft, 2003
Vinyl, brass, foam, and thread
Dimensions variable
Courtesy of the artist

Brett Reichman
Born Pittsburgh, Pennsylvania,
1959
And the Spell was Broken
Somewhere Over the Rainbow,
1992
Oil on canvas
Three panels, each: 67 × 31 in.
(170.2 × 78.7 cm)
Portland Art Museum,
Portland, Oregon, Gift of
Hudson and Feature Inc.,
New York, 2001.67A–C

Alon Reininger
Born Tel Aviv, Israel, 1947
Ken Meeks, PWA, 1985
Archival pigment print
20 × 24 in. (50.8 × 61 cm)
Courtesy of Contact Press
Images, New York

Hunter Reynolds
Born Rochester, Minnesota,
1959
Survival AIDS Series 2 ACT UP
Chicago with Memorial Dress
photographed by Maxine
Henryson, 2015
Archival chromogenic color
prints and thread
48 × 60 in. (121.9 × 152.4 cm)
Collection of Dr. Daniel Berger

Eric Rhein
Born Cincinnati, Ohio, 1961
Life Altering Spencer, from
Leaves, 2013
Wire and paper
14 × 11 × 1 in. (35.6 × 27.9 ×
2.5 cm)
Addison Gallery of American
Art, Phillips Academy, Andover,
Massachusetts, purchased
as the gift of Louis Wiley, Jr.
(PA 1963) in Memory of
Paul Monette (PA 1963) and
his partner Roger Horwitz,
2013.57.2

Marlon T. Riggs
Born Fort Worth, Texas, 1957
Died Oakland, California, 1994
Tongues Untied, 1989
Video
55:00 mins.
Courtesy of Frameline
[Pl. 17]

Oli Rodriguez
Born Chicago, Illinois, 1980
The Papi Project: Public Cruising
Spot #22, Belmont Harbor,
Chicago, Illinois, 2012
Digital archival print
18 × 24 in. (45.7 × 61 cm)
Courtesy of the artist
[Pl. 9]

The Papi Project: Public Cruising
Spot #24, Belmont Harbor,
Chicago, Illinois, 2012
Digital archival print
18 × 24 in. (45.7 × 61 cm)
Courtesy of the artist
[Pl. 10]

Tino Rodriguez
Born Ciudad Obregón, Sonora,
Mexico, 1965
Eternal Lovers, 2010
Oil on wood
18 × 24 in. (45.7 × 61 cm)
Collection of Claire Touzé
Shawaf

Adam Rolston
Born Los Angeles, California,
1962
Trojan Boxes, 1991
Ink on cardboard
Each: 11 × 11 × 17 in. (27.9 ×
27.9 × 43.2 cm)
Collection of Tim Bradbury

Dean Sameshima
Born Torrance, California, 1971
In Between Days (Without You),
1998
15 chromogenic color prints
Edition of 3 with 3 artist's
proofs
Each: 3½ × 5¼ in. (8.9 ×
13.3 cm)
Courtesy of the artist and
PERES PROJECTS, Berlin

Andres Serrano
Born New York, New York,
1950
Milk/Blood, 1989, printed 2015
Chromogenic color print
Exhibition print
27⅓ × 40 in. (69.9 × 101.6 cm)
Courtesy of the artist

Blood and Semen III, 1990
Chromogenic color print
Edition 1 of 4
40 × 60 in. (101.6 × 152.4 cm)
Courtesy of the artist

Robert Sherer
Born Jasper, Alabama, 1957
Sweet Williams, 2013
HIV- and HIV+ blood on paper
24 × 18 in. framed (61 ×
45.7 cm)
Courtesy of the artist

Kiki Smith
Born Nuremberg, Germany,
1954
Red Spill, 1996
Glass
Dimensions variable
Collection of the
Grimmerschors Foundation

Rosalind Solomon
Born Highland Park, Illinois,
1930
Silence Equals Death,
Washington, D.C., 1987–90
Gelatin silver print
20 × 16 in. (50.8 × 40.6 cm)
Courtesy of Bruce Silverstein
Gallery, New York

Daniel Sotomayor
Born Chicago, Illinois, 1958
Died Chicago, Illinois, 1992
6,000,000, 1989
Ink on vellum
11 × 14 in. (27.6 × 35.6 cm)
Sotomayor Collection,
Courtesy of Lori F. Cannon
Documentation courtesy of
the Legacy Project
[Pl. 32]

For Paul, 1990
Acrylic on cotton
31 × 64½ in. (78.7 × 163.8 cm)
Gerber/Hart Library and
Archives Bequest
Documentation courtesy of
the Legacy Project
[Pl. 60]

Shame, 1990
Ink on vellum
11 × 14 in. (27.6 × 35.6 cm)
Sotomayor Collection,
Courtesy of Lori F. Cannon
Documentation courtesy of
the Legacy Project
[Pl. 33]

Same Old Excuses, 1991
Ink on vellum
11 × 14 in. (27.6 × 35.6 cm)
Sotomayor Collection,
Courtesy of Lori F. Cannon
Documentation courtesy of
the Legacy Project
[Pl. 34]

Ellen Spiro
Born New Brunswick,
New Jersey, 1968
(In) Visible Women, 1991
Single-channel video
25:10 mins.
Courtesy of the Video Data
Bank at the School of the Art
Institute of Chicago
[Pl. 13]

Larry Stanton
Born Rockville Centre,
New York, 1947
Died New York, New York,
1984
Untitled [Hospital Drawing],
1984
Crayon on paper
14 × 17 in. (35.6 × 43.2 cm)
Courtesy of Arthur Lambert
and the Estate of Larry
Stanton

Untitled [Hospital Drawing],
1984
Crayon on paper
17 × 14 in. (43.2 × 35.6 cm)
Courtesy of Arthur Lambert
and the Estate of Larry
Stanton

Hugh Steers
Born Washington, DC, 1962
Died New York, New York, 1995
Poster, 1990
Oil on canvas
42½ × 51 in. (108 × 129.5 cm)
Courtesy of the artist's estate
and Alexander Gray Associates,
New York

Ferenc Suto
Born Easton, Connecticut,
1960
Untitled, 1986
Gelatin silver print
2 × 1¾ in. (5.1 × 4.1 cm)
Courtesy of the artist

Carl Tandatnick
Born New York, New York,
1956
Today is Day Without Art: When
is Day Without AIDS?, 1994 and
1995
Single-channel video
00:15 mins.
Courtesy of the artist

Masami Teraoka
Born Onomichi,
Hiroshima-ken, Japan, 1936
Geisha in Ofuro, 2011
Jacquard tapestry
115 × 78 in. (292.1 × 198.1 cm)
Courtesy of the artist and
Magnolia Editions
[Pl. 3]

Joey Terrill
Born Los Angeles, California,
1955
Still-Life with Forget-Me-Nots
and One Week's Dose of Truvada,
2012
Mixed media on canvas
36 × 48 in. (91.4 × 121.9 cm)
Leslie-Lohman Museum
of Gay and Lesbian Art,
Foundation purchase

Paul Thek
Born Brooklyn, New York, 1933
Died New York, New York, 1988
Dust, 1988
Acrylic on canvas board
13 × 17 in. (33 × 43.2 cm)
Watermill Center Collection

Julie Tolentino
Born San Francisco, California,
1964
THE SKY REMAINS THE SAME:
Tolentino Archives Ron Athey's
Self-Obliteration #1, 2008
Chromogenic color print
Edition 1 of 5
17 × 11 in. (43.2 × 27.9 cm)
Documentation courtesy of
Leon Mostovoy
Courtesy of the artist and
Commonwealth & Council,
Los Angeles

THE SKY REMAINS THE SAME:
Tolentino Archives Ron Athey's
Self-Obliteration #1, 2011;
printed 2015
Inkjet print
Exhibition print
17 × 11 in. (43.2 × 27.9 cm)
Documentation courtesy of
Paula Court
Courtesy of the artist

THE SKY REMAINS THE SAME:
Tolentino Archives Ron Athey's
Self-Obliteration #1, 2011;
printed 2015
Inkjet print
Exhibition print
19 × 13 in. (48.3 × 33 cm)
Documentation courtesy of
Paula Court
Courtesy of the artist

Boris Torres
Born Piñas, Ecuador, 1976
Love Forever, 2009
Oil on canvas
47 × 58 in. (119.4 × 147.3 cm)
Courtesy of the artist

T. Kim-Trang Tran
Born Vietnam, immigrated to
the United States, 1975
kore, 1994
Single-channel video
17:00 mins.
Courtesy of the Video Data
Bank at the School of the Art
Institute of Chicago
[Pl. 14]

Various Artists
The Faces of AIDS, 1999–2000
Selection of twelve posters
Each: 36 × 24 in. (91.4 × 61 cm)
Commissioned by the Chicago
Department of Public Health
[Pl. 36]

Anthony Viti
Born Rochester, New York, 1961
Elegy #60 (After MH's Iron Cross), 1993
Human blood and oil on Masonite
15 × 15 in. (38.1 × 38.1 cm)
Collection of Loring McAlpin

Darren Waterston
Born Fresno, California, 1965
Isenheim Field, 1995
Oil on wood panel
24 × 24 in. (61 × 61 cm)
Collection of Greg Kucera and Larry Yocom

Patrick Webb
Born New York, New York, 1955
The Lamentation / By Punchinello's Bed, 1992
Oil on canvas
Two panels
Each: 78 × 58 in. (198.1 × 147.3 cm)
Leslie-Lohman Museum of Gay and Lesbian Art, Gift of Brian Kloppenberg and Patrick Webb

Frederick Weston
Born Memphis, Tennessee, 1946
Blue Bathroom Series: Lifestyles/ Sexual Energy, 1999
Collage
11 × 8½ in. (27.9 × 21.6 cm)
Courtesy of the artist
[Pl. 50]

Blue Bathroom Series: Medication, 1999
Collage
11 × 8½ in. (27.9 × 21.6 cm)
Courtesy of the artist
[Pl. 51]

Albert J. Winn
Born Chester, Pennsylvania, 1947
Died Los Angeles, California, 2014
Akedah, 1995
Gelatin silver print
17½ × 21¾ in. (44.5 × 55.2 cm)
Courtesy of Scott R. Portnoff

David Wojnarowicz
Born Red Bank, New Jersey, 1954
Died New York, New York, 1992
Untitled, c. 1984
Found clock, battery, barbed wire, globe, printed paper collage, and acrylic on horse skull
13 × 24 × 10¼ in. (33 × 61 × 26 cm)
Collection of Dr. Daniel Berger
[Pl. 57]

Untitled (Buffalo), 1988–89
Vintage gelatin silver print
28⅛ × 35¾ in. (72.7 × 90.8 cm)
Collection of Michael Sodomick

Untitled (Hujar Dead), 1988–89
Black and white photograph, acrylic, text, and collage on Masonite
39 × 32 in. (99.1 × 81.3 cm)
Collection of Steven Johnson and Walter Sudol, Courtesy Second Ward Foundation

Bad Moon Rising, 1989
Acrylic, photographs, and collage on Masonite
37 × 37½ in. (94 × 95.3 cm)
Collection of Steven Johnson and Walter Sudol, Courtesy Second Ward Foundation

Martin Wong
Born Portland, Oregon, 1946
Died San Francisco, California, 1999
I.C.U., 1988
Acrylic on canvas
Diameter: 40 in. (101.6 cm)
Collection of Mr. and Mrs. Tanenbaum

Thomas Woodruff
Born New Rochelle, New York, 1954
ACOL ADIV IM and *ESOL OT NROB*, 1991
Acrylic on linen mounted on panel
Each: 31 × 21 in. (78.7 × 53.3 cm)
Courtesy of the artist and P.P.O.W Gallery, New York

Israel Wright
Born Coshocton, Ohio, 1954
Freely Carefree, 2000
Digital print from original negative
16 × 13 in. (40.6 × 33 cm)
Courtesy of the artist
[Pl. 38]

Get the Point, 2000
Digital print from original negative
13 × 16 in. (33 × 40.6 cm)
Courtesy of the artist
[Pl. 37]

Smoldering, 2000
Digital print from original negative
13 × 16 in. (33 × 40.6 cm)
Courtesy of the artist
[Pl. 40]

Warm Embrace, 2000
Digital print from original negative
16 × 13 in. (40.6 × 33 cm)
Courtesy of the artist
[Pl. 39]

Carrie Yamaoka
Born Glen Cove, New York, 1957
Steal This Book #2, 1991
Unique chemically altered gelatin silver print
20 × 24 in. (50.8 × 61 cm)
Courtesy of the artist

Sharon Zurek, director
Lora Branch, executive producer/writer
Kevin's Room, 2001
Video
60:00 mins.
Produced by the Chicago Department of Public Health and Black Cat Productions
[Pl. 35]

Contributors

Christopher Audain is a program officer at Alphawood Foundation in Chicago.

Tracy Baim is publisher and executive editor at *Windy City Times*, which she co-founded in 1985.

Staci Boris is a Chicago-based curator and former associate director of exhibitions at Alphawood Foundation.

Lora Branch is a public health administrator; educator; video producer; activist; and regional lead, HIV FOCUS, at Gilead Sciences.

Karen Finley is an artist, musician, poet, and professor at New York University's Tisch School of the Arts.

Tempestt Hazel is the co-founder of *Sixty Inches From Center*, an organization and weekly online publication, and arts program officer at the Field Foundation in Chicago.

Anthony Hirschel is an independent arts consultant and the former director of exhibitions at Alphawood Foundation.

Jonathan D. Katz is the co-curator of *Art AIDS America* and director of the doctoral program in Visual Studies at the University at Buffalo, the State University of New York.

James D. McDonough is the executive director of Alphawood Foundation in Chicago.

Danny Orendorff is the executive director of Vox Populi in Philadelphia.

Mary Patten is a Chicago-based artist and activist, and professor of Film, Video, New Media, and Animation and Visual and Critical Studies at the School of the Art Institute of Chicago.

Kate Pollasch is a curator, art historian, and writer based in Chicago.

Victor Salvo is founder and executive director of The Legacy Project in Chicago.

Joseph R. Varisco is the creator and producer of QUEER, ILL + OKAY and the former program manager at Alphawood Gallery.

Index

Photo Credits

Lizabeth Applewhite/DePaul Art Museum: pp. 148, 149 (fig. 6), 155.

Art Resource, NY/The Art Institute of Chicago: © Estate of Tony Feher, p. 26; © The Estate of General Idea, p. 28; © Doug Ischar, p. 31 and back cover.

Artists Rights Society (ARS), New York: © 2018 Judy Chicago, work by Judy Chicago reproduced on p. 20; © 2018 Estate of Ronald Lockett, p. 36.

Courtesy of Tracy Baim's Archives: p. 69.

Black Cat Productions: p. 106.

Robert Blanchon Estate: p. 85 (fig. 21).

Jonathan Bloom/University of California, Berkeley Art Museum and Pacific Film Archive: Courtesy of the Estate of David Cannon Dashiell, pp. 54–55.

Staci Boris: pp. 205–6.

William Burks/*Windy City Times*: p. 65.

Lori F. Cannon Collection: pp. 100, 103.

Mike Carter/*Windy City Times*: p. 67 (fig. 5).

Courtesy of Cheim & Read, New York: work by Jack Pierson reproduced on p. 19.

Ralph Childs: pp. 96, 99, 101–2, 104–5.

Steve Dalber: p. 81 (fig. 14).

Courtesy of Garth Greenan Gallery, New York: front cover, pp. 116, 119.

Courtesy of Gladstone Gallery, New York: p. 179.

© Felix Gonzalez-Torres, Courtesy of The Felix Gonzalez-Torres Estate: all Felix Gonzalez-Torres works reproduced on pp. 8, 12, 19, 43, 124, 193, 195, 202–9, 216, 219, 221, 228.

Isadore Howard: p. 127.

Lisa Howe-Ebright/*Windy City Times*: pp. 66 (fig. 2), 71, 72, 79 (fig. 11).

Karl Productions: p. 111 (fig. 3).

Zak Kelley/Courtesy of the Museum of Contemporary Art, Los Angeles, and ONE National Gay & Lesbian Archives at the USC Libraries: p. 123.

Erik Kommer: p. 162 (fig. 2).

Jason Mandella: p. 125.

Courtesy of Marianne Boesky Gallery, New York and Aspen: © Donald Moffett, p. 56.

Courtesy of Mary Boone Gallery, New York: © Barbara Kruger, p. 27.

Courtesy of Matthew Marks Gallery: © Nayland Blake, work by Nayland Blake reproduced on p. 43; © Nan Goldin, p. 170.

Linda Miller: pp. 74–75 (photographs incorporated into the photo mural), 82 (fig. 16), 83 (fig. 18).

Ireasha Monet: pp. 199, 203–4.

Genyphyr Novak: pp. 74–75 (photographs incorporated into the photo mural), 81 (fig. 15).

Outlines/Windy City Times Archives: p. 66 (fig. 3).

Michael Overn: pp. 162 (fig. 1), 164, 166–67.

Courtesy of Mary Patten's ACT UP/Chicago Archive: pp. 77–85.

Courtesy of Jim Pickett: p. 111 (fig. 4).

James Prinz: pp. 6–8; 12; 22–23; 25; © Glenn Ligon, Courtesy of the artist, Luhring Augustine, New York, Regen Projects, Los Angeles, and Thomas Dane Gallery, London, 29; 32–33; 39; 43; Courtesy of Alexander and Bonin, 48–49; 58–61; Courtesy of The NAMES Project Foundation, 62; 74–75; 131; 138–41; 156; 168; ©Keith Haring Foundation, 175.

Adam Reich: p. 174.

© Robert Mapplethorpe Foundation. Used by permission: p. 198.

Kevin Ryan/Courtesy DC Moore Gallery, New York: p. 57.

© School of the Art Institute of Chicago and the Brown family. Kavi Gupta/Roger Brown Estate: pp. 86, 89–91, 93.

Shelley Schneider-Bello: p. 78 (figs. 6–7).

Suzanne Tallon: p. 165.

Michael Tropea: p. 9, © Keith Haring Foundation; 15–16; 19–20; 44; 50; 113.

Video Data Bank, www.vdb.org, School of the Art Institute of Chicago: © the artist: pp. 34–35, 171.

Courtesy of Vtape, Canada: p. 153.

Julie Rodrigues Widholm: p. 218.

Rex Wockner/*Outlines/Windy City Times* Archives: p. 67 (fig. 4).

Courtesy of the Estate of David Wojnarowicz and P•P•O•W, New York: © David Wojnarowicz, pp. 142, 172–73.

Israel Wright: p. 110 (fig. 2).

JI Yang: pp. 124, 190–91, 193, 195–96, 201–2, 207–15, 219, 221–22, 225–29, endpapers/back.

This book is published in conjunction with the exhibition *Art AIDS America*, presented at Alphawood Gallery in Chicago from December 1, 2016, through April 2, 2017.

Art AIDS America was organized by Tacoma Art Museum in partnership with The Bronx Museum of the Arts. The exhibition was co-curated by Jonathan David Katz, Director of the Visual Studies Doctoral Program at the University at Buffalo (The State University of New York), and Rock Hushka, Chief Curator and Curator of Contemporary and Northwest Art at Tacoma Art Museum. The national tour was supported by the Leslie-Lohman Museum of Gay and Lesbian Art and Gilead Sciences, Inc. The original exhibition was made possible by support from The Andy Warhol Foundation for the Visual Arts and The Paul G. Allen Family Foundation.

In Chicago, the exhibition was made possible by Alphawood Foundation, a Chicago-based, grant-making private foundation working for an equitable, just, and humane society. The exhibition was presented at Alphawood Gallery, a temporary exhibition space created by Alphawood Foundation to bring *Art AIDS America* to Chicago.

For additional information about *Art AIDS America Chicago*, please see www.artaidsamericachicago.org.

Library of Congress Control Number: 2018943472
ISBN: 978-0-9996522-5-1

Published by Alphawood Foundation, Chicago
www.alphawoodfoundation.org

Distributed by University of Washington Press, Seattle
www.washington.edu/uwpress

Produced by Lucia|Marquand, Seattle
www.luciamarquand.com

Edited by Susan Higman Larsen
Designed by Zach Hooker
Typeset in Libertad by Brynn Warriner
Proofread by Carrie Wicks
Indexed by Enid Zafran
Color management by iocolor, Seattle
Printed and bound in China by C&C Offset Printing Co., Ltd.

Front cover: Howardena Pindell, *Separate but Equal Genocide: AIDS* (detail), 1991–92 (Pl. 41)

Back cover: Doug Ischar, *Untitled*, 1985 (Pl. 11)

Front endpapers: Photo mural designed for *Art AIDS America* at Alphawood Gallery, Chicago, by Alex Kostiw from archival materials researched collaboratively with John Neff. Images incorporated in the mural are from Mary Patten's ACT UP/Chicago archive (photos by Genyphyr Novak and Linda Miller) and the Bruce Johnson archives.

Back endpapers: *Chalk Column*, Alphawood Gallery, Chicago, 2017.

Karen Finley's poem "The Black Sheep," pp. 157–59, originally published in *Shock Treatment*. Copyright © 1989 by Karen Finley. Reprinted with permission of City Lights Books, www.citylights.com.

Essex Hemphill's poem "Cordon Negro," p. 188. Copyright © 1992 Essex Hemphill from *Ceremonies: Prose and Poetry*. Reprinted by permission of The Frances Goldin Literary Agency.